T0227619

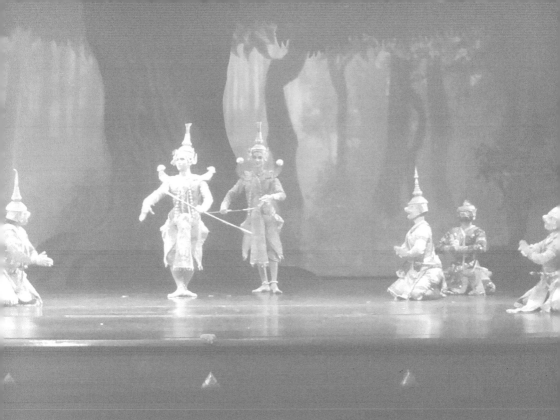

Ramayana Theater in
Contemporary Southeast Asia

Ramayana Theater in Contemporary Southeast Asia

edited by
Madoka Fukuoka

JENNY STANFORD
PUBLISHING

Published by

Jenny Stanford Publishing Pte. Ltd.
101 Thomson Road
#06-01, United Square
Singapore 307591

Email: editorial@jennystanford.com
Web: www.jennystanford.com

British Library Cataloguing-in-Publication Data
A catalogue record for this book is available from the British Library.

Ramayana Theater in Contemporary Southeast Asia

Cover image courtesy: Sala Chalermkrung Royal Theater, Bangkok

ISBN 978-981-4968-09-6 (Hardcover)
ISBN 978-1-003-29095-7 (eBook)

Contents

Preface xi

1. **Introduction: Multiple Meanings of Ramayana Theater
 in Contemporary Southeast Asia** 1
 Madoka Fukuoka
 1.1 Purpose of the Study 1
 1.2 Focusing on Ramayana as a Subject Matter
 in Art Forms 6
 1.2.1 Basic Story and Main Protagonists 7
 1.2.2 Norms and Ideologies Represented in
 Theatrical Art Forms Based on
 Ramayana 8
 1.2.3 Ramayana as Subject Matter for
 Theatrical Performance 11
 1.3 Positioning Ramayana Theater in
 Contemporary Southeast Asia 13
 1.3.1 Cultural Dimensions of
 Contemporary Southeast Asia 13
 1.3.2 Cultural Dimensions of
 Globalization in Southeast Asia 15
 1.3.3 Ramayana in the Cultural Scenes
 of Contemporary Southeast Asia 17
 1.4 Multiple Positions of Art Forms Based on
 Ramayana in Contemporary Southeast Asia 18
 1.4.1 Dissemination of Ramayana through
 a Popular Cultural Form: The
 Indonesian Comic Artist R. A.
 Kosasih's Reinterpretation of the Story 18
 1.4.2 Representations of the Cultural
 Elements among a Diaspora
 Community: A Theatrical
 Performance of Ramayana in the
 Malay Community in Singapore 21

1.4.3 Searching for the Image of the
 Ideal Leader in Contemporary
 Southeast Asia: A Collaborative
 Project since 1997 23
1.5 Outline of Chapters 25

**Appendix: Outline of Valmiki's Seven-Volume
 Version of Ramayana** **31**
A.1.1 Introduction 31
A.1.2 Main Protagonists and Summary of Each
 Volume 31
A.1.3 Some Bibliographical Notes and the Scenes
 Featured in Theatrical Works 35
A.1.4 Images of Main Protagonists in Indonesian
 Shadow Play 37

Part I Multiple Interpretations of Ramayana

**2. The Modern Development of *Ramakian*, the Thai
 Ramayana, as Seen in Films by Chaiyo Studio 45**
 Hideki Hiramatshu
 2.1 Introduction 46
 2.2 Reception of *Ramayana* in Thailand 49
 2.3 *Hanuman vs. 7 Ultraman* (1974) 52
 2.3.1 Sompote Saengduenchai 53
 2.3.2 The Story of *Hanuman vs. 7 Ultraman* 54
 2.3.3 The Aims of Creator 59
 2.4 *Suek Kumphakan* (The Battle with
 Kumbhakarna) (1984) 61
 2.4.1 *Tokusatsu* Effects and Comical
 Developments 61
 2.4.2 The Story of *Suek Kumphakan* 63
 2.5 Conclusion 66

**3. Death of Kumbhakarna: Interpretation of the Story
 by *Dalang* of Balinese *Wayang*** **71**
 Hideharu Umeda
 3.1 Introduction 72
 3.2 Kakawin Ramayana 72
 3.2.1 Sarga 1–Sarga 5 74

3.2.2 Sarga 6–Sarga 11 74
3.2.3 Sarga 12–Sarga 18 75
3.2.4 Sarga 19–Sarga 23 75
3.2.5 Sarga 24–Sarga 26 75
3.3 Balinese *Wayang* Performances of Ramayana 75
3.4 The "Death of Kumbhakarna" as Seen in the
 Kakawin Ramayana 77
 3.4.1 Sarga 22, Stanzas 1–12 77
 3.4.2 Sarga 22, Stanzas 13–48 77
 3.4.3 Sarga 22, Stanzas 49–89 78
 3.4.4 Sarga 23, Stanzas 1–8 78
3.5 The Composition of Scenes in the "Death of
 Kumbhakarna" as *Wayang* Performance 79
 3.5.1 Pattern I 79
 3.5.2 Pattern II 80
3.6 Interpretation of the Performances of
 Balinese *Dalang* Based on Real Dialogues (1) 81
3.7 Interpretation of the Performances of
 Balinese *Dalang* Based on Real Dialogues (2) 85
3.8 Conclusion 87

4. Ramayana Theater in Cambodia 91
Sam-Ang Sam
4.1 Introduction 92
4.2 Historical Dimension: Indian Ramayana 92
4.3 Ramayana (Reamker) Theater in Cambodia 93
 4.3.1 Content and Representation of Culture 95
 4.3.1.1 Preah Ream or Prince
 Rama 97
 4.3.2 Culture of the Diaspora 97
 4.3.2.1 The Khmer Rouge
 (1975–79) 97
 4.3.2.2 Refugee Movement 98
 4.3.2.3 Challenges of the New Life
 on the New Land 98
 4.3.3 Transmission 98
 4.3.4 Designation of Tangible Cultural
 Heritage (TCH) and Intangible
 Cultural Heritage (ICH) 100

	4.3.5	Contemporary Cambodia in the Globalized Era	101
	4.3.6	Popular Culture	101
	4.3.7	Tourism Culture	103
4.4		Significance of Reamker in Khmer Life	103
	4.4.1	Reamker in Khmer Court Dance	104
	4.4.2	Reamker in Khmer Masked Play	105
	4.4.3	Reamker in Khmer Shadow Play	106
	4.4.4	Reamker in Khmer Sculpture	107
	4.4.5	Reamker in Khmer Painting	108
	4.4.6	Reamker in Khmer Astrology	108
	4.4.7	Reamker in Khmer Storytelling	109
4.5		Conclusion	109

Part II Diversified Performance Contexts

5. Ramayana in the Performing Arts: Connection with the Government and Local/National/Global Indian Identity in Singapore

5. Ramayana in the Performing Arts: Connection with the Government and Local/National/Global Indian Identity in Singapore — 115

Yoshiaki Takemura

5.1		Introduction: Ramayana and Indian Diaspora	116
5.2		Arts Management and the Ramayana Events in Singapore	120
	5.2.1	Cultural Policy in Singapore	120
	5.2.2	Cultural Events and Ramayana	122
	5.2.3	Ramayana and Indian Dance in Singapore	124
5.3		Performing the Ramayana and Its Representation among the Indian Diaspora Community	126
	5.3.1	The Indian Performing Arts Scene in Singapore	126
	5.3.2	Rukumini Devi Arundale and the Ramayana Drama	128
	5.3.3	Apsaras Arts and Inheritance of Kalakshetra Style	130
5.4		Ramayana Production as a Representation of Global Indianness	132
5.5		Conclusion	137

6. **Ramayana Theater in Tourism Culture: The Story
 Presented in the Javanese Dance Drama Form,
 *Sendratari*** **143**

 Madoka Fukuoka

 6.1 Introduction 144
 6.2 Repertoire of the Stories in Shadow Puppet
 Plays and *Sendratari* 146
 6.2.1 Ramayana Stories in Shadow
 Puppet Plays 146
 6.2.2 Repertoire of the Stories in
 Sendratari 148
 6.3 Creation of *Sendratari* Ramayana in Java 149
 6.3.1 Creation 149
 6.3.2 Stories 150
 6.4 *Sendratari* Ramayana as a Onetime
 Performance 152
 6.5 Presentation of the Story in *Sendratari*
 Ramayana in Prambanan 156
 6.5.1 Characteristics of the Story in
 Sendratari 156
 6.5.2 Rejection of Local Cultural Elements 158
 6.6 Presentation of Ramayana Story in
 Sendratari Directed for Tourism Context 159

Part III Represented Ramayana

7. **A History of Thai Intellectuals' Perceptions of *Khon*,
 the Masked Dance of Ramayana, on the Modern
 World Stage** **165**

 Shinsuke Hinata

 7.1 Whose Culture? 165
 7.2 Royal Perception during the Absolute
 Monarchy 169
 7.3 Nationalist Discourses after the 1932
 Revolution 175
 7.4 From a Japanese Perspective 179
 7.5 Summary 182

8. **Exhibiting Ramayana in a Japanese Museum: Activities of National Museum of Ethnology, Japan** **187**

 Fukuoka Shota

 8.1 Reception of Ramayana in Japan 188
 8.2 Ramayana in the Southeast Asian Gallery at National Museum of Ethnology 191
 8.2.1 Historical Background of the Exhibition on Southeast Asian Culture in Minpaku 191
 8.2.2 Changes in Southeast Asia Gallery in Minpaku 193
 8.3 Visual Representation of Characters from Ramayana as Seen from the Exhibit 196
 8.3.1 Hanuman 197
 8.3.2 Ravana 198
 8.3.3 Rama 200
 8.4 Visual Recordings of *Sbaek Thomm*, the Large-Scale Shadow Theater of Cambodia 202

Part IV Commissioned Art Works

9. **Art Works** **209**

 Madoka Fukuoka

 9.1 Introduction 209
 9.2 Dance Drama Created by Didik Nini Thowok: *Urang Rayung and Anoman Vs. Rekatha Rumpung* 210
 9.3 Animation Work by Nanang Ananto Wicaksono: *Ramayana: The Last Mission* 216
 9.4 Choral Music Work by Ken Steven: *Sinta Obong* 221

Index 237

Preface

The epic poem *Ramayana* narrates Prince Rama's battle with the demon king Ravana, who kidnapped Rama's beautiful wife Sita, and how he saves his wife with the help of the monkeys' army. *Ramayana*, along with another epic *Mahabharata*, is known as one of the two main epic poems of ancient India.

Ramayana contains the elements of human drama, such as conflict over the succession to the throne, the nobility of the *kshatriyas*, and the moral values and gender norms of the society. It also indicates elements derived from the nature of heroes as reincarnations of Hindu gods, including their supernatural powers, mysterious destinies, and invincible weapons. Many animals, such as monkeys, and existence of entities other than humans, such as demons and *rakshasas*, can be witnessed in it.

Because of these characteristics, the epic has been performed in various theatrical forms as well as featured in visual art and literary works. This book examines the characteristics of the Ramayana theater as a platform that can be interpreted in diverse ways and generates multiple expressions based on it.

Ramayana is widely known in Southeast Asia and has been transmitted with its own developments in various fields. Depicting the battle, the adventure, the love and romance, and the human way of life, it has been one of the main subjects where people in Southeast Asia have generated various interpretations based on its outline or character setting, pursuing effective artistic expression. Ramayana has been popular in various theatrical genres such as puppetry, shadow play, masked dance, and dance drama. In the theatrical forms, it has been connected with the royal power and court traditions in some places. It has also been positioned as representative art form in each region and has gained focus in the contexts of tourism and designation of cultural heritage. Ramayana has been disseminated in contemporary artworks and media such as cinemas, comic works, etc. Artists in Southeast Asia have pursued the artistic expression based on the epic, projecting the social situation and cultural values of different eras in it. This book considers the

various representations of Ramayana in contemporary Southeast Asia, focusing particularly on the different theatrical works.

The book is one of the outcomes of Japan Society for the Promotion of Science (JSPS) KAKENHI grant number 19H01208, titled "Study on Multiple Meanings of Ramayana in Contemporary Art Forms in Southeast Asia" (representative: Madoka Fukuoka). I am grateful to JSPS for supporting a part of the expenses related to the commission of the artworks in this book.

In July 2019, some of the members of this research project held a panel discussion on the Ramayana theatre in contemporary Southeast Asia in ICTM (International Council for Traditional Music) in Bangkok. The panel discussion formed the base for the idea and concept of this book. Having the opportunity to see some theatrical performances in Bangkok in 2019, I could recognize the important position of Ramayana theater in various contexts.

I would like to thank the Sala Chalermkrung Theater, Bangkok, for granting the permission to use some photographs of their performances, and the National Museum of Ethnology, Osaka, Japan, for allowing me to include photographs of puppets and masks from their collections.

Since April 2020, when we started to plan the publication of this book, the global pandemic led us to rethink all our original research plans, including fieldwork and invitations to artists. In such a situation, discussions on the contents of this book were often executed among the members through online meetings. I would like to thank all the contributors who supported the publication of this book. I also thank Yuri Nishida, who supported the work on commentary writing.

I would like to express my deep gratitude to three Indonesian artists, Didik Nini Thowok, Nanang Ananto Wicaksono, and Ken Steven, who provided their original artworks for this book. Based on inspiring episodes and scenes, each artist has created the artwork with their reinterpretation of Ramayana. These artworks embody the characteristics of specialized fields, including dance, shadow puppetry, animation, and choral music. The artworks can be seen through the QR code posted in this book. Although the pandemic has constrained physical performances, it has also promoted the performances online, for better or for worse. It is evident that the performances are being made into edited video works in these several years, and we need to consider the merits and demerits of

the situation continuously. I hope the artworks in this book will indicate the potentiality of new ways of art performance.

An editor at Jenny Stanford Publishing, Singapore, who participated in the ICTM Bangkok in 2019, was interested in our panel discussion. I express my gratitude to the publisher for suggesting us to publish a book on Ramayana in Southeast Asia and thank its team for supporting us in many ways during the book editing process, particularly with our English expressions and character name notations.

I would like to thank my English teacher, Mrs Marian Dohma, for helping in the proofreading.

I hope this book will provide worthwhile information on the development and the current situation of Ramayana theater in contemporary Southeast Asia.

Madoka Fukuoka
Spring 2022, Osaka

Chapter 1

Introduction: Multiple Meanings of Ramayana Theater in Contemporary Southeast Asia

Madoka Fukuoka

*Graduate School of Human Sciences, Osaka University, 1-2 Yamadaoka,
Suita, Osaka, 565-Japan*
mfukuoka @hus.osaka-u.ac.jp

1.1 Purpose of the Study

Focusing on theatrical performance of the Ramayana, this study considers the multiple meanings and representations of the epic poem in contemporary Southeast Asia.

The ancient Indian epic poem Ramayana has been disseminated throughout large tracts of Southeast Asia since the 9th century. Versions of the epic poem have come to adopt and reflect the unique characteristics of the countries and regions where it has gained cultural currency. The epic depicting the adventure and fights of Prince Rama as the incarnation of the Hindu god, Vishnu, with the demon king Ravana, who kidnaps Rama's beautiful wife

Ramayana Theater in Contemporary Southeast Asia
Edited by Madoka Fukuoka
Copyright © 2023 Jenny Stanford Publishing Pte. Ltd.
ISBN 978-981-4968-09-6 (Hardcover), 978-1-003-29095-7 (eBook)
www.jennystanford.com

Sita, has been a source of popular themes in both traditional and contemporary art forms, including literature, performing arts, fine arts, and cinemas. Many studies of artistic versions of Ramayana have been conducted with some focusing on art forms in Asia, including Southeast Asia (Iyengar 1983, Kam 2000, Krishnan 2013, Miettinen 1992, Roveda 2016). Based on the results and information in these studies, the various theatrical performances of Ramayana in contemporary Southeast Asia are the focus of this study. The theatrical performances here include various genres such as dance works, puppet plays, and (masked) dance drama. This study also covers cinema, content cultures, and comic works. Therefore, the object of the study can be precisely defined as "dramatic art forms."

In contemporary Southeast Asia, we can see the various contexts in which the theatrical performances of Ramayana are positioned as important cultural elements, including tourism, diaspora, popular culture industry, and cultural exchange programs. The performances for tourists, for example, indicate the popularity of the epic poem and the dramatic effects in various theatrical expressions rooted in the regional art traditions of Southeast Asia. Various theatrical forms of the Ramayana have been appreciated by tourists, such as shadow puppets, masked or non-masked dance drama, rod puppet plays, recitation, and singing.[1]

The spectacles in Ramayana theater, featuring a variety of characters, masks, costumes, dance movements, voice and music, are representative of the main objects in tourism culture that responded to the "tourist gaze" based on tourists' "anticipation of intense pleasure" (Urry 1990: 3). Tourism culture has also provided an opportunity to position Ramayana theater as one of the valuable cultural heritage sites in each region. Similar examples can be found in international or interregional cultural exchange programs, as well as cultural events in diaspora communities. In these contexts,

[1]Balinese *kecak* also performs Ramayana story in multi-layered voice performances and body movements. Voice performances in *kecak* are derived from the traditional trance dance in ritual, *sanghyang dedari*. In the 1930s, the German artist, Walter Spies, had produced a performance of *kecak* together with the local people in Bedulu, Bali in a performance adopting the Ramayana story (Picard 1990: 60). After producing the *kecak* performances in some villages in Bali, including the famous Bona, Spies and his local collaborators established the style of performance of the Ramayana story in 1937. Because male voice performers are compared to monkey soldiers in Ramayana, the performances were known as "monkey dance" in tourism culture.

the question of how to express cultural elements from diverse perspectives always arises.[2]

In contexts where cultural forms are valued as national heritage, as seen in the designation of UNESCO, the evaluation of intangible cultural heritage also raises some important research topics on Ramayana theater in contemporary Southeast Asia. In 2018, *khon*, the masked dance drama in Thailand, was placed on the Representative List of the Intangible Cultural Heritage of Humanity of UNESCO. Ramayana is the only repertoire of the dance drama. The description of the *khon* on the UNESCO page explains the genre as follows:

> On one level, khon represents high art cultivated by the Siamese/ Thai courts over centuries, while at another level, as a dramatic performance, it can be interpreted and enjoyed by spectators from different social backgrounds (UNESCO page).
>
> (https://ich.unesco.org/en/RL/khon-masked-dance-drama-in-thailand-01385)

This explanation indicates both the sophistication of the genre as a part of court culture and its popularity as a dramatic performance for many audiences.[3]

The theatrical performances of the epic have also come to be perceived as the common cultural heritage of Southeast Asia since the 1970s. Since the first large-scale international festival and seminar on Ramayana held in Indonesia in 1971, numerous events have provided opportunities to indicate the diverse interpretations and performances of the epic poem in the region. As described in Section 1.4.3, the purpose of the events gradually changed from the indication of the diversity among regions to the collaborative creation of a new work based on the epic poem. Since 1997, this epic poem has also been regarded as a symbol of the cultural solidarity of the Association of Southeast Asian Nations (ASEAN), representing the political and economic unity of the region that has been seen in many collaborative creations based on the Ramayana (Tiongson 2019).

[2]Focusing on the stories indicated for outsiders, including tourists, and the stories in the indigenous art forms, the differences found between the tourism performances and the performances in the indigenous context will be discussed in Chapter 6.

[3]The process of designation and the intellectuals' perception of the cultural heritage under the relationship between Thailand and neighboring countries in Southeast Asia will be examined by Shinsuke Hinata in Chapter 7.

Ramayana has also been one of the main subjects of contemporary art forms in Southeast Asia. Cohen (2016) described the artistic activities of the current generation of artists in Southeast Asia, whom he positioned as "post traditional" artists. Focusing on new-generation shadow puppet artists, many of whom are both university-educated and the descendants or pupils of traditional practitioners, Cohen pointed out that they are "seizing the codes of performance culture, inhabiting received forms, and re-making them to speak to both local particularities and global issues" (Cohen 2016: 191). He described the various kinds of creative activities of these new-generation shadow puppet artists. Although the examples do not have a direct connection with Ramayana, there are some works based on the shadow puppet genres whose main repertoire is drawn from Ramayana. Positioning the new generation of shadow puppet artists as the leading figures in the contemporary art scene is suggestive in our appreciation of current art forms in Southeast Asia. The artist who created the special animation work for this book, Nanang Ananto Wicaksono, has also been positioned as a "post traditional" shadow puppet artist (Cohen 2016: 202–203).

In the contemporary art scene, we note some prominent works that have both direct and indirect connections with Ramayana theater. As an example, the Indonesian film titled *Opera Jawa* (2006), directed by the Indonesian director, Garin Nugroho, depicts a contemporary adaptations of the Ramayana story. The story progresses in the form of a Javanese dance drama known as *langendriyan*. Some leading contemporary dancers in Indonesia, such as Martinus Miroto, Eko Supriyanto, and Jecko Siompo, performed dances and acted as the main protagonists in the work; puppeteer Slamet Gundono appeared and performed songs in some scenes as well. In addition, many contemporary artists participated in the creation of other elements such as the settings, objects, and music (Aoyama 2010). The work has also been developed into a form of dance theaters and performed in several countries. An art exhibition of the objects used in this work had also been held. This contemporary adaptation of the Ramayana story was dramatized in a new interpretation, reaching a different ending from the traditional story of the epic. It can thus be positioned as a works of contemporary art based on the story world of the epic poem.[4] Ramayana had been one of the themes of popular art forms such as comic books and commercial movies, as Hiramatsu has described in Chapter 2.

[4]As for the contemporary dance work related to Ramayana indirectly, refer to the column article on Thai contemporary dancer Pichet Klunchen's latest work.

In their search for both traditional elements and modernity in Ramayana, Southeast Asian artists have sought a variety of ways to create artistic works based on, or in relationship with, the epic poem.[5] In this way, its themes and forms can be accepted by a wide audience in the contemporary world.

This study considers Ramayana theater as a platform where multiple meanings and senses of value are negotiated. It focuses on the relationships between cultural representation and the multiple meanings of Ramayana theater, as well as other dramatic art forms. Focusing on the various contemporary contexts of art performance where the epic poem has been represented, the study also considers the ideologies and moral values contained in the theatrical forms of the epic poem. The various performance contexts will be considered in this study, such as tourism, diaspora communities, production of popular content culture, cultural diplomacy, designation as intangible cultural heritage, transmission, and the representation/ exhibition of culture, as well as the performance in the rituals. The cases examined in the study are as follows: The imagery of the hero's character applied in Thai content culture, the moral values indicated in the popular episodes of Ramayana in Balinese shadow puppetry, the current situation of Ramayana arts in Cambodia, the fluctuating interpretation and acceptance of creative art works based on Ramayana among the Indian diaspora in Singapore, representations of Ramayana theater in tourism culture in Java, consideration of the history of representation and intellectuals' perception of the Thai masked dance drama, *khon*, and an ongoing museum exhibition in Japan.

In this introduction, I will first outline the story of Ramayana and examine the characteristics of the epic as the subject matter of various forms of theatrical expression. Secondly, I will position Ramayana theater in contemporary Southeast Asia. After considering

[5]An Indonesian composer of choral music, Ken Steven, talked about his idea to create a long choral work on Ramayana as his next work based on the traditional story in the talk session of the choral music festival in Singapore ("Voices: A Festival of Song 2020 in Conversation with Roldan, Vizconde-Roldan, Steven & Maniano" in "Muziksea: The Gateway of the Southeast Asian Choral Music," 5 December 2020 in Esplanade, Singapore). Thus, Ramayana can be positioned as the source of the idea to create the contemporary dramatic art forms based on traditional cultural elements. As his first trial, Ken Steven created a short piece of choral music for this book (see Chapter 9). https://www.youtube.com/watch?v=PmYQxF-Z168&feature=emb_rel_pause, https://www.esplanade.com/offstage/arts/voices-muziksea-the-gateway-to-southeast-asian-choral-music, accessed on 17 December 2020.

the current cultural situation in Southeast Asia, I will consider the art forms of Ramayana in the cultural dimensions of contemporary Southeast Asia. Thirdly, I will examine the various positions of art forms based on Ramayana in contemporary Southeast Asia through case studies. Finally, I will describe the structure of the book and provide a summary of the following chapters.

1.2 Focusing on Ramayana as a Subject Matter in Art Forms

Considering the relationship between the epic poem and theatrical forms, it is necessary to examine the theatrical expressions manifested in the performances. There are various elements of theatrical forms, including verbal elements such as narrations, lines, recitation, poems, and singing, and nonverbal elements such as dancing, acting, setting, and music. Verbal expressions in theatrical forms are often performed in a stylized manner, as Walter Ong pointed out in his study on orality and literacy (Ong 1982: 139–155). In a more specific dimension, the researcher of Malay literature, Amin Sweeney, pointed out the stylized forms of language and presentation in Malay shadow play, *wayang Siam*, in his study (Sweeney 1991: 19–20).[6]

As for the Ramayana theaters, some forms use many or minimal or no verbal expressions. On the other hand, many theatrical forms make use of visual elements such as dancing, acting, stage settings, costumes, masks, and puppets. Sound elements, including music and songs, are also important. The form of the communication of theatrical performances includes various elements related to both the visual sense as well as the audial sense of humans. The experience of seeing artistic performance is different from the experience of reading written texts and different from performing common verbal communication in daily life.[7] Some forms realize a shared comprehension of the story among many people who do

[6]Based on a study of the language of the Malay shadow play, Sweeney indicated the stylized forms of language and presentation and pointed out the commonalities with other types of traditional drama and various forms in the field of traditional medicine and spirit mediumship (Sweeney 1991: 19).

[7]The differences between seeing a performance and reading written texts are same as the differences pointed out by Ong (1982). Moreover, seeing a stylized performances is also different from oral communications in daily lives.

not understand the difficult literate form, and some forms have the effect of authorizing the particular presence of power through visual manifestations. In this study, the expression of the theatrical forms was positioned as the synthesis of these various elements. In this section, the description mainly focuses on the ideology and moral values of the Ramayana epic, including various interpretations and messages. The visual variations in design and formation are also covered in some parts.

1.2.1 Basic Story and Main Protagonists

The main plot of Ramayana depicts the fight between Prince Rama and the demon king Ravana, who kidnaps Rama's beautiful wife, Sita. With the help of a monkey army, Rama defeats Ravana and rescues Sita.

Valmiki's seven-volume version is widely known as the popular Sanskrit version. The texts are considered to have been established from around 4th century BC to the 4th century CE. It is a magnificent epic poem of nearly 24,000 verses, or *sloka*, with the basic unit consisting of 32 syllables. Written in rhyme, the epic poem was passed down in narrative forms.

The main plot mentioned earlier is based on the contents of the second to sixth volumes. The first and seventh volumes (*Bala Kanda* and *Uttara Kanda*) depicting Rama's birth as the incarnation of the Hindu god, Vishnu, and the ascension of Rama as god Vishnu are considered an addition by a later author to deify Rama (Sen 1976: x, Richman 1991: 8).

The story of Ramayana was disseminated in a wide region of Southeast Asia, and it was transmitted in a variety of versions.

For example, in Indonesia, the adaptation of the Indian poet Bhattikavya's variant text of the Rama story in the 9th century is known through its translation into the ancient Java language.[8] The translator is unknown except for the designation "Yogesvara" (master of Yoga). Titled *Kakawin Ramayana*, this version is considered to be the earliest masterpiece in the history of Javanese literature as well as the oldest extant literature in Southeast Asia. As described by

[8]In the introduction of the English translation of Kern's old Javanese Ramayana, Robson describes that the version is not only connected with Valmiki's composition but also with another work by Bhattikavya. For more details, refer to Robson (2015).

Hideharu Umeda in Chapter 3, Kakawin Ramayana is the important source for the performances of shadow puppet play in Bali. As well as the written texts, a bas relief of the Ramayana was also created in Prambanan, a historical site in central Java in the 9th century.

Ramayana was transmitted through the reliefs of ruins, paintings, sculptures, and written texts. It was also transmitted through theatrical forms such as dance dramas, shadow plays, rod puppet plays, masked dramas, recitations, and singing. The epic poem is considered an important theme in the art forms of Southeast Asia, whose name differs between regions: It is called "Ramayana" in Indonesia, "Ramakien" in Thailand, and "Reamker" in Cambodia, among others.

Although many characters appear in the story, the most prominent protagonists are as follows:

Rama: The eldest prince of the Ayodhya, Kosala kingdom

Ravana: Demon king in the Lanka kingdom

Lakshmana: Rama's younger half-brother

Hanuman: A monkey soldier

Sita: Rama's wife. Princess of the Videha kingdom

Angada, a prince of the monkey kingdom; Indrajit, the son of Ravana; Kumbhakarna and Vibhishana, the younger brothers of Ravana; and the monster bird Jatayu are also positioned as important.

The contents of each volume of Valmiki's version and pictures of the main protagonists may be found in the Appendix at Page 31.

1.2.2 Norms and Ideologies Represented in Theatrical Art Forms Based on Ramayana

The story features universal themes such as love and romance, adventure, war, and battle. Additionally, it focuses on several specific traditional concerns, such as the characteristics of royal authority, the importance of religious beliefs, gender norms between men and women, loyalty to a monarch and to the elders, the virtue of princely positions or the Kshatriya, collaboration between members of society, and a didactic moralism regarding good and evil.

Some of these themes have been applied to important contemporary issues in modern times. For example, the epic

depicts the image of a virtuous king/Kshatriya. The act of Rama in choosing to be exiled in the forest of his own will to support his father's prestige as king is considered to reflect the personal virtue of Rama as a Kshatriya or prince. The ideal image of a Kshatriya in the epic was developed as an image of the leader in creative works. An example is the image of the ideal of leadership presented in the collaborative creation based on Ramayana in ASEAN described by Tiongson (2019) that will be examined in Section 1.4.3.

In addition to his virtue as a princely protagonist, Rama also embodies many aspects of masculinity, such as armed strength, intelligence, and elegant appearance. These images of masculinity are complimentary to the images of femininity embodied by the heroine, Princess Sita, such as dedication, chastity, delicacy, and beauty. The images of masculinity and femininity have also been one of the themes of both traditional and contemporary art forms based on Ramayana. Some works have confronted the issues of gender norms represented in the epic poem. As described in Section 1.4.1, in his works, the Indonesian comic artist R. A. Kosasih (1919–2012), for example, depicted the character of Trijata, Ravana's niece, as an active woman who supported the captured Princess Sita (Fukuoka 2015). The film *Opera Jawa* (2006) mentioned in Section 1.1 presents the process of the heroine's consciousness of her autonomy.

Ramayana theater has focused on the political context too. The case of the performances of *wayang*, puppet theater in Indonesia during the economic crisis in 1997, reflected the importance of facing the crisis by collaborating with members of society as represented in Ramayana. At the moment of the economic crisis in Southeast Asia, then President Suharto had puppet theater performances presented in seven regions of Indonesia (*Kompas* January 19, 1998). The episode entitled "*Rama Tambak*" (Rama reclaims the sea) was adopted as the program at this occasion. This episode depicts the process of the construction of the bridge across the sea by Rama's army on the way to the demon's kingdom, and it features the active contributions of the monkey soldiers. The episode that indicates the collaboration between members of the community has been known as the source of Suharto's inspiration to construct the *orde baru* (new order) system when he was inaugurated as the second president of the country. According to the study by Clark, the episode of "*Rama Tambak*" indicates the traditional Javanese ideology of the

relationship between the master and serving vassal named "*kawula gusti*" (Clark 2001: 169–171). The intention of the organizer of the performance was to indicate the possibility to overcome the crisis by people's devotion to the "new order" government. The performance event was positioned as the "spiritual solution" to the economic crisis (Clark 2001: 168). On the other hand, the intention of the organizer wasn't indicated appropriately in the performances. Based on the critical opinions and writers' activities at that time, Clark pointed out the discrepancy between the interpretation on "*Rama Tambak*" and the "*kawula gusti*" ideology (Clark 2001: 169–171). We can know the situation just before the collapse of "new order" Indonesia, where the writers and the journalists developed their activities referring to the ideology of Ramayana.

Other elements such as recognition of the value of loyalty to one's family elders and the regional community can be seen in the epic. The death of Kumbhakarna, the younger brother of the demon king Ravana, is a popular episode in shadow puppet plays in Java and Bali. Despite the recognition of his elder brother's misdeeds, Kumbhakarna faced a losing battle for the kingdom. This episode is often mentioned in contrast with the story of another younger brother, Vibhishana. Born with a beautiful appearance and noble character, Vibhishana valued justice and ultimately betrayed his elder brother Ravana by changing sides to Rama's army. Although his act can be considered legitimate from a general moral viewpoint, many people in Java and Bali decide in favor of Kumbhakarna, who remained loyal to his elder brother. The moral value contained in the episode is discussed by Hideharu Umeda in Chapter 3.

Because it contains important traditional norms as well as universal elements, there are also many creative works based on Ramayana that reinterpret these traditional themes of the poem.

Unlike the Mahabharata, another ancient Indian epic poem whose spread was mainly to Indonesia, Ramayana has been accepted in a wider swath of Southeast Asia.[9] One of the main sources of the epic's breadth of influence is the religious affinities of Ramayana. As the main protagonist, Prince Rama appears as the seventh incarnation of

[9]The spread of the story of Mahabharata in Indonesia has mainly been in Java and Bali. There are enormous bodies of episodes derived from Mahabharata in the repertoire of shadow puppetry or *wayang* in Java and Bali, as well as in the tradition of rod puppet theater or *wayang golek* in West Java/Sunda.

the Hindu god Vishnu, and he has remained one of the most popular incarnations of the god, along with Krishna (in Mahabharata) and Gautama Buddha. In Thailand, some elements embodying a fusion of Hinduism and Buddhism appear, such as the blend of the Ramayana story with the Jataka tales, and the overlap of the image of virtuous Rama with the king as the most virtuous position in Buddhism.[10]

The epic poem was also one of the main sources of artistic themes in the regions where Islamic thought spread, such as Malaysia and Indonesia. Although some versions disparaged the Hindu gods in relation to Islamic values, Ramayana was still an important source of philosophy for people in these regions. It is known that in the process of missionary work in the 15–16th century, Javanese Islamic saints utilized shadow puppet performances based on Hindu epic poems, including Ramayana. Due to these religious affinities, Ramayana's applicability has been widely accepted in numerous regions of Southeast Asia.

1.2.3　Ramayana as Subject Matter for Theatrical Performance

As the source of material for theatrical performances, the clear and compelling structure of the story and the spectacle of such characters as a prince, a princess, monkeys, and a demon king constitute elements especially suited to dramatic performance. These elements are expressed concretely in dramatic forms through various elements such as music, singing, dancing, costumes, visual images, and stage settings.

As indicated in Chapter 6, in the performances of dance drama for tourists at the famous Indonesian historical site, Prambanan, central Javanese styles of dance and music are presented. In the stage directions in tourism performances, the scene where a monkey soldier, Hanuman, sets fire to the demon king's kingdom is featured effectively. In Javanese dance drama for tourists, real torches are used, and the actor playing Hanuman actually sets fire to some stacks of rice straw set on the stage conveying to tourists a realistic feeling of burning fire on the stage. Hanuman players also

[10]Rutnin Mattani described the position of King Rama I as the incarnation of the Hindu god Vishnu, "the Great Preserver, who saved the world of Siam from its evil enemies and who restored peace and prosperity to the land" (Rutnin 1996: 53).

perform dynamic acts such as jumping and turning somersaults: These dynamic acts and setting of fire can also be seen in Balinese *kecak* performances presented in many tourism sites on the island. Thai masked dance drama, *khon* performance for tourists, features a sophisticated stylized performance and elaborated design or motif in the performance. Originally rooted in court culture, Thai *khon* features luxurious costumes and stage setting, masks, and dancing with stylized slow movements.

Thus, the characteristic protagonists are effectively represented in the style of each region.

As for the story, based on the main plot of Ramayana, each region has developed the original story into its own versions of episodes and introduced various stylistic differences. In theatrical performances in Java, Indonesia, for example, there are two main streams of the story world of Ramayana: the classical version is similar to Valmiki's version, while another version derived from a 16th century text *Serat Khanda* (Aoyama 1998, see also Chapter 6). The classical Valmikian version of Ramayana was adopted as the main repertoire of the performances in the context requiring the representative traditions of Indonesia, including the dance drama for tourists (Aoyama 1998: 150). The later version, which contains various complicated human relations and plots reflecting the belief system of Javanese mysticism, has been the main repertoire of the performances of shadow play, *wayang*. In the episode of the birth of the demon king Ravana in Javanese shadow puppet, a rivalry between legitimate Islamic thought and Javanese mysticism can be seen. One researcher on Javanese literature, Laurie Sears, analyzed the process of change in the episode in the 18–19th centuries and pointed out that the inadequate indication of the mysticism contained in the episode had been the object of criticism of Javanese mysticism from a legitimate Islamic viewpoint (Sears 1996: 65).

In the regions of mainland Southeast Asia, the story is integrated with the religious thought of Buddhism. Rutnin, a researcher of Thai classical dance and drama, pointed out that the episode of masked drama, *khon*, includes the didactic theme of Buddhism (Rutnin 1996: 7). Rutnin also describes that in the traditional *khon* performance, short episode of white monkey and black monkey leads the main story where the demon king is defeated by the virtuous king (Rutnin 1996: 8). While the aforementioned Indonesian episode positions

the existence of demon king as the result of destiny, the Thai episode indicates the didactic moralism.

Based on these flows of stories, each region developed particular derivative episodes and highlighted scenes indicating them.

Because of this capacity to adapt to different regions, Ramayana theater has been positioned as an important symbol of both cultural diversity and cultural affinity throughout many parts of Southeast Asia. In addition to the many Ramayana festivals held throughout the region since the 1970s, we can see unique performances in the contexts of international and interregional exchange programs, experimental performance programs, and educational projects.

1.3 Positioning Ramayana Theater in Contemporary Southeast Asia

Geographically, Southeast Asia is the vast area of the southeast region of Asia, consisting of regions in south China, east of the Indian subcontinent, and the northwest of Australia. It is divided into two regions: mainland and maritime. Using the current names of the countries, the mainland includes Cambodia, Myanmar, Thailand, Laos, and Vietnam, while the maritime consists of Indonesia, Malaysia, Singapore, the Philippines, Brunei, and East Timor, which became independent in 2002. Diversity is a prominent characteristic of the region, in both the biological and cultural dimensions.

In this section, the position of Ramayana theater in the current cultural situation of the region, as well as the historical trajectory of nation building, is examined.

1.3.1 Cultural Dimensions of Contemporary Southeast Asia

Throughout history, Southeast Asia has been known as a region of cultural diversity whose original cultures were constructed by the inclusion of various cultural elements and acculturation. The region was influenced by cultures from many areas, such as China, India, West Asia, and Arab lands, and from the West. It is difficult to see cultural integration in Southeast Asia because of this diversity. Multiplicity and the mixture of ethnic groups, languages, and religions have

been prominent characteristics of the area of Southeast Asia. As for people's everyday religious lives, various religious traditions based on the belief of animism and ancestor worship have accumulated. In the history of cultural exchange with the external world, there were communities that converted to Islam, and communities where the foundation of people's everyday lives is based on Buddhism. We can also see the communities of Christianity, as described below. The multiplicity of religions is one of the prominent characteristics of culture in the area.

Colonialism has influenced almost all regions in Southeast Asia. Encounters with various foreign cultures, as well as the indigenous cultures of former colonies, have impacted the construction of culture in the region. In colonial cities, for example, the formation of new hybrid art genres took place. As one of the results in the religious dimension, there are many communities that converted to Christianity in Southeast Asia. Many local people with cultural and social capital were incorporated in the institutions, political constructions, and industrial and educational system established in the colonies, and their activities developed toward movements for independence and nationalism. Benedict Anderson has pointed out the importance of the dissemination of national media such as novels and newspapers through print capitalism in the formation and dissemination of the image of national solidarity. He also pointed out the importance of the educational pilgrimage to the city experienced by young nationalists (Anderson 1983: 17–40, 109–112).

The former colonial territories or boundaries had great impact on Southeast Asia as administrative regions. Independence from colonial rule and modernization have been important elements in the construction of integrated states in Southeast Asia. Despite the differences in the degree and direction of national construction seen inside the area, cultural elements were positioned as important factors in the process in each region. Besides visual cultural elements such as historical sites, religious architectures, and ethnic costumes, the various performing art forms were positioned as one of the important cultural items in the process. Art forms deriving from Ramayana, with its wide dissemination and deep penetration in Southeast Asia, are important cultural forms in consideration of the cultural situation in this area. In the history of the nation building in Southeast Asia, the epic Ramayana was connected with the royal

power of kings in some cases. One of the reasons for this is that Ramayana is an epic poem and the protagonists are positioned as the incarnation of gods. Prince Rama and monkey soldier, Hanuman, take over the genealogy of Hindu gods, and they are positioned as the existence that connects the human world and the world of the gods. The connection of the godhood of Rama with the royal power of the king is because of the status of Ramayana as an "epic poem." In Chapter 7, Hinata describes the changing process of the position of Ramayana in Thai political and cultural discourses. In Chapter 4, Sam-Ang Sam describes the situation in Cambodia. Connected with the royal power of the king, art forms based on the Ramayana developed styles of court culture in some regions that were positioned as representative forms in the nation-states.

1.3.2 Cultural Dimensions of Globalization in Southeast Asia

The ongoing globalization of information and technology is considered the main feature of the current cultural situation in Southeast Asia. Inda and Rosaldo defined globalization as "the intensely interconnected world where the rapid flows of capital, people, goods, images, and ideologies draw more and more of the globe into webs of interconnection, compressing our sense of time and space, and making the world feel smaller and distances shorter" (Inda and Rosaldo 2002: 4). If we consider the cultural dimensions of globalization, many factors can be seen in the background, including the development of various kinds of media, the commodification of culture caused by the expansion of consumption activities, tourism and migration, the influences of regional development, and the modernization of education. Through these developments, the connections between particular cultural genres and regions lose relevance as the various forms of cultural expression are disseminated across existing boundaries. Anthropologist Arjun Appadurai termed this situation "global cultural flow" (Appadurai 1996: 32–43), pointing out a situation where the cultural scape had been divided and entangled. He called this situation "deterritorialization" and positioned it as the main trend of globalization (Appadurai 1996: 52–53). In this situation, the flow and dissemination of cultural elements beyond the region or space are prominent. Against this background,

along with the theory of cultural authenticity and standardization of culture, there is debate over "cultural imperialism," which refers to a situation where the main cultural industry invades the surrounding culture (Steger 2017: 80–91). However, the global situation has been shown to be more complicated, and the stereotype of "global vs. local" or "the West vs. the third world" is no longer considered applicable (Inda and Rosaldo 2002: 15–26).

As a region with multiple cultures, global or peripheral cultural flow has historically been seen in Southeast Asia. New hybrid art genres have been formed that have been disseminated through media or performances beyond the borders of their home regions. In the discussion of global history, these cases can be positioned as a phenomenon not only in modern times, but also through historical trajectories (cf. Steger 2017: 17–37). In particular, the transmission of Ramayana theater shows the great influence of cultural flows across regions. In mainland Southeast Asia, for example, the Khmer version of Ramayana theater in the 12th century was transmitted to Ayutthaya in the 14th century when Ayutthaya invaded Khmer. In 1767, the Thai version of Ramayana theater was transmitted to Burma, when many artists in Ayutthaya were taken captive by Burma. It is important to consider this situation in any analysis of the global cultural history of Southeast Asia.[11]

A prominent phenomenon in today's Southeast Asia is the formation of a uniform sense of value or standard of cultural expression because of the development of media, the rapid flow of things and information, economic development, and the educational system. There are tensions between these values and standards, and traditional moral values, historical or local viewpoints, etc. The disseminated standards promoted the artistic activities of Southeast Asian artists in the global art scene, as well as affecting changes in indigenous art expression. The important point is that in this situation, people face these senses of value and standards and search for originality in their cultural expression. Accordingly, art forms based on Ramayana can be positioned as important cultural platforms in this situation.

[11]As Shinsuke Hinata points out in Chapter 7, the Thai version of Ramayana had also been reimported to Cambodia, and the performances in both of the countries have influenced each other until today. Thus, the process of global history has also affected the current cultural situation.

1.3.3 Ramayana in the Cultural Scenes of Contemporary Southeast Asia

Due to the predominance of the global situation, it is necessary to consider cultural practices performed across regional boundaries. The relationship of cultural practices with the development of the media and the commodification of culture should be recognized. In consideration of the contemporary development of Ramayana theater in Southeast Asia, focusing on the various kinds of cultural representations both within each region and as directed toward external regions seems important. Such representations include performances for tourism purposes, experimental performances based on the epic poem in the contemporary art world, performances among diaspora communities, the preservation and transmission of the art tradition as a cultural heritage, and representations in various contexts. On these occasions of cultural representation, Ramayana can be positioned as an important platform where people share various meanings through the reinterpretation of themes explored in this epic poem. Through an approach to Ramayana that considers its potential as an abundant source of religious, cultural, and social value, Southeast Asian artists search for and express their cultural identity. Examination of the relationship between cultural representation and the multiple meanings of Ramayana theater would be significant in considering the cultural situation of contemporary Southeast Asia.

The sphere of the area of Southeast Asia has been defined in many ways throughout history. The beginning of the official categorization of Southeast Asia as one region during World War II was a strategic definition aimed at controlling the outsider's viewpoint. In the latter half of the 1990s, ASEAN, which started as five countries, became an alliance of 10 countries.[12] This situation largely came about as a result of a union between countries oriented toward socialism and those more deeply predicated on liberalism. Southeast Asia, as a unified area, now maintains relationships with other parts of the world. In Southeast Asian countries, there are also national regional interchanges.

[12]Ten states of Southeast Asia are members of ASEAN, while East Timor has been positioned as an observer state.

Within such a cultural and political configuration, Ramayana has been considered a cultural unifier in Southeast Asia. As mentioned previously, the religious affinities embedded in this epic poem have enabled its dissemination to many regions of Southeast Asia, where religious diversity is prominent. The dissemination of the epic poem, not only through written texts or visual media, but also through theatrical performances, is also important in cultural diplomacy. Ramayana, as represented in the various theatrical forms of each region, indicates the cultural diversity of the region of Southeast Asia. Throughout its history of dissemination, there have been a variety of different forms of expression of the epic poem.

1.4 Multiple Positions of Art Forms Based on Ramayana in Contemporary Southeast Asia

To indicate the multiple position of art forms based on Ramayana in contemporary Southeast Asia, I will examine three cases: Dissemination of the story through comic works, indication of identity in the cultural events in the diaspora community, and collaborative creations based on Ramayana in ASEAN.

1.4.1 Dissemination of Ramayana through a Popular Cultural Form: The Indonesian Comic Artist R. A. Kosasih's Reinterpretation of the Story

The stories of Ramayana in the works of Indonesian comic artist R. A. Kosasih (1919–2012) constitute a suggestive example of the reinterpretation of the epic poem and dissemination of the original storyline through popular cultural media.[13] It is also an example through which to examine the correlation between the performances of traditional theater and representations in comic works. Kosasih's work was published in the 1950s and was popular from the 1960s through the 1980s in Indonesia.[14] His comic style came to be called

[13]Laurie J. Sears described Kosasih's work in one chapter of her book *Shadows of Empire* (Sears 1996). Inspired by the description, this author studied the comic works. For more detail, refer Fukuoka (2015).

[14]Here, I referred to his work published in 1975 in Bandung (Kosasih 1975).

komik wayang because his first work, published around 1954, was derived from one of the episodes of Mahabharata in the puppet theater or *wayang* performance, and the characters were shown wearing the costumes of the West Javanese dance drama, *wayang orang*. In his comic works, Kosasih, writing in Indonesian, provided many explanations or narrations in addition to dialog. Examination of the various Ramayana texts reveals Kosasih's modifications of older ones and original creations in his unique version. From the 1960s through the 1980s, his work was an important medium in Indonesia, especially in Java and Bali, because people could not commonly access animation via television or computer at that time. Further, as Laurie Sears pointed out, Kosasih presented readers with the full story of Ramayana, avoiding conventional regional viewpoints, such as the Javanese, Sundanese, or Balinese (Sears 1996: 276). Kosasih's unique accomplishment is his chronological reconstruction of the complete plots of Ramayana and Mahabharata, including both modifications and new creations, as well as some adaptations as puppet theater episodes. These adaptations include both the entire adoption of the puppet theater story and partial adaptations from the puppet theater repertoire. In addition, there are distinct modifications by Kosasih of episodes in puppet performance such as the birth of the monkey soldier, Hanuman. As indicated in these examples, Kosasih's comic work was closely related to the performances of the puppet theater in Indonesia at the time. Since his childhood, Kosasih was familiar with the forms of rod puppet theater popular in his hometown, Bogor. He also became familiar with the shadow puppet theater, the performance of which he had often listened to on the radio. He adopted some of the episodes or parts of these theatrical forms in his creative works. On the other hand, puppeteers who read Kosasih's comic work sometimes revised their versions of performances under the influence of the representations in the comic works.

Kosasih also illustrated morality through the dialogue and behavior of his characters, as well as through his plot and character modifications and creations. As a result, many intellectuals and artists in Indonesia required their children to read Kosasih's works,

not only to familiarize them with the whole storyline of Indian epic poems, but also to familiarize them with the character's moral consciousness.

His work includes some prominent creations or modifications of characters or stories. As mentioned in Section 1.1, Kosasih overturned the traditional norms of gender imagery in his work. He depicted the active superheroine character of the female protagonist, Trijata, as the demon king Ravana's niece. In the background of the depiction lies the influence of Western comics that he had read as a boy; the depiction is considered to reflect the representations of Western popular culture.

Kosasih's presentation of Hindu gods is an important element that avoids a certain kind of bias. The Javanese puppet theater that spread during the Islamic era nevertheless adopted Indian epics as their main sources; Hindu gods were described as causing confusion in this world. However, Kosasih did not adopt such a negative view of the Hindu gods in his work and emphasized that the noble Rama was the incarnation of the Hindu god Vishnu. By not supporting the negative view of Hindu gods, Kosasih presented them in the same way as Valmiki's version of Ramayana. For this reason, Kosasih succeeded in attracting readers to the original Indian epic.

Based on the Indian version of Ramayana, he created an original story that contained episodes from puppet theater and his own creation. His modifications and creations are regarded as a "standardization" of Ramayana in Indonesia, with elements of puppet theater episodes added, which had previously only been enjoyed by Javanese, Balinese, or Sundanese people.

In addition to the contents of the stories, his illustrations are also vital. G. M. Sudarta (1946–2019), an Indonesian cartoonist, set a high value on Kosasih's skillful methods of setting scenes and his depiction of characters, for instance, as viewed from the side or partly turned away, and his method of dividing scenes was influenced by the positions of puppets and scenery in puppet performances. Sudarta also observed that Kosasih's comic characters are well proportioned and realistically Asian. He asserts that these qualities were extremely significant for the Indonesian people's acceptance

of Kosasih's work (personal interview with the author, July 8, 2008). In the 1950s, Indonesia had little contact with visual media or animation except for films. The popularization of television did not take place until the latter half of the 1970s. Therefore, in the 1950s and the 1960s, when Kosasih began to draw his comics, Indonesians had few opportunities for entertainment by visual media. For this reason, Kosasih's work became widespread, and its popularity depended partly on its low cost and the reader's familiarity with the story.

The composition of Ramayana in Kosasih's comic works adopted the classical version of Ramayana, but with many modern modifications. Based on the classical Ramayana, episodes of puppet performance, and his unique creations, Kosasih's original version impressed many readers. For one thing, he revealed the entire plot of the epic poem, thereby making new readers familiar with puppet play episodes and enabling them to understand the overall structure. In addition, the virtuous souls and ways of life illustrated by Kosasih's characters attracted many readers' sympathy and increased their knowledge of the moral values of Ramayana. This presentation of the whole plot of Ramayana in a linear way without regional embellishments and his emphasis on the story's moral sensibility were Kosasih's important achievements.

1.4.2 Representations of the Cultural Elements among a Diaspora Community: A Theatrical Performance of Ramayana in the Malay Community in Singapore

As an example of the representation of cultural elements through performances of Ramayana theater, I will consider the case of a performance of the original theatrical form of Ramayana in the Malay community in Singapore. The important purpose of the performance was to show the Javanese tradition as a representative cultural tradition in the Malay community to many people, as well as to consider an effective way of preserving and transmitting traditions within and around the community.

In August 2016, a series of events entitled *"Pusaka"* (heritage/ heirloom) were organized by the Malay Heritage Center and the

Javanese Association in Singapore.[15] The event was held in the Kampong Gelam/Glam district.[16] In Singapore, inhabited by people from a variety of origins, the Javanese cultural tradition is positioned as one of the Malay cultural traditions.

The performance of a theatrical play of Ramayana to close the event was original, and the version staged was a fusion of dance drama and shadow puppetry performed by a mixed group of Javanese performers from Indonesia, local Singaporeans, members of the Malay community, and the *gamelan* music group from the National University of Singapore. The shadow play was used effectively as a stage background to explain the passage of the story. The performance unfolded the linear plot of the classical version of Ramayana with verbal elements such as dialogues and narration. The construction of the story was similar to the dance drama for tourists in Indonesia, *sendratari*, and visual elements such as dancing and costumes were also featured. In particular, the adoption of shadow puppetry as the background of the stage and the live performance

[15]The event was a related event of the 2016 Singapore International Festival of Art (SIFA), "*Potentialities*," which was held from August 11 to September 17 at various venues throughout the country. The Malay Cultural Heritage Center held a special exhibition on the Javanese Heritage in Singapore entitled "*Pusaka*" from May 29 to August 28 in association with these events. The closing performance of this exhibition was the theatrical performance of Ramayana performed by Javanese performers from Singapore, gamelan players from the University of Singapore, local people, and artists invited from Java. In SIFA, artists from all over the world were invited to attend. Indonesian contemporary dancer Sardono Kusumo was involved in a series of events entitled "*Sardono Retrospective*,"which included a film screening from August 13 to 28 at the Malay Cultural Heritage Center, and, on August 21 and 22, a performance by Sardono in which he actively painted on a large canvas as he danced, and a performance of his latest dance production, "Black Sun," on August 26 and 27 at the art space 72-13. In the film screening, a documentary film was screened where Sardono and his colleges produced "*kecak* Rino," the new performance style of *kecak* dance in Bali.

[16]*Kampong Glam Heritage Trail* introduces the region as follows; Kampong Glam was where the Malay royalty once resided, and where one of the most significant and important mosques in the country, Masjid Sultan, is located. It was where many diverse communities, such as the Javanese, Sumatrans, Baweanes (people from Bawean Island), Banjarese (people originating from the southern and eastern coast of Kalimantan in Borneo), Arabs, Chinese, and Indians, once called home. Though Kampong Glam is no longer inhabited, these communities have left their mark in different ways, from the buildings in the area and long-time businesses to vernacular place names.

of *gamelan* music indicated the community members' desire to demonstrate authentic Javanese cultural elements.

While Javanese-ness featured some cultural elements, devices for comprehensive presentation were shown in the verbal dimension of performance. The Indonesian language was used in the performance, and English subtitles were projected for comprehension of the story.

During the event, a puppet-making demonstration and a Javanese dancing workshop were also held. These demonstrations and workshops were important mediums for the people of Javanese origin to show their artistic tradition to many people. On the other hand, they were also opportunities for visitors to become familiar with the Javanese tradition as one of the Malay cultural elements in Singapore.

It also presented a successful Ramayana performance viewed by many people, including Malay descendants, particularly descendants of immigrants from Java, local Singaporeans, and tourists from overseas. Some of the significant elements of the event were the demonstration of Javanese cultural identity, the attempt to pass this tradition down through educational workshops, and the production of cultural events for the local community and tourists. Collaboration to create a special version of Ramayana theater was also significant.[17]

This is an example of the efforts that can be made to preserve a common cultural heritage and share it with community members from different cultural backgrounds through original collaborative work.

1.4.3 Searching for the Image of the Ideal Leader in Contemporary Southeast Asia: A Collaborative Project since 1997

In addition to considering the examples from particular regions, there is value in focusing on interregional or international collaborative work based on new interpretations of Ramayana in recent years. Since the first international Ramayana festival was held in 1971, various such festivals have been held in Southeast Asia.

[17]Yoshiaki Takemura summarizes the art performances of Ramayana in Singapore in Chapter 5.

The festivals entitled *Realizing Rama*, initiated in 1997 by the ASEAN Committee on Culture and Information, are considered a cultural collaboration based on Ramayana as the common platform (Tiongson 2019). Marshall Clark wrote of the Ramayana dance performance that reflected shared ASEAN cultural values in 1997 as follows (Clark 2010: 217):

> The intention was to transcend the usual ASEAN "cultural" exercise of performing a mere anthology of dances originating from the ten member countries. Instead, in their desire for a creative collaboration between leading writers, choreographers, composers, and dancers of each of the ten member countries, they chose the Ramayana as a binding theme (Clark 2010: 217).

As Clark noted, Ramayana festivals in the 1970s presented an opportunity to introduce original styles that had diverged over time. More recently, the festivals have gradually changed for the purposes of engaging in a collaborative project whose participants seek to reinterpret the epic poem together. Tiongson also described the collaborative production of dance theaters performed in 1997. Various artists from ASEAN countries collaborated to indicate the process of the accomplishment of selfless leadership through the reinterpretation of the traditional Ramayana. He pointed out the importance of the production style of dance performance that "is uniquely ASEAN" (Tiongson 2000: 27). Tiongson wrote the libretto of the dance performance and described "selfless leadership" as follows:

> *Realizing Rama* inquires into the theme of selfless leadership, which these countries need to help them combat their most urgent problems, such as graft and corruption, exploitation of labor, women and children, destruction of the environment, drug trafficking, and the abject poverty of the masses (Tiongson 2000: 27).

Under project director, Nestor O. Jardin, the staff members of production also consisted of international members such as the Indonesian composer, Rahayu Supanggah, artistic director/choreographer, Denisa Reyes of the Philippines, and co-choreographer, Phatravadi Mejudhon of Thailand. Ramayana theater is now one of the most significant fields within which creative collaboration can occur between artists in Southeast Asia.

The project *Realizing Rama* is considered a prime example of artists reinterpreting Ramayana to search for ideal or essential leaders in contemporary Southeast Asia.

The process of searching for cultural identities of Southeast Asian people based on this epic poem will be one of the primary subjects considered here.

1.5 Outline of Chapters

These cases indicate the various positions of art forms based on Ramayana such as affective media to disseminate the traditional value of the story, a source of authentic cultural elements, and a platform for new collaborative creation. There are various possibilities in the presentation of Ramayana, including how to use verbal texts of existing artistic forms and how to present the storyline or the regional cultural elements.

In this study, besides considering themes of the poem through the analysis of existing works or presentations, we consider how the actual created art works present new interpretations of Ramayana. The form of this book which contains artwork as well as written texts is the result of considering the possibility of new forms of academic writing on performing art forms.

The book consists of four parts as follows:

In the first part, "Multiple Interpretations of Ramayana," various interpretations of the ideologies and moral values contained in the Ramayana story are considered through case studies of Thai popular content culture, performances of shadow puppetry, *wayang*, in Bali, and an examination on Ramayana theater in Cambodia.

Hideki Hiramatsu introduces Thai films featuring the monkey soldier, Hanuman, and explores the representation of Hanuman's character as a superhero in Thai popular content culture. Positioning the film work as an achievement in popularizing Ramayana, he also introduces the collaborative creation of the 1974 film depicting Hanuman's lively part in the Ultraman series. It is an attempt of the collaboration between Japanese Tsuburaya Productions and Thai Chaiyo productions under the circumstances of anti-Japanese movements in Thailand in the 1970s.

Hideharu Umeda focuses on the well-known episode *"Kumbakarna Gugur"* (the death of Kumbhakarna), and considers the important sense of values of the Balinese people, such as loyalty and devotion to elders, justice, moral obligation, and the way of depicting "death." Not only as a researcher but also as a puppeteer or *dalang* of Balinese shadow play, he will also indicate his original interpretation of the death of Kumbhakarna.

Sam-Ang Sam introduces Cambodian art forms based on Ramayana. Covering from traditional genre to contemporary genre, he examines the importance of Ramayana in the various artistic genres in Cambodia. Historical consideration about the art forms and Ramayana is indicated.

In the second part, "Diversified Performance Contexts," the cultural platforms where Ramayana theater was positioned as an indicator of people's identities—such as international festivals, diaspora communities, and tourism—are discussed.

Yoshiaki Takemura focuses on Ramayana and its fluctuating value in the Indian diaspora community in Singapore. Based on the current situation of events regarding Ramayana and cultural policy in Singapore, Takemura analyzes a dance work based on Ramayana created by an Indian dance group. Through the analysis, he examines the current value and interpretation of Ramayana among the Indian diaspora in Singapore.

Madoka Fukuoka focuses on the presentations of the Ramayana story in Javanese dance drama for tourists. Through an examination of the contrasts with the traditional shadow puppets, she considers the difference in the presentation of stories between the tourism context and the local indigenous context.

The third part, "Represented Ramayana," focuses on the cultural politics seen in cultural diplomacy between Japan and Southeast Asian countries.

Shinsuke Hinata focuses on the history of representation and intellectuals' perception of the Thai masked drama of Ramayana on the modern world stage, in the 20th century. Through a historical examination of Ramayana, the Thai version, Ramakien, and Thai masked drama, *khon*, he considers the transition of the representation of the epic and the intellectuals' perception of the cultural heritage in the relationship between the neighboring countries in Southeast Asia.

Shota Fukuoka focuses on the understanding of the Ramayana in Japan through museum exhibitions and considers the shift from the literature-centered recognition/perception before World War II to the performing arts-centered one today. He also introduces attempts to take a holistic approach for the exhibition of Southeast Asian culture, where the relationships between culture and livelihood, social structure, religion, and ritual are emphasized.

In the fourth part, "Commissioned Art Works," created works on Ramayana are presented.

Didik Nini Thowok, an Indonesian cross-gender dancer, created masked dance work depicting the characteristic female protagonist in Ramayana. Inspired by the Cambodian story of Mermaid Savan Macha, he created new work based on Javanese shadow play stories focusing on the mermaid, Urang Rayung, the monster crayfish, Rekatha Rumpung, and the monkey hero, Hanuman. The episode on Urang Rayung is one of the spin-offs related to the episode *Rama Tambak*, Rama's reclamation of the sea. Didik pointed out that there are many created spin-off episodes derived from the episode of Rama's army's reclamation of the sea, because it is an episode that depicts the activities of many characters. The work can be positioned as the Javanese adaptation of the episode of the mermaid and Hanuman, as well as the episode of the Cambodian version.

Nanang Ananto Wicaksono, an Indonesian puppeteer and animator, created an animation work focusing on Rama distressed after the battle with demon king Ravana, which depicts his search for life in his next incarnation. This work focuses on the very last part of the Ramayana story, which had not previously received such attention. It can also be positioned as a work that connects the story world of Ramayana with that of another ancient Indian epic poem, Mahabharata.

Ken Steven, a composer of choral music in Indonesia, created his original choral work based on the episode of "Sinta Obong." The dramatic elements of the episode are expressed by his original style of choral music and the voice performance, choreography, and the Balinese influenced costume.

Based on their biographical trajectories and cultural experiences, the artists have presented their works with their original interpretations.

Column: Contemporary dance work by Thai dancer Pichet Klunchen

Thai contemporary dancer Pichet Klunchen presented his creative duo work titled *No. 60* in TPAM Yokohama in February 2020 with a female member of his company. The work is based on 59 core poses called *theppanon* in Thai traditional dance, including the masked dance drama, *khon*. *No. 60* indicates the search for a new phase of creation after mastering the 59 traditional movement patterns. In his creative works, Pichet Klunchen pursues emancipation from the restriction of tradition. However, his emancipation is not the abandonment of tradition, but the pursuit of an advanced phase rooted in tradition. Based on the strict consideration of the skills and knowledge of the traditional masked dance drama *khon*, Pichet Klunchen presented the possibilities of new creation together with a member of his company Kornkarn Rungsawang. Although the work did not depict the elements of the story of Ramayana directly, it can also be regarded as a creative work sharing connections with the tradition of Ramayana theater.

Kornkarn Rungsawang had originally been trained in Thai traditional dance drama, *lakhon*. *No. 60* is also the result of an international collaboration between many artists, including two main dancers from Thailand, a sound designer and musician from Singapore, Zai Tang; a dramaturg from Taiwan, Tang Fu Kuen; CG designer Jaturakorn Pinpech; lighting designer, Jui Hsuen Tseng; company manager, Sojirat Singholka; and production manager, Cindy Yeong.

References

Anderson, B. (1983) *Imagined Communities: Reflections on the Origin and Spread of Nationalism* (Verso, London).

Aoyama, T. (1998) *Cosmos of the Ramayana: Transmission and Ethnic Form* (in Japanese), eds. Kaneko, K., Sakata, T., and Suzuki, M., "Reception and transmission of Rama stories in Indonesia: Changes to stories and representations." (in Japanese) (Shunjusha, Tokyo), pp. 140–163.

Aoyama, T. (2010) Transformation of the Ramayana in the flim Opera Jawa, *Trans-Cultural Studies* 13, pp. 37–60.

Appadurai, A. (1996) *Modernity at Large: Cultural Dimensions of Globalization* (University of Minnesota Press, Minneapolis).

Clark, M. (2001) Shadow boxing: Indonesian writers and the Ramayana in the new order, *Indonesia* 72, pp. 159–187.

Clark, M. (2010) *Ramayana in Focus: Visual and Performing Arts of Asia*, ed. Krishnan, G. P., "The Ramayana in Southeast Asia: Fostering regionalism of the state?" (Asian Civilizations Museum, Singapore), pp. 216–225.

Cohen, M. I. (2016) Global modernities and post-traditional shadow puppetry in contemporary Southeast Asia, *Third Text*, 30(3–4), pp. 188–206.

Fukuoka, M. (2015) Reinterpretation of the Ramayana in Indonesia: A consideration of the comic works of R. A. Kosaish, *Bulletin of National Museum of Ethnology*, 40(2), pp. 349–367.

Inda, J. X. and Rosaldo, R. (2002) *The Anthropology of Globalization: A Reader*, eds. Inda, J. X. and Rosaldo, R., "Introduction: A world in motion" (Blackwell Publishing, MA), pp. 1–34.

Iyengar, K. R. S. (ed.) (1983) *Asian Variations in Ramayana* (Sahitya Akademi, New Delhi).

Kam, G. (2000) *Ramayana in the Arts of Asia* (Select Books, Singapore).

Kosasih, R. A. (1975) *Ramayana A, B, C* (Penerbit Erlina, Bandung) (In Indonesian).

Krishnan, G. P. (ed.) (2013) *Ramayana in Focus: Visual and Performing Arts in Asia* (Asian Civilization Museum, Singapore).

Lindsay, J. (1991) *Klasik, Kitsh, Kontemporer: Sebuah Studi tentang Seni Pertunjukan Jawa* (Gajah Mada University Press, Yogyakarta) (In Indonesian).

Miettinen, J. O. (1992) *Classical Dance and Theatre in South-East Asia* (Oxford University Press, Singapore).

Ong, W. (1982) *Orality and Literacy: The Technologizing of the Word* (Methuen, London).

Picard, M. (1990) Cultural tourism in Bali: Cultural performances as tourist attraction, *Indonesia*, 49, pp. 37–74.

Richman, P. (1991) *Many Rāmāyaṇas: The Diversity of a Narrative Tradition in South Asia*, ed. Richman, P. "Introduction: The diversity of the Ramayana tradition," (University of California Press, Berkeley), pp. 3–21.

Robson, S. (2015) *Old Javanese RĀMĀYAṆA* (Research Institute for Languages and Cultures of Asia and Africa, Tokyo University of Foreign Studies, Tokyo).

Roveda, V. (2016) *In the Shadow of Rama: Murals of the Ramayana in Mainland Southeast Asia* (River Books, Bangkok).

Rutnin, M. M. (1996) *Dance, Drama, and Theater in Thailand: The Process of Development and Modernization* (Silkworm Books, Chiang Mai).

Sears, L. J. (1996) *Shadows of Empire: Colonial Discourse and Javanese Tales* (Duke University Press, Durham).

Sen, M. L. (1976) *The Ramayana: Translated from the Original of Valmiki: A Modernized Version in English Prose* (Firma KLM Private Limited, Calcutta).

Steger, M. B. (2017) *Globalization: A Very Short Introduction* (Fourth edition) (Oxford University Press, New York).

Sweeney, A. (1991) *Boundaries of the Text: Epic Performances in South and Southeast Asia*, eds. Flueckiger, J. B. and Sears, L. J., "Literacy and the epic in the Malay world," (Center for South and Southeast Asian Studies, The University of Michigan, Ann Arbor), pp. 17–29.

Tiongson, N. G. (2000) Realizing RAMA, Realizing ASEAN, *SPAFA Journal,* 10(2), pp. 26–27.

Tiongson, N. G. (2019) Transforming tradition in the dance drama Realizing Rama 1997–2006: Documenting the process of "inter-creation" in an ASEAN production, *Perspectives in the Arts & Humanities Asia*, 9(2), pp. 3–28.

Urry, J. (1990) *Tourist Gaze: Leisure and Travel in Contemporary Societies* (Sage Publications, London).

Appendix

Outline of Valmiki's Seven-Volume Version of Ramayana

A.1.1 Introduction

Valmiki's seven-volume version of Ramayana is widely known as the Sanskrit version. It is assumed that the texts were composed between fourth century BC and the fourth century CE. It is a magnificent epic poem with nearly 24,000 verses, or *slokas*, as the basic unit consists of 32 syllables (two lines of 16 syllables each). Written in the style of rhyme, the epic poem had been passed down in the narrative form.

The following description is a summary of each volume of Valmiki's version. These summaries are based on the English translations by Makhan Lal Sen (1976, 1978) and the Japanese translations and bibliographical notes by Yutaka Iwamoto (1980, 1985). The spellings of the protagonists' names and the names of the main kingdoms are adopted from Sen's 1978 writings.

A.1.2 Main Protagonists and Summary of Each Volume

Rama: Prince of Ayodhya, in Kosala kingdom

Ravana: King of Langkah kingdom

Lakshmana: Rama's half-brother

Sita: Princess of Mithila in Videha

Hanuman: Monkey soldier from Kishkindhya kingdom

The First Volume: *Balakanda*

Dasaratha, the king of Ayodhya, performed the Aswamedha sacrifice ritual to be blessed with sons. At the same time, the gods in heaven were troubled by the horrible demon king, Ravana. Therefore, God Vishnu decided to reincarnate himself as one of King Dasaratha's sons. The king and his three wives were blessed with four princes. The first queen, Kausalya, gave birth to Prince Rama who was the reincarnation of God Vishnu. Kaikeyi gave birth to Bharata, and Sumitra gave birth to Lakshmana and Satrughna. Rama, as the eldest brother, stood high in his father's favor and his younger brother, Lakshmana, was devoted to him.

When they were young men, Rama and Lakshmana traveled with the priest Viswamitra to the Videha kingdom. Janaka, the king of Videha, had a daughter named Sita (which means "a ridge between rice fields") who was born from the earth. The king had a mysterious bow, and he claimed that only the person who could draw the bow could have Sita as his wife. Many heroes had tried and failed. However, when Prince Rama pulled the bow, thunder roared, and the bow broke into two. King Janaka gladly allowed his daughter Sita to marry Prince Rama. Upon receiving the news, King Dasaratha traveled to Videha with his other sons and attended the wedding ceremony. Dasaratha's other sons were also married princesses of Janaka's relatives.

The Second Volume: *Ayodhyakanda*

As he became old, King Dasaratha ordered the priest Vashishtha to make preparations to hand over the throne to his eldest son, Rama.

However, the king's second wife, Kaikeyi, was against this. When King Dasaratha was once gravely injured on a battlefield, he had survived due to her care. At that time, he had granted her two wishes and had promised to fulfill those. Therefore, Kaikeyi urged the king to expel Rama into a forest for 14 years and make her son, Bharata, the successor to the throne. Prince Rama decided to go into exile himself to ensure that his father was not guilty of the breach. His wife Sita and his younger brother Lakshmana also decided to go with him. Then, the three exiled themselves into the forest with the sympathy of the people.

King Dasaratha, unable to bear this loss, died. When Bharata learned of his father's death, he went to look for his elder brother.

He apologized to Rama for his mother's mistake and begged him to return to the kingdom. When Rama refused, Bharata took Rama's sandals and placed them on the throne and, in the absence of Rama, ruled the kingdom on his behalf.

The Third Volume: *Aranyakanda*

Rama, Sita, and Lakshmana lived in Dandaka forest, and the brothers spent time trying to exterminate the Rakshasas in order to protect the ascetics in the forest. During this time, Ravana's younger sister, Surpanakha, proposed Rama for the first time; he rejected the proposal and recommended his younger brother, Lakshmana. However, Lakshmana also refused to marry Surpanakha. Rejected and angry, Surpanakha tried to swallow Sita. At his elder brother's command, Lakshmana cut Surpanakha's ears and nose. She hurried back to the kingdom of Ravana, across the sea, and incited her elder brother to take revenge. She also urged Ravana to kidnap the beautiful Sita and make her his wife.

Ravana asked his old friend Marica to help him kidnap Sita. Marica disguised himself as a golden deer and attracted Sita's attention. While Rama and Lakshmana were chasing the deer, Ravana disguised himself as an old ascetic and kidnapped Sita. He took her to the Langkah kingdom.

During the journey, hearing Sita's screams for help, Jatayu, a vulture who was an old friend of King Dasharatha, tried to rescue her, but Ravana fatally injured Jatayu.

Rama and Lakshmana met Jatayu while searching for Sita. Jatayu died after telling Rama that Ravana had kidnapped Sita.

The Fourth Volume: *Kishkindhyakanda*

Grieving Rama and Lakshmana met the monkey king Sugriva in Lake Pampa. Sugriva told them about his brother Vali, who had robbed his hometown, Kishkindhya, and usurped his wife. Rama promised to help Sugriva in return for his help in rescuing Sita. He defeated Vali and helped Sugriva to take the throne. Sugriva summoned all the monkeys to help Rama. Hanuman, a monkey warrior, met Jatayu's younger brother Sampati and learned about Ravana's whereabouts and found that Sita had been taken to the Langkah island across the ocean.

The Fifth Volume: *Sundarakanda*

Hanuman flew to Langkah by jumping from the huge Mahendra Mountain. To scout the place, he shrunk and sneaked into Ravana's castle. After scouting the castle, he found Sita imprisoned in the Ashoka forest garden. He gave her the ring that Rama had given him and told her that Rama will come to rescue her.

After that, Hanuman changed into a huge monkey figure and frightened the women guards and damaged the garden. He defeated Ravana's followers but was ultimately captured by Ravana's son Indrajit in the Langkah kingdom. Hanuman informed them that he had come to ask Ravana to release Sita. Although Ravana tried to kill Hanuman, his younger brother Vibhishana advised him that the messenger should not be killed. Hanuman was released but his tail was set on fire. Then, Hanuman jumped across Langkah, burning and damaging the kingdom, and returned to Rama.

The Sixth Volume: *Yuddhakanda*

Rama appreciated Hanuman for fulfilling his mission. He decided to advance into Langkah, but for that, he had to cross the ocean.

With the advice from Sugriva, Rama's army began constructing a bridge over the ocean. Ravana assembled his army and commanded them to stop Rama. Since Ravana's younger brother Vibhishana did not support his actions, he was banished. Vibhishana finally joined Rama's side. Following the advice of Vibhishana, Rama prayed and asked for the help of the Sea God, the Ocean. The Sea God called upon Nala as the descendant of the skillful artisan of sea and ordered him to construct a bridge. The monkey army collected stones and wood and helped Nala. The bridge across the sea was constructed, and Rama's army reached Ravana's kingdom.

A huge battle took place between Rama and Ravana's army. After a series of combats, Ravana's younger brother Kumbhakarna was roused from his long sleep by Ravana. Kumbhakarna was killed by Rama's army on the battlefield.

Ravana's son Indrajit was an outstanding witchcraft-savvy warrior and tried to defeat Rama's army. However, he was killed by Lakshmana after a fierce battle.

Ravana, furious after the loss, appeared on the battlefield and fierce battle with Rama took place. Finally, Rama defeated Ravana with a weapon that God Brahma had given him. Ravana's funeral was solemn.

Rama gave the throne of Langkah to Vibhishana.

Upon meeting Sita, Rama refused to accept her as his wife because she had been in Ravana's captivity for a long period. To prove her innocence, Sita jumped into the fire, and Agni, the fire god, picked up the innocent Sita and handed her to Rama.

Rama and his entourage returned to Ayodhya and took the throne.

The Seventh Volume: *Uttarakanda*

The people in Ayodhya were dissatisfied that Sita was made the queen as she had been in Ravana's captivity for a long time. Learning of people's dissatisfaction, Rama commanded Lakshmana to send Sita back into the forest. Sita moved to Valmiki's hermitage, where she gave birth to twins, Kusa and Lava.

Valmiki told the story of Ramayana to the children. When King Rama realized that the two reciting the story were his own children, he summoned Sita and asked her to pledge her chastity.

When Sita swore, "To prove my innocence, the goddess of the earth will open her arms and embrace me," the goddess appeared from the ground and disappeared into the ground after hugging Sita.

Grieving, Rama was comforted by God Brahma and was told that he would reunite with Sita in heaven. Rama entrusted the affairs of the kingdom to his two sons, ascended to heaven, and returned to the original form of God Vishnu.

At the beginning of the seventh volume, the details of Ravana's birth as a Rakshasa and his grace from God Brahma are narrated.

The ascetic Valmiki heard the story of Rama's life from God Narada. God Brahma then advised him to describe the story in the form of *slokas*; Valmiki is said to have created poems that can be sung along with stringed instruments and taught them to Rama's twins Kusa and Lava to convey them to posterity.

Therefore, Valmiki is assumed to be of the same age as Rama.

A.1.3 Some Bibliographical Notes and the Scenes Featured in Theatrical Works

According to Iwamoto's commentary, the stories on Rama's marriage in the first volume are about half of the contents, and the rest are the

Brahmanist myth and legend narrated by holy priests Viswamitra and Vashishtha (Iwamoto 1980: 240–241). The beginning of the first volume also describes, in detail, how the poet Valmiki began to narrate the story using poetry or *slokas*. Iwamoto positioned the second volume, depicting the power struggle in the court and the expulsion of Rama as the most human part and established the contrast with the subsequent volumes that depict the fairy tale stories, including the demon's kingdom, monkey soldiers, and the battles between them (Iwamoto 1980: 244–245).

The main plot that is widely known is based on the contents in the second through sixth volumes. The first volume and, especially, the seventh volume that depict Rama's birth as the incarnation of Hindu God Vishnu and the ascension of Rama as God Vishnu are considered the additional version composed by another author during a later period to deify Rama (Iwamoto 1980: 258, Richman 1991: 8, Sen 1976: x). Pointing out the inconsistency of the description about Sita's chastity in the seventh volume as the duplication of the sixth volume, Iwamoto admitted the importance of the seventh volume for later readers (Iwamoto 1980: 258). Sen also described that he had not excluded the seventh volume Uttarakanda, which in all probability appears to be a later addition by a different poet or poets, as the main story ends in the sixth volume (Sen 1976: x).

Currently, in the theatrical form in Southeast Asia, the contents in the second through sixth volumes are positioned as the main part of the story. Some theatrical forms perform the outline of the contents, while others perform partial features.

Some of the most spectacular parts are Rama's participation in the competition to win Sita's hand in marriage, the active contribution of the monkeys, especially Hanuman, Rama's army's great effort to make a bridge across the ocean to enter Langkah, and some battle scenes between Rama and Ravana's army. The episodes on the battle of Sugriva and Vali in Kishkindhya kingdom had been featured in some theatrical plays.

There are also many partially created episodes. For example, in Southeast Asia, there is an episode in which the monkey warlord Hanuman falls in love with a mermaid living in the sea while building the bridge across the ocean (refer to Chapters 4 and 9).

A.1.4 Images of Main Protagonists in Indonesian Shadow Play

Below are the main protagonists' images from the Indonesian shadow play and rod puppet play. These images are reprinted by courtesy of the National Museum of Ethnology, Osaka, Japan.

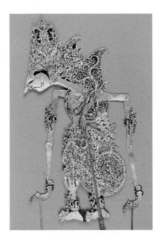

Figure A.1.1 Rama in Javanese shadow puppetry, *wayang kulit* (name in Java: Ramawijaya). National Museum of Ethnology, Osaka, Japan.

Figure A.1.2 Ravana in Javanese shadow puppetry, *wayang kulit* (name in Java: Rahwana). National Museum of Ethnology, Osaka, Japan.

Figure A.1.3 Lakshmana in Javanese shadow puppetry, *wayang kulit* (name in Java: Lesmana, Leksmana). National Museum of Ethnology, Osaka, Japan.

Figure A.1.4 Sita in Javanese shadow puppetry, *wayang kulit* (name in Java: Sinta, Sinto). National Museum of Ethnology, Osaka, Japan.

Figure A.1.5 Hanuman in Javanese shadow puppetry, *wayang kulit* (name in Java: Hanoman, Anoman). National Museum of Ethnology, Osaka, Japan.

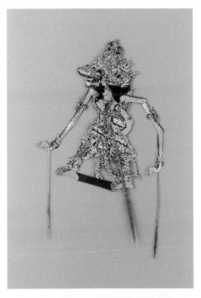

Figure A.1.6 Sugriva in Javanese shadow puppetry, *wayang kulit* (name in Java: Sugriwa). National Museum of Ethnology, Osaka, Japan.

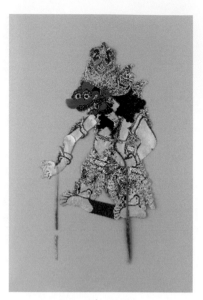

Figure A.1.7 Kumbhakarna in Javanese shadow puppetry, *wayang kulit* (name in Java: Kumbakarno, Kumbokarno). National Museum of Ethnology, Osaka, Japan.

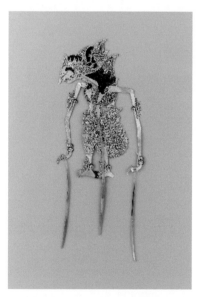

Figure A.1.8 Vibishana in Javanese shadow puppetry, *wayang kulit* (name in Java: Wibisana). National Museum of Ethnology, Osaka, Japan.

Figure A.1.9 Jatayu in Javanese shadow puppetry, *wayang kulit*. National Museum of Ethnology, Osaka, Japan.

References

Iwamoto, Y. (1980) Annotated Ramayana (in Japanese), Valmiki (tr. Iwamoto Yutaka). *Ramayana 1* (Heibonsha, Tokyo).

Iwamoto, Y. (1985) Annotated Ramayana (in Japanese), Valmiki (tr. Iwamoto Yutaka). *Ramayana 2* (Heibonsha, Tokyo).

Richman, P. (ed.) (1991) *Many Rāmāyaṇas: The Diversity of a Narrative Tradition in South Asia* (University of California Press, Berkeley), pp. 3–21.

Sen, M. L. (1976) *The Ramayana: Translated from the Original of Valmiki: A Modernized Version in English Prose* (Firma KLM Pvt. Ltd., Calcutta).

Sen, M. L. (1978) *The Ramayana of Valmiki* (Munshiram Manoharlal Publishers Pvt. Ltd., New Delhi).

PART I
MULTIPLE INTERPRETATIONS OF RAMAYANA

Chapter 2

The Modern Development of *Ramakian*, the Thai *Ramayana,* as Seen in Films by Chaiyo Studio

Hideki Hiramatshu
Center for Southeast Asian Studies, Kyoto University,
Yoshida-honmachi, Sakyo-ku, Kyoto, Japan
hirama @cseas.kyoto-u.ac.jp

The chapter focuses on the modern development of Ramayana in Thailand.

The region considered in this chapter and the names of the main characters are as follows:

Region in this chapter: Thailand

Names of the main characters in this chapter, Sanskrit names are written in parentheses ():

Ongkhot (Angada)

Intrachit (Indrajit)

Kumphakan (Kumbhakarna)

Phra Rak (Lakshmana)

Ramayana Theater in Contemporary Southeast Asia
Edited by Madoka Fukuoka
Copyright © 2023 Jenny Stanford Publishing Pte. Ltd.
ISBN 978-981-4968-09-6 (Hardcover), 978-1-003-29095-7 (eBook)
www.jennystanford.com

Phra Ram (Rama)

Thotsakan (Ravana)

Nang Sida (Sita)

Sukureep (Sugriva)

Palee (Vali)

Phiphek (Vibhishana)

2.1 Introduction

The Thai *Ramayana* is known as the *Ramakian* (also written as
Ramakien), which signifies "the glory of Rama" in the Thai language
(similar to the meaning of *Reamker* in Cambodian). In Thailand, the
Ramakian has been protected and nurtured by the royal family in the
khon (masked drama) and *nang yai* (large shadow puppet) traditions
since the Ayutthaya kingdom. In modern times, *Ramakian* is also
enjoyed by the common people through the *likay* (folk theater) and
nang talung (shadow puppet) forms. In recent years, adaptations of
the story into puppet shows have made *Ramakian* popular among
foreigners.[1] The tale has also been adapted into films and animated
productions. The character of Hanuman is particularly popular, and
many children are avowed Hanuman fans. In several of these films,
the protagonist gains mystical powers by tattooing the form of the
white monkey god, Hanuman, on their body.[2]

[1]The Joe Louis Theatre has incorporated puppet shows into its program and performs
the show in a way that is easy for even foreign tourists to understand. There are
ingenious tricks built into the performance, such as the Hanuman doll tapping
the shoulders of members of the audience. The survival of the Theatre has been
precarious, but its productions can presently be enjoyed at Asiatique the Riverfront
in Bangkok.

The Sala Chalermkrung Theatre, a storied venue for *khon* theater, also hosts
foreigner-friendly performances of a digested version of the *Ramakian* for tourists.
The 40-minute show includes numerous acrobatic feats to ensure that tourists
with no prior knowledge of the story can watch without getting bored. One little-
known fact is that foreigners with tickets to the Wat Phra Kaew temple are given free
admission to this show, which is without charge for all Thai people, whether or not
they possess a ticket. Meanwhile, the long-form *khon* performance of the *Ramakian*
epic can be seen in its entirety at the National Theatre.

[2]Some analyses suggest that the influence of the *Ramakian* on modern Thai society
does not stop at external levels such as these. Research posits that the effect reaches
deep into the internal aspects of people themselves. Intriguing observations such
as the following are not uncommon: "Even in Modern Thai drama, every element
is a rehash of classic literature, such as the *Ramayana* and *Jataka*, and the audience
interprets works with that encoding as presupposed fact" (Hamilton 1992).

Here, we focus on two works by Thai director Sompote Saengduenchai, who studied film in Japan: *Hanuman vs. 7 Ultraman* (1974), in which the modern Japanese hero Ultraman fights alongside the legendary Thai hero Hanuman, and *Suek Kumphakan* (1984), an adaptation of the fight with Kumbhakarna in the *Ramakian*. I use these works as a lens through which to view reception of the *Ramayana* in Thailand and to clarify the significance of the development of *Ramayana* in modern times (Figs. 2.1–2.3).

Figure 2.1 Cover of a cartoon edition of the *Ramakian*.

Figure 2.2 DVD jacket of an animated *Ramakian* movie.

Figure 2.3 A souvenir facemask with a "cute" image of Thotsakan's face.

2.2 Reception of *Ramayana* in Thailand

Before embarking on a detailed consideration of the works of Chaiyo Studio, I would like to reaffirm the history surrounding the reception of the *Ramayana* in Thailand.[3] At present, *Bot Lakhon Ramakian* (dramatic verse of the *Ramakian*, 1797), compiled during the time of Rama I,[4] is considered the canonical form of the text in Thailand.[5]

[3]I refer primarily to (Iwamoto 1980, 1985; Ono 1999, 2000; Iyengar 1983) regarding the acceptance of the *Ramayana* in Thailand.

[4]Ruled from 1782 to 1809. At the time, the dance troupe of the royal palace of Rama I and that of the palace of his younger brother, the viceroy, customarily produced the *Ramakian* in concert. However, these productions apparently escalated over time to the brink of actual conflict. One reason for the dispute was dissatisfaction about the decision that the king's dancers should always play the side of Phra Ram (Rama) while the viceroy's dancers should play that of the demons that were routed by the hero (Mattani 1996: 63).

[5]In this paper, while I focus on the Central Thai *Ramakian*, which has become canonized as "the Ramayana of Thailand," I urge the reader to remember that various regional versions of the *Ramayana* tale exist, such as those of Northern and Eastern Thailand. Interestingly, some of the versions are closely related to *Jataka.*

Given the fall of the Ayutthaya kingdom caused much of its literature to be lost or destroyed, the period in which the *Ramayana* began to be known as the *Ramakian* in Thailand is unknown. While the Thai word *kian* originates from the Sanskrit word *kirti*, the prevailing theory suggests that the word arrived by way of the Cambodian word *reamker* (=ramakirti) (Iwamoto 1985: 317). And as is often the case with folk tales, determining with any degree of precision when the story of the *Ramayana* appeared in Thailand is exceedingly difficult. The story itself likely crossed over from India during ancient times. While traders were quite likely the primary medium by which folk tales spread throughout the land, the oral tradition of the *Ramayana* tale was introduced to Thailand by Brahmin monks who recited the story as part of their ritual chants.

The *Bot Lakhon Ramakian* invokes not only Valmiki's Sanskrit *Ramayana* but also the Tamil, Bengali, and even Malay versions of the tale, and was compiled by edict of Rama I,[6] the founder of the Chakri royal dynasty, that continues to rule Thailand today. While the influence of the southern Indian Tamil culture is strongly felt in all aspects of Thai culture, the form of the *Ramayana* introduced to Thailand before the establishment of Rama I's version of the text was most likely influenced by oral *Ramayana* tales from the Tamil region.[7] Interestingly, Rama VI,[8] who was educated from a young age in Britain, focused on the discrepancies between the Thai Ramakian and Valmiki's Ramayana in a book titled *The Origin of the Ramakian* (Fig. 2 4), in which he himself attempted to determine the origin of the story. In the book, Rama VI emphasizes the influence of the Sanskrit *Ramayana* texts in the Bengal region (the ancient kingdom of Anga),[9]

[6]The "Rama" designation for kings of the Chakri dynasty is primarily a convention for foreigners, and was introduced by Rama VI.

[7]It is likely that in addition to the *Iramavataram (Kamp Ramayanam)*, written in Tamil in the 12th century, fragmentary portions of the oral Ramayana that spread throughout the Tamil region prior to the aforementioned work also made their way to Thailand.

[8]From a young age, Rama VI exhibited significant literary talent. Over the course of his life, in addition to translating and adapting many Eastern and Western literary works into the Thai language, Rama VI wrote a vast array of original literature. He further founded a private troupe composed of his aides and guards and performed himself in productions.

[9]According to Rama VI, many Thai Brahmins are of Bengali descent (Rama VI 1975: 173).

Vishnu Purana, and *Hanuman Nataka* (Rama VI 1975: 173). In any event, unlike the *nang yai* tradition, whose transmission from the Angkor empire to the Ayutthaya dynasty is essentially viewed as fact, the *Ramayana* as an oral legend was almost certainly transmitted to Thailand by sea from southern India, via ancient trade routes (and by land through Burma). The possibility that the *Ramayana* passed through the Mon people of Dvaravati—whose presence in the region surrounding predates that of the Thai people themselves—has been noted.[10] As previously noted with respect to the routes by which folk tales entered Thailand, divining the details of transmission and spread is unfortunately nearly impossible at present.

Figure 2.4 Cover of "The Origin of the *Ramakian*," by Rama VI.

[10]Known as *Thawarawadi* (Sanskrit: *dvāravatī*) in Thai. The main proponents of the Dvaravati culture, the Mon people espoused Buddhist beliefs and boasted a high cultural standard. Unfortunately, modern research has barely begun to elucidate the details of Dvaravati culture. Further progress in this research area should lead to greater understanding. The argument for a Mon vector also references (Yoshikawa 1973: 97).

2.3 *Hanuman vs. 7 Ultraman* (1974)[11]

Let us now move to a detailed discussion of film works. I will first examine *Hanuman vs. 7 Ultraman* (Fig. 2.5).

Figure 2.5 DVD jacket of *Hanuman vs. 7 Ultraman*.

[11]In Japan, the film was given the title *The 6 Ultra Brothers vs. the Monster Army*, and was released in theaters dubbed over in Japanese in 1979. Many saw the movie in theaters. When the first film premiered at the Sala Chalermkrung Theatre in 1974, it was so popular that the line to get in snaked around the block. Modern movies often include scenes of daily life in the hustle and bustle of the city underneath the theater billboard for *Hanuman vs. 7 Ultraman*.

2.3.1 Sompote Saengduenchai

Hanuman vs. 7 Ultraman is a film by Chaiyo Studio,[12] which was founded by Sompote Saengduenchai (1941–2021). Sompote studied film in Japan for some time, and learned about *tokusatsu* from Eiji Tsuburaya. As Sompote brought *tokusatsu* effects to the Thai film industry, he can arguably be named "the father of *tokusatsu* in Thai film." Sompote lived in a temple as a boy. After working odd jobs, including a stint as a cameraman for the song and dance department of Bangkok Bank, he won a scholarship in 1962 to study film at Toho Co., Ltd. in Japan. Sompote asserts that in addition to learning from Eiji Tsuburaya, he had the privilege of studying under masters such as Akira Kurosawa.[13] In his home, dubbed "Ultraman Land" for more than 10,000 Ultraman-related pieces of merchandise on display, Sompote possesses photographs of Yuzo Kayama from *Red Beard* (1965) and a copy of Kurosawa's *High and Low* (1963), a film for which he served as an assistant during an internship.

After studying in Japan for two years, Sompote returned to Thailand, and began producing television dramas, releasing his first full-length film production, *Tah Tien* (1973). The film tells the story of a showdown between the guardian *yaksha* (*yak* in Thai) of two temples—Wat Arun (the Temple of Dawn) and Wat Pho (Temple of the Reclining Buddha)—that face each other on opposite banks of the Chao Phraya river, near the royal palace. *Tah Tien* is a work steeped in Thai legend. While its *tokusatsu* effects are somewhat unrefined compared to Sompote's later work, the film managed to reconstruct the legend with a unique comical flair, and was reasonably successful at the box office. One of the *yaksha* that protects Wat Arun is the

[12]The word *chaiyo* means "victory" in Thai. According to Sompote, Kukrit Pramoj, the 13th Prime Minister of Thailand and an accomplished politician and writer, gave the studio its name. While Chaiyo Productions is often used as the name for the studio, Sompote himself has stated that "Productions" is a misnomer, and "Studio" is the correct designation; I have therefore followed this convention here. Furthermore, the name the film house was originally given by Kukrit was ostensibly Chaiyo Scope.

Chaiyo Studio has produced a total of 16 films and various other works, including TV dramas based on classical literature. On the topic of Sompote himself, the Japanese film critic Yomota Inuhiko has written an intriguing description of the man in "Sompote: The King of Thai *Kaiju* Film." (Yomota 2003: 253–262).

[13]Opinions attributed to Sompote in this paper are taken from three interviews I conducted with him (March 27, 2018, at the Japan Foundation Bangkok; August 13, at Sompote's home; and March 5, 2019, at Sompote's home).

demon king Thotsakan (Ravana) in the *Ramakian.*[14] *Yaksha* are believed to have been evil men who later repented for their actions and converted to Buddhism. Tah Tien, the namesake of the film, is the name of a pier near Wat Pho, which itself boasts 152 marble carvings of scenes from the *Ramakian*. By the way, the yaksha of Wat Arun makes an appearance in Jumborg Ace & Giant (1974), in which the *yaksha* fights against Jumborg Ace in space.

2.3.2 The Story of *Hanuman vs. 7 Ultraman*

Hanuman vs. 7 Ultraman was released in the same year as Jumborg Ace & Giant, and is the third production of Chaiyo Studio. *Hanuman vs. 7 Ultraman* demonstrates a much higher level of quality than previous Chaiyo films, particularly with respect to composition and cinematography. While the film is officially considered a joint Japanese–Thai production, in reality, Sompote produced nearly the entire work on his own, and only a few *tokusatsu* scenes were shot at Tsuburaya Productions studios in Japan. Several references to the *Ramakian,* the Thai version of *Ramayana,* are skillfully woven into the film. Two memorable scenes include the birth of Hanuman as the child of the wind god and Hanuman's voyage to obtain medicinal herbs to heal Phra Rak (Lakṣmaṇa) after Phra Rak is wounded by a spear. First scene takes place at the beginning of the movie, when the wind god Vayu pours the energy (semen) of Lord Shiva into the mouth of Suwaha,[15] from which Hanuman is then born. In the second scene, Hanuman travels to the abode of the sun god after Phra Rak is wounded by the spear of Kumphakan (Kumbhakarna)

[14]While Thotsakan is normally believed to have been a *yaksha*, he is also believed to have been a *rakshasa* or an *asura*. In Thailand, the difference between *yaksha*, *rakshasa*, and *asura* is not clear, and the terms are not often distinguished from one another. Generally speaking, the terms are usually viewed as being the same. The yaksha of Thotsakan that appear in the *Ramakian* are also believed to guard the *ubosot* (ordination hall) of the Wat Phra Kaew (Temple of the Emerald Buddha) where the principal idol of the temple, the Emerald Buddha, is enshrined. The hallways and walkways of Wat Phra Kaew contain 178 wall paintings of scenes from the *Ramakian*.
[15]In the *Ramakian*, Suwaha was cursed by her mother for reporting on her mother's infidelity to her father, and was made to undergo penance by standing motionless on one leg, with her mouth open (Ohno 2000: 126). Strictly speaking, because Thai legend holds that Hanuman was born when the wind god poured the energy of Lord Shiva into Suwaha's mouth, Hanuman is the son of Lord Shiva. However, in common practice, he is believed to be the son of the wind god.

and convinces the god to delay the rising of the sun. Hanuman then flies to retrieve the medicinal Sankharani Trichawa (Sanjivani) herb, which is said to lose its potency if it is touched by the sunlight. In the film, the Sankharani Trichawa is anthropomorphized into the form of a flower spirit. The scene in which the female spirit scampers away from Hanuman is rendered with a playful air that is likely to entertain any child who watches the film.

Thai children read and learn about the *Ramakian* in school textbooks. The name of the herb retrieved by Hanuman is ostensibly even posed as a question on school tests. However, not many students are capable of answering the question, and the overall difficulty of questions related to the *Ramakian* causes many students to fail in classical literature exams. Any child who has watched *Hanuman vs. 7 Ultraman* would presumably not have difficulty remembering the name of the Sankharani Trichawa, which Hanuman shouts many times. I daresay that in this sense, the film might even help struggling children pass their classical literature exams. Interestingly, Hanuman travels to obtain medicinal herbs in two scenes in the *Ramakian*. The first scene is outlined above. The second involves Hanuman traveling to a different mountain to retrieve an herb that will help Phra Rak recover from the wound received from an arrow (the Naga Pash) fired by Intrachit (Indrajit), son of Thotsakan. In the first scene described, Hanuman wraps his tail around the mountain and returns home with only its herbs (shown as flowers in the movie). However, Hanuman rips the entire mountain out of the earth and carries it back with him in the latter scene.

The story of the film *Hanuman vs. 7 Ultraman* is as follows. A young Thai boy with a strong sense of justice and of right and wrong tumbles upon three men that have stolen Buddhist idols from a temple. The boy chases the men, but is shot in the head and killed. Having watched the entire scene unfold from her home in the M78 nebula, Ultra's mother rescues the boy's corpse from cremation, takes it back to the M78 nebula, and imbues the corpse with the heroic soul of Hanuman, the white monkey god. Thus, "Ultra Hanuman" is born. Interestingly, the Ultra brothers, who also live in the M78 nebula, are introduced by the narrator as "faithful believers

of Buddhism" (Fig. 2.6). Notably, Ultraman is said to be a devout Buddhist in Thailand.[16]

Figure 2.6 The script of *Hanuman vs. 7 Ultraman*, in which "Ultra's Mother and the Ultra Brothers are faithful believers of Buddhism" is written (provided by Sompote Saengduenchai's daughter).

Turning the focus to "Ultra Hanuman," we first remark on the much-observed manner in which he flies through the sky. Rather than flying like Ultraman or Superman, in the direction of his outstretched hands, Ultra Hanuman flies horizontally while standing

[16]When collecting the boy's corpse, the giant hand of Ultra's mother suddenly appears from the heavens. This can be read as a reference to the "Great Hand" of the Buddha, who is always ready to save good-hearted beings in its infinite mercy.

vertically, with his legs arranged in a Buddhist swastika orientation in the way Thai celestials (*thewada*, skr: *devatā*) are depicted when flying. Images of *thewada* cavorting in the sky with their legs in a swastika orientation are painted on the walls of many Thai temples. The scene of "Ultra Hanuman" moving through the sky above the Chao Phraya River like a *thewada* is rather surreal and would be quite unthinkable in the Japanese Ultraman series. "Ultra Hanuman" himself is also rather brutal. "Ultra Hanuman" proclaims that he "will not forgive anyone that slights Buddhism," and is depicted as crushing the idol robbers with his fists and feet. This portrayal can be interpreted as adherence to the personality of Hanuman as depicted in the original *Ramakian* and a reflection of traditional Thai values, in which the sin of the theft of a Buddhist idol is grave, and thus its punishment is also severe.[17]

After defeating the idol thieves, "Ultra Hanuman" joins forces with the six Ultra Brothers[18] and fights to exterminate *kaiju* (giant monsters). In this film's timeline, the sun has drawn too close to the Earth and rendered Earth a burning hell. A rocket designed to create rain is fired into the atmosphere. However, due to human error,[19] the rocket accidentally explodes and awakens kaiju, who have been sleeping deep underground. The boy transforms into "Ultra Hanuman" and attempts to fight the kaiju, but he falls into a dire predicament. The six Ultra Brothers travel from the M78 nebula to save the boy. The scene in which the six brothers and Hanuman join forces to defeat the last kaiju, whose allies have been vanquished was criticized in Japan as indicative of bullying or mob violence. This audience reaction appears to have been unique to Japan.[20]

The last kaiju is Gomorrah. According to Sompote, this monster was actually inspired by and modeled to look like the water buffalo

[17]Sompote explains that he intentionally made Ultra Hanuman scary to teach children Buddhist lessons, particularly that one reaps what one sows.

The victory of *dharma* (justice in accordance with Buddhist law) over non-*dharma* is generally believed to be one of the central themes of the *Ramakian*.

[18]The reason for the Thai title including the numeral 7—that is, including Ultra's mother in the count—is that the number 6 in Thai is pronounced "hok," which can also mean "stumble" or "fall." The producers did not want the movie to stumble or fall, and thus avoided this number.

[19]This happens because a male scientist overconfident in the achievements of science refused to heed the warnings of his female assistant to check the rocket a last time, and arrogantly pushed the launch button.

[20]In Japan, later entries in the Ultraman series are also criticized as depicting mob justice and bullying (SUPER STRINGS Surfrider 21 1991: 62).

Trapee, who appears in the "Trapa Trapee" episode of the *Ramakian*. While the story of "Trapa Trapee" does not itself feature in *Hanuman vs. 7 Ultraman*, I nevertheless wish to describe the story here. This myth, in which parent and child buffaloes face off against one another, appears not only in the Thai *Ramakian*, but also in Laos (Iyengar 1983). Versions of the *Ramayana* titled *Khwai Trapee* (Water Buffalo Trapee) exist in Laos and northern Thailand, and their popularity is considerable.[21] In this episode, Trapee defeats his father, the water buffalo tyrant King Trapa. However, Trapee himself becomes a tyrant, and while boasting of his own might, he challenges the divine monkey king Palee (Vali) to a fight. Palee tells his younger brother that if thick blood flows out of the cave in which the fight will occur, his brother should assume that the water buffalo has died. However, if thin blood flows forth, his brother should assume that Palee has died, and must then seal the cave to prevent the water buffalo from escaping. On the day of the fight, rain dilutes the blood flowing from the cave. Palee's younger brother, Sukureep (Sugriva), mistakenly assumes his brother has died, and seals the cave. This later leads to a quarrel between the brothers. Sukureep is exiled by his king brother, and in an effort to aid Sukureep, Prince Rama kills Palee.[22] To revert

[21]Other episodes popular in Thailand, Laos, and Cambodia include the story of Hanuman wooing the enemy mermaid (Suvannamaccha), and the story of Hanuman fighting and ultimately reconciling with Macchanu, his son with Suphannamatcha. Macchanu is a white monkey with a fish's tail. As his mother is Thotsakan's daughter, Macchanu first appears in the story as Hanuman's enemy. At first, neither Hanuman nor Macchanu realizes they are father and son. Hanuman then asks Macchanu the names of his father and mother, discovering that he himself is Macchanu's father. Unfortunately, the young monkey does not believe him. Hanuman grows an extra pair of arms and brings forth stars from his mouth, finally allaying his son's doubts (this is a famous scene; this form of Hanuman is frequently depicted in designs). At the Asean Plus *Ramayana* Festival 2016, held in Bangkok, the Laotian team performed this episode, and the Thai audience reacted ecstatically (see Hiramatsu 2018b for more information).

[22]In the story of the *Ramakian*, both Palee and Sukureep moved so quickly during their fight and looked so similar that Prince Rama was unable to shoot at Palee. He decided to tie a white cloth around the wrist of the younger brother, Sukureep, to be able to distinguish the brothers and is thereby able to correctly kill the elder brother. Parenthetically, Rama places a garland around Sukureep's neck in the Valmiki version and a crown of flowers on Sukureep's head in the Cambodian *Reamker*. Further, the various versions of the tale in India each have their own method by which Rama tells the brothers apart (Ono: 129, 394). Finally, in the *khon* version of the *Ramakian*, Palee, the son of Lord Indra, wears a green mask, whereas Sukureep, the son of the Sun God, wears a red mask with an image of his father on it. The brothers are distinguishable by their clothes, and the matter of the difference becomes moot.

to the story of Gomorrah in *Hanuman vs. 7 Ultraman*, the monster walks on two legs despite original Trapee's being four-legged because of budget cuts. As the production company had insufficient funds to hire the four actors required to play a four-legged creature, resolved to make Gomorrah stand upright, a position requiring only two actors.

I would like to take an additional minor detour from the discussion of the *Ramakian* itself to consider the modeling of Ultraman's face. In Japan, Ultraman's facial appearance is most commonly a blend of the Maitreya Buddha and an archaic smile, while in Thailand his face is fashioned on that of the Sukhothai Buddha. Sompote says that he was inspired by the image of standing Buddha in Sukhothai province and recommended to his master Eiji Tsuburaya that they reproduce this likeness. Intriguingly, Sompote's house exhibits a sketch of the face of the Sukhothai Buddha changing into the face of Ultraman and a picture of Sompote discussing the idea with Eiji Tsuburaya. In fact, many Japanese and Thai people alike who have personally viewed the Sukhothai Buddha have remarked that the elegant comport and gentle countenance of the Sukhothai Buddha are reminiscent of Ultraman. The likeness caused a rift between Tsuburaya Productions and Chaiyo Studio following the death of Tsuburaya's son, Noboru, and disputes over the rights to the likeness have even reached the courts. The fight over the copyright to Ultraman has not concluded. Paradoxically, the Supreme Court of Japan has ruled against Tsuburaya in the lawsuit brought before it, while the Supreme Court of Thailand has declared Sompote the loser of the lawsuit tried in Thailand, the dispute has even spread to courts outside of Japan and Thailand.

2.3.3 The Aims of Creator

I would now like to discuss an essential aspect to consider when interpreting *Hanuman vs. 7 Ultraman*: the aims of its creator, and specifically his opinion on the significance of the alliance between Hanuman and Ultraman. In the 1970s, democratic political movements were gaining strength in Thailand. In 1973, the year before the film's release, the administration in power was toppled in an uprising known as the "October 14th Event" or the "Day of Great Sorrow." Alongside these movements, Japan-bashing and

boycotts of Japan-made goods grew in popularity (Hiramatsu 2010: 19). The visit of Prime Minister Kakuei Tanaka to Thailand in 1974 further sparked fierce protests and demonstrations.[23] At the time, critics of Japan claimed that Japanese tourists would visit Thailand on Japanese airlines, sojourn in Japanese hotels, and buy goods in Japanese department stores, thereby avoiding investing in the Thai economy. The Thai branch of the Daimaru department store—the first building in Thailand with an escalator—resolved to attract customers by showcasing a Muay Thai (traditional Thai martial art) fight in a makeshift ring in front of the store. However, the fighters neglected to perform the compulsory *wai khru* ritual (a dance of gratitude toward one's teachers) before the fight, and were lambasted for their failure to respect Thai traditions and culture. Fearing a similar situation, and out of a desire to express his gratitude to his masters, Tsuburaya and Kurosawa, Sompote elected to narrate a story in which Ultraman—a symbol of Japan— would fight alongside Hanuman, a symbol of Thailand. Following the fight, the Ultra Brothers do not leave chaos in their wake. Instead, the brothers are thanked, and quickly depart to their homeland.[24] The film is imbued with Sompote's wish to help improve strained Japanese–Thai relations and his hope for friendly interaction between the two countries. While this explanation was adapted from rationalizations provided by Sompote, and critics may argue that these justifications were added ex post facto. Nevertheless, no degree of criticism can negate the fact that Ultraman and Hanuman fighting together is undeniably an epochal and influential concept.

Further, we must also acknowledge that the film is not merely a collaboration between Japanese and Thai hero characters, but also an effort to revive and repaint the heroes of the *Ramakian*, a mainstay of traditional Thai culture, with the new tools of *tokusatsu* film.

[23]Interestingly, photos exist of Prime Minister Tanaka, who managed to enter Thailand safely, wearing a Hanuman mask.

[24]At the end of the movie, Hanuman bids farewell to each of the Ultra Brothers, hugging and kissing them while performing dances similar to those performed on a traditional *khon* stage. Hanuman appears to wipe tears from his face with his hands. I wonder how Ultraman, a product of modern Japanese culture, would have felt being hugged in Thailand by Hanuman, a legendary Thai hero.

2.4 *Suek Kumphakan*[25] (The Battle with Kumbhakarna) (1984)

Next I would like to discuss the first live-action adaptation of the *Ramakian* in Thailand: the Chaiyo Studio production *Suek Kumphakan* (Fig. 2.7).

Figure 2.7 DVD jacket of *Suek Kumphakan.*

2.4.1 *Tokusatsu* Effects and Comical Developments

Following productions like *Hanuman and the Five Riders* (1975)[26]— the sequel to *Hanuman vs. 7 Ultraman*—Phra Rod Meree (1981), based on a Thai Buddhist tale, and Khun Chang Khun Phaen (1982),

[25]The English title is *The Noble War.*

[26]The sequel to *Hanuman vs. 7 Ultraman*. The story is as follows: The idol-robbers killed by Hanuman in the first movie are sent to hell, where they are saved from a trial by the King of the Underworld (Yomarat) by the henchmen of King Dark, who intends to use the robbers as his own pawns. The robbers return to Earth and begin to torment the Kamen Riders. Hanuman then comes to the aid of five Kamen Riders.

based on a popular folk tale, *Suek Kumphakan* was released in 1984 as Chaiyo Studio's 14th production. The costumes and classical music compositions used in this film are nearly identical to those used in the *khon* performances of the *Ramakian*. However, the usual gravitas of *khon* performances is absent, and the depiction of the fight between Kumphakan, younger brother of Thotsakan and an intellectual in his own right, plays out at a light, comfortable tempo. While virtually self-evident, Kumphakan is also the elder brother to Phiphek (Vibhishana), who was exiled by elder brother and head of the family, Thotsakan, and becomes Phra Ram's adviser and counselor.[27] The characteristics of *Suek Kumphakan* are similar to those of *Hanuman vs. 7 Ultraman*: the use of *tokusatsu* effects and comical developments are an underlying theme throughout. The *tokusatsu* scenes here are considerably restrained compared to those in *Hanuman vs. 7 Ultraman*. Nevertheless, shots of Hanuman, Hanuman and Sukureep, and Hanuman, Sukureep, and Ongkhot (Angada) flying through the air with their legs in the unmistakable swastika pose are, if anything, more surreal than similar scenes in *Hanuman vs. 7 Ultraman*.

Suek Kumphakan features exactly the same footage of Hanuman traveling to retrieve medicinal herbs used in *Hanuman vs. 7 Ultraman*. As previously noted, this scene was filmed at Tsuburaya's studios. However, while *Hanuman vs. 7 Ultraman* only featured the scene of the sun god and the medicinal herbs, *Suek Kumphakan* also includes footage of Phra Rak falling onto Kumphakan's spear (Mokhasak). The majority of Sompote's works feature footage or scenes reused from previous productions. For example, a scene in *Suek Kumphakan* includes Hanuman disturbing Kumphakan, who is meditating in prayer in a river. The river, which Kumphakan had previously held back, rushes forth, and pours downstream, causing crocodiles to sink beneath the waves. This footage was previously used in *Kraithong* (1980), which is based on a famous folk tale about crocodile killers. Other famous contrasting scenes include one in which Hanuman transforms into rotten dog meat, and Ongkhot into a crow, who then rides the meat down the river, picking at the meat greedily. This is a famous scene in which Hanuman attempts to

[27]In the Thai *Ramakian*, Phiphek is captured by Phra Ram's army after being exiled from Lanka. Phra Ram, aware of what Phiphek has been through, accepts him as his ally.

torment Kumphakan, who loves pleasant smells and despises odors. The meat appears so real in its depiction in Sompote's film that the director may have used genuine meat containing live maggots. Including such a depiction in the "dignified" *khon* performances of the *Ramakian* would be unthinkable.

2.4.2 The Story of *Suek Kumphakan*

As has been previously asserted, comical story development is a hallmark of Chaiyo Studio productions. Comical narrative is indeed more prominent in *Suek Kumphakan* than in *Hanuman vs. 7 Ultraman*. Nowhere is this clearer than in the depiction of a contest between the wise Kumphakan and the red monkey king Sukureep. Kumphakan urges Sukureep to uproot an orchid tree in an attempt to exhaust and defeat the monkey king. Sompote's choice to depict in film "The Battle with Kumbhakarna" among the countless scenes of *Ramakian* may be based on the director's identification of this contest of strength as the perfect vehicle for comic expression. Even the behavior of the brave Kumphakan is farcical , while the traditional solemnity of a *khon* performance is absent.

One might argue that a main theme of "The Battle with Kumbhakarna" is the sorrowful image of two brothers, forced by the cruel hand of fate to fight one another as enemies. In *khon* performances[28] (Fig. 2.8), Kumphakan lies close to death after being struck by Phra Ram's arrows in the final scene of battle. Crying, Phiphek flies to meet his fallen brother and wails in despair as he kneels at his dying brother's feet. The audience cannot help but watch expectantly, as the scene juxtaposes the strength and preciousness of brotherly love against the cold and cruel machinations of fate. Often performed slowly and carefully, with a grave and solemn air, this scene of two brothers' eternal farewell is rendered comically and even restlessly in the movie. Kumphakan is

[28]Information regarding "The Battle with Kumbhakarna" as shown in *khon* performance was referenced from "Ocean Media, *The Khon Performance, Khon Ramawatan Section 2, Disc 1, Part: The War with Kumphakan.*" Further, the chapter of "The Battle with Kumbhakarna" has been recently performed in the year-end regular performance of the Ramakian by the (former) Queen Sirikit Project (Fig. 2.9a,b). Every year, this performance uses large stage props similar to those seen in "Super Kabuki" to achieve a grand, acrobatic spectacle, and involves a large number of extra performers. Many of the performers are women.

a just and noble warrior.[29] In the original story, Kumphakan laments the inhumanity of his elder brother Thotsakan, whose meaningless fight with Phra Ram he considers unconscionable, and does not wish to join. However, in order to fulfill his *katanyu* (filial devotion, obligation, and gratitude) to his elder brother, Kumphakan steps onto the battlefield against his will. Kumphakan sacrifices himself for *katanyu*. In certain contexts, *katanyu* can be translated as "filial piety,"[30] the most important value in Thai society (Hiramatsu 2018a: 60).

Figure 2.8 VCD jacket of a *khon* performance of the *Ramayana*.

[29]Members of the Thotsakan clan and other dignified *yaksha* always wear a crown (*mongkut*, Skr: *makuṭa*). A characteristic of his persona is that Kumbhakarna does not wear a crown, perhaps because he is a just warrior who does not feel the need to brandish his power and authority in front of others.

[30]Here, the term is used not in the Confucian sense, but to refer to the Buddhist virtue.

การแสดงโขน

ชุด ศึกกุมภกรรณ ตอน โมกขศักดิ์

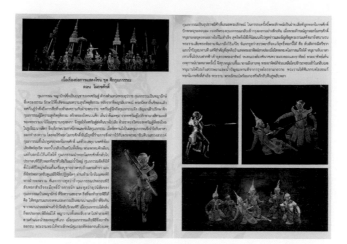

Figure 2.9 Flyers for a performance (2013) of the *Ramakian* "Battle with Kumbhakarna" staged by the (former) Queen Sirikit Project (now Queen Mother).

In *khon* performances, Phra Ram—an avatar of Lord Vishnu—reveals his true form to the dying Kumphakan by proclaiming: "You are a noble warrior of justice (*yuttitham*) and truth (*sachatham*), and you are filial devotion (*katanyu*) incarnate. I forgive you, and after you die, you shall pass into paradise (Sukhavati)." In this way, *khon* performances conclude by underscoring the virtuous nature of Kumphakan's *katanyu*. These lines, however, make no appearance in *Suek Kumphakan*. Released in 1981, *Phra Rod Meree* is described by Sompote as being produced to teach the modern youth about the importance of *katanyu*.[31] Sompote's omission of the reference of the value of *katanyu* in *Suek Kumphakan* is therefore unlikely. Why the concept makes no appearance in *Suek Kumphakan* is truly a mystery.

Further, in *khon* performances, Phra Ram stands by placing his legs on the thighs of Kumphakan while Kumphakan remains standing, with his back straight and turning over while pivoting his body away from Phra Ram. Phra Ram then strikes an imposing victory pose. Similar to the pose commonly seen in Japanese *kabuki*—in which, actors stretch out one hand and place the other above their head (known as a *mie*)—this famous pose is often depicted in works of art. However, this scene is not included in Sompote's movie. On stage, the maneuver is exceedingly difficult, as the actor has only

[31]Please refer to (Hiramatsu 2020) for more about *Phra Rod Meree*.

one chance to perform the pose correctly, creating an electrifying momentary tension for the audience. In contrast, no such tension or urgency is possible in a film adaptation—a possible reason for the omission of the scene.

Thus, upon comparing scenes common to the Chaiyo Studio production *Suek Kumphakan* and the traditional *khon* performance of the *Ramakian*, one may argue that the film uses comicality to render the story more understandable and accessible to the broader public. Notably, we have entered an age in which the *Ramakian*, once protected in the halls of the royal family as an orthodox element of traditional culture through *khon* and *nang yai* performances, can be performed in the comical manner seen here without fear of reproach or criticism.[32]

2.5 Conclusion

Foremost among the achievements of Chaiyo Studio is undoubtedly its role in introducing *tokusatsu* special effects to the world of Thai cinema. However, the studio's considerable contribution toward "popularizing" the *Ramakian*—primarily through the films *Hanuman vs. 7 Ultraman* and *Suek Kumphakan*—must be equally highlighted. To exercise some poetic license, I assert that the studio pioneered a method with which the common folk could access the *Ramakian*, enabling the public to enjoy a story previously only narrated through rarefied, high-class performance art (*khon* and *nang yai*) with the familiarity and comfort reminiscent of comics and picture novels. In effect, to assert that these films have contributed considerably to the popularization of the *Ramakian* as common entertainment would not be an exaggeration.

Currently, free adaptations of the *Ramakian* to alternate forms are ever more common. *Ramakian* is even performed in the folk theater style of *likay* , which is often belittled as a vulgar art.

[32]Nevertheless, even in *Suek Kumphakan*, the manners of Phra Ram and Phra Rak do not contain elements of comicality. However, even in the "solemn" *khon* form, the monkey armies move with considerable comicality and lightness. While I have just compared the gestures of *khon* performance to the poses of *kabuki*, in reality that the movements seen in *khon* are—apart from portrayals of the monkey army—quiet and suggestive gestures, and the comport of the form is most reminiscent of Japanese Noh drama.

Similarly, the breadth of roles that women are permitted to play has grown considerably and reflects more modern attitudes. Women were traditionally forbidden to participate in *khon* performances, outside of the roles of the heroine Nang Sida (Sita), and other females, or the golden deer. Trends are presently shifting toward female performances of nearly every role in the play. For example, a *khon* club that performs for the Thai International Airways stages a production in which a woman plays the part of Phra Rak (Fig. 2.10). As these free adaptations continue to evolve, and the narrative is molded to fit the norms and mores of modern society, I am excited to observe how Thai acceptance and reception of the *Ramayana* develops.[33]

Figure 2.10 A 2016 calendar that features an image of a *khon* club inside Thai International Airways.

[33]I plan to discuss issues related to women and the *Ramakian* in the future.

References

Bose, Mandakranta (2004). *The Ramayana Revisited.* (Oxford University Press, UK).

Fukuoka, M. (2015). Reinterpretation of the Ramayana in Indonesia: A Consideration of the Comic Works of R. A. Kosaish, *Bulletin of National Museum of Ethnology*, 40(2), pp. 349–367.

Hamilton, A. (1992). Family Dramas: Film and Modernity in Thailand. *Screen*, 33(3) Autumn, pp. 259–273.

Hiramatsu, H. (2010). The Reception of Japanese Literature and Japanese Culture in Thailand: from Mikado and Madam Butterfly to 'Blythe' Doll (in Japanese), *Ritsumeikan Studies in Language and Culture*, 21(3), pp. 17–28.

Hiramatsu, H. (2018a). Norms of Gratitude in Thai films, Television Dramas, CMs, and MVs: Virtue or Oppression? In the Name of Filial Piety (in Japanese). In: *Southeast Asian Popular Culture: Identity, Nation, and Globalization*, eds. Fukuoka M., Fukuoka S. (Style Notes, Tokyo), pp. 60–81.

Hiramatsu, H. (2018b). Ramayana Festival in Asean (in Japanese). In: *Southeast Asian Popular Culture: Identity, Nation, and Globalization*, eds. Fukuoka M., Fukuoka S. (Style Notes, Tokyo), pp. 444–446.

Hiramatsu, H. (2020). Comical Thevada and Feminine Ogre: Innovative Characters Reflecting Modern Thai Contexist. In: *Twelve Sisters, A Shared Heritage in Cambodia, Laos, and Thailand*, ed. Yamamoto H. (Thailand P.E.N. Center), pp. 68–73.

Iyengar, K. R. S. ed. (1983) *Asian Variations in Ramayana* (Sahitya Akademi, New Delhi).

Iwamoto, Y. (1980). Annotated Ramayana (in Japanese), Valmiki (tr. Iwamoto Yutaka). *Ramayana 1.* (Heibonsha, Tokyo), pp. 225–350.

Iwamoto, Y. (1985). Annotated Ramayana (2) (in Japanese). Valmiki (tr. Iwamoto Yutaka). *Ramayana 2.* (Heibonsha, Tokyo), pp. 269–362.

Mattani Mojdara Rutnin (1996) *Dance, Drama, and Theater in Thailand: The Process of Development and Modernization* (Silkworm Books, Chiang Mai).

Ohno, T. (1999). *Ramayana in India* (in Japanese) (Osaka University of Foreign Studies Southeast Asian Classical Literature Study Group, Osaka).

Ohno, T. (2000). *Comparative Research on the Various Southeastern Versions of the Ramayana* (in Japanese) (Osaka University of Foreign Studies Southeast Asian Classical Literature Study Group, Osaka).

Rama VI (Phrabatsomdet Phramongkutklaochaoyuhua) (1975). *The Origin of the Ramakian* (in Thai) (Nakorn Dhon Publisher, Bangkok).

Richman, P. (1991). *Many Rāmāyaṇas: The Diversity of a Narrative Tradition in South Asia* (University of California Press, Berkeley).

Sakae, M. (1961). *Thailand's "Journey to the West" (the Ramakian)* (in Japanese) (Heibonsha, Tokyo).

Super Strings Surfrider 21, ed. (1991). *An Introduction to Ultraman Research* (in Japanese) (Chukei Publishing, Tokyo).

Suvit Phuwansuwan (2005). *The Story of the Ramakian (Complete Version), with Wat Phra Kaew Wall Paintings* (in Thai) (Wakhasin, Bangkok).

Suzuki, M. (1998). Ramayana in Sri Lanka: History, Ritual and Tradition (in Japanese). In: *Cosmos of Ramayana: Tradition and Ethno-forms*, eds. Kaneko, K., Sakata, T. and Suzuki, M. (Shunjusha, Tokyo), pp. 221–244.

Tsuburaya, H. (2013). *Ultraman is Crying* (in Japanese) (Kodansha, Tokyo).

Udo, S. (1993). Phrommacak, An another Rāma Story of Lānnā Thai (in Japanese), *Area and Culture Studies* 47, pp. 227–300.

Yomota, I. (2003). *The Populist Imagination of Asian Film* (in Japanese) (Seidosha, Tokyo).

Yoshikawa, T. (1973). Conditions of the Acceptance of the Ramayana in Thailand (in Japanese), *Southeast Asia: History and Culture*, 1973(3), pp. 97–105.

Chapter 3

Death of Kumbhakarna: Interpretation of the Story by *Dalang* of Balinese *Wayang*

Hideharu Umeda
Faculty of Cultural Policy and Management,
Shizuoka University of Art and Culture, 2-1,
Chuo, Naka-ku, Hamamatsu City, Shizuoka, Japan
h-umed@suac.ac.jp

Region in this chapter: Bali, Indonesia

Performance story: Death of Kumbhakarna in the battle between armies of Rama and the demon king, Rawana. Rawana's younger brother Kumbhakarna goes into battle, fights Rama, and is killed

Names of the main characters in this chapter, Sanskrit names are written in parentheses ():

Rama (Rama)

Laksamana (Lakshmana)

Rawana (Ravana)

Kumbhakarna (Kumbhakarna)

Ramayana Theater in Contemporary Southeast Asia
Edited by Madoka Fukuoka
Copyright © 2023 Jenny Stanford Publishing Pte. Ltd.
ISBN 978-981-4968-09-6 (Hardcover), 978-1-003-29095-7 (eBook)
www.jennystanford.com

Wibisana (Vibhishana)

Anoman (Hanuman)

Sugriwa (Sugriva)

Tualen, Merdah, Delem, and Sangut appear as followers of the two armies and as important translators involved in the progress of the story.

3.1 Introduction

Wayang, the Balinese shadow puppet theatre that is popular on various performing arts, is different from the *wayang* of Central Java in terms of not only the puppets used, the language, and the type of *gamelan* that provides the accompaniment, but also the performance style. Balinese *wayang* is smaller in scale than Javanese *wayang*: in traditional *wayang* performed under a coconut-oil-lit lamp, the screen size is about 1.5 m in height by about 3 m in width; the number of people in a troupe is typically 7, and the duration of a performance is anywhere from 2 to 3 hours.[1]

In this chapter, I focus on Balinese *wayang*, particularly on the story of the "Death of Kumbhakarna" as depicted in the Balinese verses of Kakawin Ramayana. Comparing the contents of this work with the contents of the script created by the *dalang* (*wayang* performers),[2] I clarify the *dalang*'s interpretation of this story in their performance.

3.2 Kakawin Ramayana

The *Ramayana* is a seven-volume epic compiled by Valmiki in ancient India in the 2nd century BC. This epic was later introduced to Java

[1]Literature that briefly describes Balinese *wayang* includes: Spitzing (1981), Fischer and Cooper (1996), Dibia and Ballinger (2004), and Umeda (2020); see Hobart (1987) and Hinzler (1981) for theatrical and anthropological studies, and Zurbuchen (1987) for linguistic studies.

[2]In addition to handling the puppets, the *dalang* also narrate the lines of the characters featured, sing the appropriate songs, and give directions to the *gamelan* player. They also serve as religious functionaries to dispel the impurities caused by human transgressions. Historically, men have played the role of *dalang*, but in recent years, women have too started to become *dalang*. Substantial research has focused on female *dalang* (Goodlander 2016) as well.

in the mid-9th century, where it is said to have been rewritten in old Javanese as the *Kakawin Ramayana*, an epic poem consisting of 26 *sarga* (cantos). The contents of Kakawin Ramayana however vary from Valmiki's version and are said to be based on the Bhattikavya, written in India between the 6th and 7th centuries (Zoetmulder 1974: 227). In Bali, Kakawin Ramayana is considered the work of Yogiswara. The work describes only the first six volumes of Valmiki's seven-volume epic, and the part corresponding to the seventh volume, *Uttarakanda*, is a legacy inherited from Java, written in old Javanese, in the 10th century. Another epic poem written in Java in the 16th century during the establishment of the Islamic kingdom is "*Serat Kandhaning Ringgit Purwa*," which had a great influence on Javanese *wayang* performances. However, this epic poem was not introduced to Bali. Thus, the Kakawin Ramayana and the *Uttarakanda* are considered the original sources of the Ramayana stories in Bali, with the former particularly constituting the principal component of performing arts depicting stories from the Ramayana (Saran and Khanna 2004: 186). The *dalang* who perform *wayang* are so familiar with the Kakawin that they can recite it from memory, and their performances are derived from it.

The ancient text of Kakawin Ramayana is inscribed in Balinese script on the leaves of the *lontar* palm. While this script can be read by only some intellectuals, many of the *dalang* are able to read it and understand the contents; however, a vast majority of Balinese cannot read it. Hence, the contents are transmitted through word of mouth as oral literature. The recitation of the old Javanese kakawin and the interpretation and narration of the story alongside in Balinese language is called *Pepaosan*, which is how Balinese people understand the story of Ramayana as communicated in the Balinese narrative.[3]

However, in 1977, the Balinese literary scholar I Gusti Made Widia worked on an Indonesian translation of the Kakawin, rewrote its contents in the form of a story, and published it as a general book (Widia 1977). He also translated this Kakawin into Indonesian (Widia 1979). In 1987, a new Indonesian language edition of the Kakawin Ramayana was published through a project by the Department of

[3]Also known as *Mabebasan* or *Mekekawin*. *Pepaosan* is a word derived from the High Balinese, and *Mabebasan* is a word derived from Low Balinese. *Mekekawin* is derived from the word Kakawin (Rubinstein 1992: 85).

Primary Education in Bali (Dinas Pendidikan Dasar Propinsi Bali Dati I 1987). This made the Kakawin readily available to many Indonesians, including the Balinese.[4] These translations played an important role in the lives of the younger generation of *dalang*, who could not read the Balinese script or old Javanese fluently. Two English- language translations were also published, contributing to research abroad (Santoso 1980, Robson 2015).

The following is a summary of the Kakawin Ramayana as per the order of its *sarga*:[5]

3.2.1 Sarga 1–Sarga 5

King Dasaratha of Ayodiya had four sons: Rama was the oldest, followed by Bharata, and subsequently by Laksamana and Satruguna. Among them, only the third and fourth sons were born to the same queen. A dispute over the succession to the throne led to Prince Rama being banished from Ayodiya and sent to live in the forest. He is followed by his wife, Princess Sita, and his half-brother Laksamana. In the forest, Surpanaka, the younger sister of Rawana, the demon king of Alengka, falls in love with Laksamana at first sight, but is rejected by the latter. Further, on realizing that she is the sister of the demon king, Laksamana cuts off the tip of her nose.

3.2.2 Sarga 6–Sarga 11

Surpanaka recounts her humiliation to her brother Rawana, the king of Alengka, and tells him about the beauty of Princess Sita, wife to Prince Rama. She urges her brother to seduce Sita. On listening to her description of Sita's beauty, Rawana hatches a plan, kidnaps Sita through trickery, and imprisons her in the kingdom of Alengka. When Rama and Prince Laksamana learn of this, they set out to rescue Sita: along the way they befriend a monkey army that comes to their aid and head for the kingdom of Alengka. Anoman, a white monkey with special powers, manages to cross the sea to reach Alengka and tries to negotiate for the return of Princess Sita, but fails.

[4]Subsequently, Poerbatjaraka (2010) was published.
[5]For more detailed verse-by-verse summaries, see Zoetmulder (1974: 217–226) and Robson (2015: 5–13).

3.2.3 Sarga 12–Sarga 18

In Rangka, Rawana is criticized by his younger brothers Wibisana and Kumbhakarna for his outrageous act of kidnapping Princess Sita; they beseech him to return Princess Sita to Prince Rama immediately, but he does not listen to them. Meanwhile, Rama's army crosses the sea and finishes preparations for war with Alengka.

3.2.4 Sarga 19–Sarga 23

War breaks out between the two armies, and amid the pitched battle fought back and forth, the generals of Rawana's army eventually fall one by one to Rama's deadly arrows. Rawana's younger brother Kumbhakarna, who had opposed the war, also went to war on his brother's orders and was killed by Rama after a fierce battle.

3.2.5 Sarga 24–Sarga 26

After winning the battle with King Rawana, Prince Rama is reunited with Sita, and they return to Ayodiya, where they are welcomed by Rama's brother Bharata, who has been ruling the kingdom in Rama's absence. After ten years of staying as guests of Rama in Ayodiya, the friends who had helped him in the battle returned to their respective countries.

The *Kecak* is an easy-to-understand performance of the contents of the Kakawin Ramayana, mainly created for tourists' consumption. Created in the early 20th century, the show depicts a good-vs-evil tale in which Princess Sita is kidnapped by Rawana, and Prince Rama ultimately wins back his wife.[6] The concise contents, the various characters representing humans, demons, and animals that appear in the performance, and the ingenuous direction make it an enjoyable performance for tourists.

3.3 Balinese *Wayang* Performances of Ramayana

Balinese *wayang* performances mainly depict the Mahabharata, and it would be no overstatement to say that Ramayana is performed

[6]In Bali, *Kecak* is performed in many places for tourists, with performances depicting different episodes from the Kakawin Ramayana.

merely as a complementary performance.[7] In addition to these two epic poems, other performances particular to Bali are also performed, although less frequently.[8] However, this does not mean that such performances are not popular.

In Bali, *wayang* that perform the Ramayana are called *Wayang Ramayana*. The *gamelan* musical compositions that form the accompaniment to the performance of the Mahabharata are known as *gamelan gender wayang*, which comprise four metal keyboard instruments, while a lively composition called *gamelan gender wayang batel* is used to add various beat instruments.[9] To the Balinese people, the performance of Ramayana with a *gamelan* accompaniment but without any beat instrument is considered entirely lacking. However, as the number of performers increases, the cost of commissioning performance also increases; hence, such performances are rare (Hinzler 1981: 229–230).

Since microphones were not used on the stage in the past, the *dalang* who performed the Ramayana to the loud accompaniment of the *gamelan* required not only the general skills of a *dalang*, but also a voice strong and forceful enough not to be drowned by the loud sound of the *gamelan*. They also needed the technical ability to perform battle scenes featuring violent and dizzying movements of the puppets and mimicry skills to imitate the unique calls of a monkey. Today, with the use of microphones, force of voice is no longer essential, but a few *dalang* can still perform the Ramayana fluently.

The reason for the infrequency of performances is also due to the number of items performed. The Mahabharata being a long story is the source for countless derivative performances by *dalang* known as *kawi dalang*. In the case of Ramayana, however, Balinese *dalang* often perform a part of the original without relying on derivative performances, which however does not mean there are no creative performances, but that the number of secondary performances is much lesser than that of the Mahabharata, partly due to the brevity of the original Kakawin.

[7]A long epic poem consisting of a total of 18 volumes. It is the story of the feud between the Pandawa clan and the Korawa clan over territory.
[8]Spitzing (1981: 59–83) lists 14 types, including the Mahabharata and the Ramayana.
[9]Also commonly referred to as *Gamelan batel.*

3.4 The "Death of Kumbhakarna" as Seen in the Kakawin Ramayana

The Death of Kumbhakarna is one of the most beloved Balinese *wayang* programs (Saran and Khanna 2004: 188) frequently performed as a Ramayana performance. It is also often featured as a theme in *Wayang* Ramayana contests. In this section, I would like to specifically focus on how the death of Kumbhakarna is depicted in the Kakawin Ramayana. Note that the Death of Kumbhakarna is depicted in the second half of Kakawin Ramayana's 26 *sarga*, from Stanza 89 of *Sarga* 22 to Stanza 8 of Sarga 23.

3.4.1 Sarga 22, Stanzas 1–12

Stanza 1 begins with Rawana trembling with rage on hearing the news of the death of his uncle Prahasta in battle. He decides to send Kumbhakarna, who refuses to fight and goes back to sleep, next to the battle and orders his retainers to wake Kumbhakarna. The retainers then made a great amount of noise with musical instruments, and elephants and chariots were made to walk and run over Kumbhakarna. He was finally roused from his deep slumber and prepared himself for an audience with his brother Rawana, who was pale with shock at the death of his uncle.

3.4.2 Sarga 22, Stanzas 13–48

From the 13th stanza onward, the work is structured around a series of conversations between the elder brother Rawana and the younger one, Kumbhakarna, as the former bids the latter to go to war. Rawana narrates how he was violently attacked by the enemy while Kumbhakarna slept and how he lost many of his fellow warriors. Then, in the 16th stanza, Rawana orders Kumbhakarna to go fight on the battlefield. Kumbhakarna's sorrowful reply begins from Stanza 19. First, he describes how this catastrophe is the result of his brother's failure to listen to the advice. From Stanzas 25 to 40, Kumbhakarna recounts at length his brother's atrocities. On hearing the accusations levelled at him, Rawana is furious. However, in the end, Kumbhakarna goes to fight the battle.

3.4.3 Sarga 22, Stanzas 49–89

Stanzas 49 onwards describe the battle. Kumbhakarna begins his fight against the monkey army, and his tremendous strength brings unending misery to the monkeys. Kumbhakarna continues to fight, bathing, drinking, and covered in monkey blood. In Stanza 67, Prince Rama orders Sugriva, the monkey king, to go into the battle, and a great melee ensues.

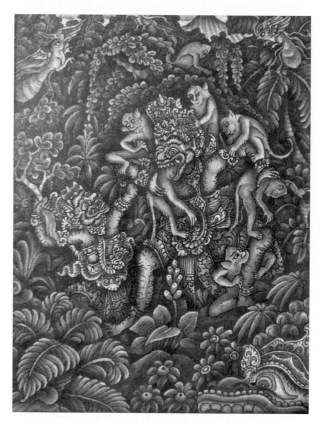

Figure 3.1 Kumbhakarna fighting monkeys.
(Traditional Balinese Painting, author unknown)

3.4.4 Sarga 23, Stanzas 1–8

In the first stanza, Wibisana, the youngest brother of Rawana, who had forsaken his elder brother and sought refuge in Rama's army,

could not bear to watch the monkeys' deaths and begs Rama and Laksamana to step in and slay Kumbhakarna, his elder brother. From the second stanza onwards, the narration is about how Kumbhakarna's armour is broken by Rama and Laksamana, his legs and hands are severed by arrows, and even his great, bellowing mouth is filled with arrows: the final scene of Kumbhakarna groaning, with blood gushing, but still rolling and fighting continues for seven stanzas, until at last Kumbhakarna falls to an arrow shot in the chest by Prince Rama and dies on the battlefield.

The description of the battle scene, which begins in the latter half of the 22nd stanza, is extremely graphic depicting the brutality of the battlefield in such detail that a reader cannot help but avert their gaze from the content. Why does this *wayang*'s depiction of Kumbhakarna's brutal death fascinate Balinese audiences?

3.5 The Composition of Scenes in the "Death of Kumbhakarna" as *Wayang* Performance

In this section, I describe the composition of scenes in the *wayang* performance of the "Death of Kumbhakarna," which is based on the contents of the Kakawin. Although every *dalang* considers the composition of scenes based on their thorough knowledge of the contents of the Kakawin, Sedana, in describing the *dalang* who performed in the All Bali *Wayang* Contest held in 1994 under the auspices of the Bali Culture Board on the theme of the "Death of Kumbhakarna," broadly divides the scene composition into the following two patterns (Sedana 1994: 23–25).

3.5.1 Pattern I

Scene 1: Rama and Laksamana appear with their attendants and move toward the battlefield with the monkey army.

Scene 2: Rawana and two of his attendants appear, and Rawana orders his attendants to wake Kumbhakarna.

Scene 3: Kumbhakarna meets Rawana, tries to persuade the latter, but does not succeed, and hence, goes to war.

Scene 4: Following the battle between Kumbhakarna and the monkeys, Rama and Laksamana, at the behest of Wibisana, use their might and valour to slay Kumbhakarna on the battlefield.

3.5.2 Pattern II

Scene 1: Kumbhakarna meets Rawana and after unsuccessfully trying to persuade his brother, he goes to the battlefield. Before he leaves, a send-off party, with women dancing and cheering, is held to celebrate the soldiers' march to the battlefield.

Scene 2: Rama and Laksamana, together with their attendants, move toward the battlefield with the monkey army.

Scene 3: Anoman informs Rama that Kumbhakarna is headed to the battlefield.

Scene 4: Following the battle between Kumbhakarna and the monkeys, Rama and Laksamana go into battle at the behest of Wibisana, and Kumbhakarna is slain on the battlefield.

Comparing these two patterns, the first difference can be observed in the opening scene. Pattern I begins from the camp of Rama's army while Pattern II begins from the camp of Rawana's army. Pattern II features the additional scene of a send-off party that cheers the soldiers marching to the battlefield, a feature not seen in Pattern I. Since each performance in the competition has a set time limit and must be completed within the given time, the *dalang* must select and perform only the core scenes of the performance. The scenes common to both these patterns are (a) the face-to-face scene between Rawana and Kumbhakarna, where the latter is trying to persuade the former, and (b) the scene featuring the fierce battle.

Battle scenes are indispensable to *wayang* performances, and a plot in which good ultimately triumphs is a standard structure. These are the minimum requirements for the composition of a *wayang* performance, but scenes of romance and tragedy are also essential because each scene has a *gamelan* tune for that particular scene, which contains not only theatrical content, but also musically rich expression. Attempts to faithfully reproduce the contents of the Kakawin cannot enliven the atmosphere as there are no women in the performance. Thus, it is believed that Pattern II was a deliberate

attempt to create a scene in which women make an appearance, but this is not mentioned in the Kakawin. However, regardless of the differences between the two patterns, Bali's *dalang* are as faithful to the Kakawin as possible in their performance of the "Death of Kumbhakarna."

3.6 Interpretation of the Performances of Balinese *Dalang* Based on Real Dialogues (1)

In this section, I discuss how the script of the "Death of Kumbhakarna" (Bandem 1981/1982, deBoer and Bandem 1992) was interpreted and performed by I Ketut Madura (1949–1979), a *dalang* from Sukawati, on August 10, 1977.

Madura is from Sukawati, a village in the Gianyar regency, which has produced many *dalang*; he was born into a *dalang* family and learned *dalang* not only from his village, but also from the National High School of Performing Arts (KOKAR) in Denpasar, where he won the first prize at the first *dalang* contest held in Bali in 1971.

Madura's performance was a faithful reproduction of the contents of the Kakawin. Based on Sedana's classification, Madura's performance script followed Pattern II. I compare that script and the contents of the Kakawin below.

Since all Ramayana characters use old Javanese in Balinese *wayang*, there are attendants who appear during the performance solely to provide translations in Balinese and supplementary explanation. The attendants on the good side (here, Rama's camp) are a father and son duo named Tualen and Merdah, respectively, while the attendants on the villain's side (here, Rawana's camp) are the brothers Delem and Sangut.[10]

Scene 1 of Madura's performance from *Sarga* 22, Stanza 13 begins with the face-to-face encounter between King Rawana and his brother Kumbhakarna, who has just been woken from his deep slumber. Delem translates and provides the supplementary

[10]Also called *penasar* or *pandasar*. Both are derived from the Balinese word "*dasar*," meaning "foundation" or "base." The attendants are characters unique to *wayang*; they do not appear in the Ramayana stories, but without them, Balinese theatre would not be possible, and they serve as the foundation for Balinese theatre. Although they appear in other Balinese plays, their names and personalities are different from those of the attendants in *wayang*.

explanation for Rawana's words, while Sangut does the same for Kumbhakarna. The first line begins with Kumbhakarna asking his brother why he has been summoned, but this scene is not found in the Kakawin. An exhausted Rawana quietly informs Kumbhakarna of their unfavourable position in the war and then orders him to set out to slay Rama. In the Kakawin, Kumbhakarna, whose advice to his brother goes unheeded, heads to the battlefield without saying a word, but in Madura's *wayang*, the following lines are added:

> I agree! I won't be insolent to you. No, I am always mindful of kingdom of Alengka. Who will be offered up for it? That is the reason for my existence. My blood came from my honored mother, and from my father, great King Werawana. I will be ready if I am defeated by the enemy. I feel that I am a sacrificial offering for my country Alengka. (deBoer and Bandem 1992: 169)

In these lines, he states that the reason for his going to war is not for the sake of his brother, but rather for his own death on the battlefield, so that his own blood might be sacrificed for Alengka. The *dalang*, having already alluded to Kumbhakarna's death at this point, replaces the reason for his death as "patriotism."

These words are supplemented by the words of the attendant Sangut, whose lines convey that Kumbhakarna would "repay my debt to Mother Earth" (in this case the Alengka nation), which has nurtured him and suggests that his death would be a sacrifice. A metaphor is used to express this saying that although the beautiful sandalwood flowers that bloom on the earth will eventually wither and fall to the ground, they will still carry a lingering fragrance (deBoer and Bandem 1992: 169). Moreover, by restating the old Javanese word for "blood" spoken in Kumbhakarna's lines as "beautiful fragrant flowers" in Balinese by Sangut, the fated Kumbhakarna's death is "beautified" in its subsequent depictions.

Madura, whose performance is structured on the lines of Pattern II, adds a send-off scene before Kumbhakarna marches to the battlefield, which is not found in the Kakawin. The only female character in this performance is a Balinese-speaking lady-in-waiting (*condong*), who speaks when her companions pray for Kumbhakarna's victory and make offerings as he goes to war (deBoer and Bamdem 1992: 175–176). In this scene, sweet tunes befitting

a romantic scene are played, and the lady-in-waiting performs a beautiful dance for Kumbhakarna before he goes to battle. This kind of direction aims for a theatrical effect that causes a beautiful flower to bloom amidst the story of a bloody battle.

In Madura's performance, following Kumbhakarna's departure, the scene shifts to Rama's camp. The father and son attendants, Tualen and Merdah, appear first, explaining the state of the war in a conversation in Balinese and suggest that Kumbhakarna will command the next attack. Then, the monkeys of Rama's army go out to battle.

In the battle scene, the battle between Kumbhakarna and the small monkeys is developed first, followed by single combat with the Sugriva, the king of the monkeys. Sugriva is mortally wounded, but Kumbhakarna is so enraged at having his ear bitten off and nose bitten that he kills and eats the monkeys one by one in a ferocious scene. During this attack on the monkeys, Kumbhakarna's brother Wibisana says to Rama and Laksamana:

> Take heed! The monkeys are being destroyed by my brother. He has already defeated the god Indra and Wesrawana as well. If you don't go to the battlefield, all the monkeys will be killed by Kumbhakarna, who is victorious in hell, on earth, and in heaven. (deBoer and Bandem 1992: 194)

These lines correspond to Stanza 1 of *Sarga* 23. Although not in the lines above, at the end of the first stanza in the Kakawin, Wibisana justifies his brother's murder by describing Rama's actions as "warning him out of love for the world" (Robson 2015: 605). The two princes, Rama and Laksamana, who had avoided fighting Kumbhakarna on account of Wibisana, heard these words, which could be construed as permission from Wibisana, and immediately charged into the battle.

From this point, according to the Kakawin, Kumbhakarna's legs and arms are cut off in turn, and his lips are sealed with arrows so that he cannot open his mouth. Still, Kumbhakarna rolls on, crushing the monkeys and closing in on Rama and Laksamana; here, Madura adds a line to Wibisana that is not found in the Kakawin.

> Cremate Lord Kunbakarna, that he may return to heaven. (deBoer and Bandem 1992: 196).

This line can be the part that implies why Rama and Laksamana did not fell Kumbhakarna with a single blow. The strategy by which they cut off his limbs one by one is extremely brutal, but also an expression of Rama and Laksamana's anguish at being unable to slay Kumbhakarna with a single blow in front of Wibisana, the *dalang*'s interpretation being that the action may have been prompted by a faint hope that "if they wound him this gravely, then Kumbhakarna might retreat and they might not have to take his life." In other words, Wibisana's last line is a strong message to Rama and Laksamana; "Don't spare my feelings." Another viewpoint can be as follows: this line spoken by the younger brother just before his elder brother is killed in front of his eyes could also be seen as Wibisana telling himself that his brother's death is justified, that is, it is a "righteous death" that will see him welcomed not in hell but in heaven, as summed up in the final line "my brother will return to heaven." After being slain by Rama's final arrow, the performance ends with these words from his attendant Tualen:

> He was brave in defense of Alengka, and he will find heaven. He, Lord Rama, avatar of God Wisnu, has exorcized the ogre qualities from your nature, for you succeed in becoming a true and virtuous exponent of the Law. (deBoer and Bandem 1992: 196).

As per this line, Rama's action is considered to have purified his "demonic nature" and is thus justified. In other words, Kumbhakarna's death is a "righteous death," and Rama's act is positioned as a "purification," leading to a glorious end. However, the actual contents of *Sarga* 23, Stanza 8 of the Kakawin state that blood flows from the eyes, mouth, and nose of Kumbhakarna, an arrow pierces through his chest, and that when he died finally with a great sound, thousands of monkeys that were trapped beneath him perished. However, this part of the story is never told. On the contrary, in the 9th stanza, which immediately follows Kumbhakarna's death, it is written that the gods in the heavens rejoiced and that the goddesses were greatly inspired and moved as though they were dancing. Could such gods really have welcomed Kumbhakarna into the heavens? Yet, this interpretation is not unique in Bali. The majority of the *dalang* perform based on this interpretation, and the audience goes home satisfied with this conclusion.

The death of Kumbhakarna is a reminder of the "fight to the end" that took place between the Balinese royal family and the Dutch army at the Badung royal palace on 20 September 1906, known as the *Puputan Badung*. It is a historical fact that the royal family of the Badung dynasty, besieged by the Dutch, chose "a dignified death" to protect their honor and faced their enemy in ceremonial dress (Covarrubias, 1972 [1937]: 34). Many Balinese people pay homage to the Badung royal family who "fought to the end" before the Dutch army, and to this day, ceremonies are held on the anniversary of the incident. Kumbhakarna''s death is a projection of the royal family's death in the puputan for the people of modern Bali, or perhaps the members of the royal family who lost their lives in this battle projected the fated Kumbhakarna onto themselves before their own deaths. In other words, to the Balinese, Kumbhakarna is not a "villain," but a hero who died a "dignified death." However, Prince Rama also had to remain a "hero" to the Balinese people. Tualen's final line was very much the key line that justified Prince Rama's position as well, which, if otherwise would make him appear a "villain" who slaughtered Kumbhakarna.

3.7 Interpretation of the Performances of Balinese *Dalang* Based on Real Dialogues (2)

In this section, I discuss my own interpretation of this performance as a Japanese *dalang* based on my experience of having performed it many times in Japan. My performance was based a script I learned from I Nyoman Sumandhi (1944~), a *dalang* from the village of Tunjuk in the Tabanan regency, in 1993.

The scene composition I studied corresponds to Pattern I as classified by Sedana. However, I add the send-off scene in which women appear from Pattern II. Scene 1 begins with a face-to-face meeting of Rama and Laksamana and their attendants, Tualen and Merdah, which is created by the *dalang* and is not found in the Kakawin. Here, they talk about the state of the battle up to the previous day, and Prince Rama orders the monkey army into battle because of the possibility that Kumbhakarna would lead the next attack.

Scene 2 is where Rawana orders his retainers to wake Kumbhakarna. In the Kakawin, it is written that they use musical instruments to create a great noise and walked elephants and rode chariots over the sleeping Kumbhakarna. Such scenes create a comical atmosphere that is juxtaposed against the brutal scenes that follow. Since it is not written in the Kakawin how they finally woke Kumbhakarna, the *dalang* is free to create it.

Scenes 3 follows the exact same structure as Madura's performance. However, the interpretation of the performance is different. Japanese cultural background and historical experience form a large part of this background. There is no denying that there was a time in Japan when people considered it a virtue to give up their lives for their lord. In *Hagakure*,[11] a book written during the mid-Edo period, there is a description of the mindset of those who serve their lord, wherein it says, "*Bushidō to iu wa, shinu koto to mitsuke tari* [The way of the warrior (bushido) is to be found in dying]" (Yamamoto 2010: 42). Although Hagakure covers a wide range of topics, including the duties of a samurai, daily life, culture, etc., this "view of life and death" has been the focus of much attention, and since the Meiji era, laying down one's life in battle for one's country (for the Emperor) has been a symbol of loyalty and patriotism. Dying rather than surrendering as well as dying as a kamikaze suicide airman was considered a "beautiful death," which is an outcome of giving up one's life for one's country.

Taken in that context, Kumbhakarna's death is also a "beautiful death." The original notion of a "beautiful death" can be traced to classical Greek literature. The poet Tyrtaeus, writing in the seventh century B.C., described the deaths of those who fought bravely for their homeland as "beautiful deaths" (Gerber 1999: 51).[12] However, we must not forget that in Japan's case, following its defeat in World War II and reflecting on its history, there are both pros and cons to depicting death as a thing of beauty. Given this cultural and historical background, I add the following lines to the attendant Sangut as Kumbhakarna is wounded by Rama and Laksamana:

[11]Around 1716, Yamamoto Tsunetomo dictated the principles of a samurai and recorded them in writing. There are several English translations of the book.

[12]It is fine thing for a brave man to die when he was fallen among the front ranks while fighting for his homeland (Gerber 1999: 51.

Why are you fighting so hard? Just what are you fighting for? For whom are you fighting? Were you not opposed to this fight? There is no point in dying here. You don't have to hasten your death. Come on, surrender to Rama's army.

In response to these questions, Kumbhakarna simply stares at Sangut, and, without any response, continues to fight. This silent act is also an expression of his own conflict about the fight. Finally, after Kumbhakarna's death by Rama's arrow, Tualen ends the performance by speaking quietly to his son Merdah, who had praised Kumbhakarna's death, cautioning him against such a thing.

Do you really think so? Do you know how many monkeys' lives were claimed by Kumbhakarna? How many thousands lie crushed beneath his corpse? Why should that death be beautiful or dignified? Why do we continue this foolish strife? Just when will the world be rid of such strife? For the answer to that, son, you might as well softly ask the wind.

These lines bear the message that "war is a vain and foolish thing that brings nothing." The words of the old attendant Tualen allude not only to the great wars between relatives as told in the Mahabharata, a story that follows the Ramayana, but also to the situation in today's world with its constant war and conflict as seen in the lyrics of Bob Dylan's "Blowin' in the Wind" in the end.

3.8 Conclusion

In this chapter, I have taken up the "Death of Kumbhakarna," a famous performance of a part of the Ramayana story in Balinese *wayang*. I examined how Balinese *dalang* have interpreted and scripted the story based on the original contents in the Kakawin, the composition of the program and the scripts actually performed based on Balinese *dalang*, and my own script as a Japanese *dalang*.

Most importantly, the *dalang*, with their exhaustive knowledge of the Kakawin, do not simply follow the plot, but weave in their own interpretations and messages into the script not found in the original Kakawin based on their own understanding of the historical and cultural background of place where the show is performed. Every Balinese audience knows that Kumbhakarna will be killed by Prince

Rama in the end, and what the audience wants from the performance is not the death, but the process of dying, and touching of their heart strings through the story of Kumbhakarna, who was forced to fight despite his suffering, and Rama, who was forced to slay him. Indeed, the *dalang* express their own interpretation through the words of the characters.

References

Bandem, I. M. (1981/1982). *Wimba Wayang Kulit Ramayana (Ketut Madra)* (Proyek Penggalian/Penbinaan Seni Budaya Klasik/Traditional dan Baru, Denpasar).

Covarrubias, M. (1972 [1937]). *Island of Bali* (Oxford University Press, Jakarta).

deBoer, F. E. and Bandem, I. M. (ed. & trans.). (1992). 'The Death of Kumbhakarna' of I Ketut Madra: A Balinese Wayang Ramayana Play, *Asian Theatre J.,* 9(2), pp. 141–200.

Dibia, I. W. and Ballinger, R. (2004). *Balinese Dance, Drama and Music* (Periplus, Singapore).

Dinas Pendidikan Dasar Dati I (1987). *Kekawin Ramayana I, II* [Kekawin Text in Old Javanese and Indonesia] (Dinas Pendidikan Dasar Dati I, Denpasar).

Fischer, J. and Cooper, T. (1998). *The Folk Art of Bali: The Narrative Tradition* (Oxford University Press, Kuala Lumpur).

Gerber, D. E. (ed.) (1999). *Greek Elegiac Poetry: From the Seventh to the Fifth Centuries BC* (Harvard University Press, Cambridge and London).

Goodlander, J. (2016). *Woman in the Shadows: Gender, Puppets, and the Power of Tradition in Bali* (Ohio University Press, Athens). Hinzler, H. I. R. (1981). *Bima Swarga in Balinese Wayang* (Martinus Nijhoff, The Hague).

Hobart, A. (1987). *Dancing ShShadows of Bali* (KPI, London and New York).

Phalgunadi, I. G. P. (1999). *Indonesian Ramayana, the Uttarakanda* (Sundeep Prakashan, New Delhi).

Poerbatjaraka (2010). *Ramayana Dawah-Kuna, Teks dan Terjumahan* (Perpustakaan Nasilnal, [Jakarta]), 2 vols.

Robson, S. (2015). *Old Javanese Rāmāyaṇa* (Research Institute for Languages and Cultures of Asia and Africa, Tokyo University of Foreign Studies, Tokyo).

Rubinstein, R. (1992). Balinese Music in Context: Sixty-Fifth Birthday Tribute to Hans Oesch, ed., Schaareman, D., Pepaosan: Challenge and Change (Amadeus, Winterthur) pp. 85–113.

Saran, M. and Khanna, V. C. (2004). *The Ramayana in Indonesia* (Ravi Dayal, Delhi).

Sedana, I. N. (1994). *Kumbhakarna Lina: Sebuah model Pengolahan Lakon* (Sekolah Tinggi Seni Indonesia, Denpasar).

Santoso, S. (1980). *Ramayana Kakawin vol. 1–3* (Institute of Southeast Asian Studies and International Academy of Indian Culture, Singapore and New Delhi).

Spitzing, G. (1981). *Das indonesische Schattenspiel: Bali-Java- Lombok* (Dumont, Köln).

Umeda, H. (2020). *Bali to no Kagee Ningyo Shibai Wayang* [In Japanese: *Balinese Shadow Theatre, Wayang*] (Mekong, Tokyo).

Widia, I. G. M. ([1977]). *Ramayana* (Guna Agung, Denpasar).

Widia, I. G. M. ([1979]). *Kakawin Ramayana I-IV* (Sumber Mas Bali, [Denpasar]).

Yamamoto, T. (2010). *Hagakure: The Secret Wisdom of the Samurai*, trans. Bennett, A. (Tuttle Publishing, Tokyo, Vermont, and Singapore).

Zoetmulder, P. J. (1974). *Kalangwan* (Martinus Nijhoff, The Hague).

Zurbuchen, M. S. (1987). *The Language of Balinese Shadow Theater* (Princeton University Press, Princeton, NJ).

Chapter 4

Ramayana Theater in Cambodia

Sam-Ang Sam

Office of the Chancellor, Paññāsāstra University of Cambodia,
No. 70 Chea Sophara (Street 598), Sangkat Kilometre 6,
Khan Russei Keo, Phnom Penh, Cambodia
samangsam@puc.edu.kh

The list of names of the main characters in Cambodia. Sanskrit names are mentioned in parentheses ():

Preah Ream (Rama)

Reap (Ravana)

Sita

Hanuman

Preah Leak (Lakshmana)

Kumbhakar (Kumbhakarna)

Intrachitt (Indrajit)

Sukrip (Sugriva)

Ramayana Theater in Contemporary Southeast Asia
Edited by Madoka Fukuoka
Copyright © 2023 Jenny Stanford Publishing Pte. Ltd.
ISBN 978-981-4968-09-6 (Hardcover), 978-1-003-29095-7 (eBook)
www.jennystanford.com

4.1 Introduction

Ramayana is a 2000-year-old Indian epic by the poet Valmiki, a 48,000-line epic odyssey (or 24,000 Sanskrit verses) (Tranet 1999: 1; Narayan 1972: xi; Gaer 1954: x; Menen 1954: 9),[1] with an essentially moral tale, describing the adventures of Preah Ream or Prince Rama, an incarnation of Lord Vishnu. This incredibly lengthy epic has been perceived to be not a fact but rather an idea, not scientific but philosophical and moralistic. It contains all in its plots: war, adventure, romance, fantasy, religion, and philosophy both in heaven and on Earth. Jonah Blank wrote: "Imagine a story that is the Odyssey, Aesop's fables, Romeo and Juliet, the Bible, and Star Wars all at the same time" (1992: ix). However, the central subject matter of the Khmer Reamker evolves around the wars and conflicts between Preah Ream (Rama) (King of Ayodhya)[2] and Reap (Ravana) (King of the Island of Lanka) who had abducted Sita (Rama's wife) and took her to Lanka. Preah Ream was joined by his brother Prince Preah Leak (Lakshmana) and Hanuman (White Monkey), head of the monkey chieftains with their troops of monkeys. The warring armies of Preah Ream and Reap are also known as the Pavilion Army and the Lanka Army, respectively.

4.2 Historical Dimension: Indian Ramayana

In India, Ramayana and Mahabharata are considered the two most treasured and sacred pieces of literature of Hindus, while the former is more popular than the latter. Ramayana or a lengthy story of adventures of Rama places an emphasis on the Hindu and Brahman faiths, stressing the importance of rituals, incarnations, and magical powers of deities. Ramayana was popular and diffused among

[1]On this account, Natthapatra Chandavij and Promporn Pramualratana said that there were 25,000 verses (1998: 16).

[2]"Ayuthyea" (Ayodhya) means "country of no battle; city of no war; name of Rama's city in the Reamker story" (Chuon 1967: 1675). In the book *Reamker* (1964), Aiyuthyea is used in lieu of Ayuthyea. In the Indian Ramayana, Ayodhya, the city of the Kingdom of Kosala, means the "Invisible City" (Gaer, 1954: 3). It was changed to the "City of Victory" by Rama after he defeated Ravana and the Lanka Army and his return to Ayuthyea (ibid.: 177).

localities in India as an oral tradition some 2500 years ago. The Sanskrit version was believed to have been written around 750 BE. It was then adapted by Tulsi Das (1532–1623) and followed by Valmiki who transcribed it as an epic poem in a verse form (Chandavij and Pramualratana 1998: 16; Gaer 1954: ix).[3] It was believed that while reciting the verses, the narrator had the power to cure the sick, calm those in sorrow, and guide the dying to heaven (ibid.).

The classic texts reflect not only the Hindu religious practices, but also Indian geography and politics. They present plots about the good and evil, the fair-skinned Aryans of the North, and dark-skinned Tamils of the South (in Lanka), or the Aryans who migrated to India some 4000 years ago, portrayed as deities and humans versus the Tamils being the demons.

The story of Rama usually begins with his birth and ends with his coronation, concluding after Rama's completion of his 14-year banishment and the defeat of the demon race.

4.3 Ramayana (Reamker) Theater in Cambodia

The Indianization of Southeast Asia has been felt throughout the region. However, it is not one of military or colonization, but cultural influence. Khmer Reamker combines two words: *Ream* (Rama) meaning "Rama" and *Ker (Kerti)* meaning "Fame." Thus, *Ream + Ker (Ramakerti)* means "Fame of Rama" (Chuon 1967: 1046). Various sources give meanings to the Ramayana as "In Honor of Rama" (King Rama I 2002 [1807]); "Glory of Rama" (Tranet 1999; Boisselier 1989; Martini 1978); "Way of Rama" (Chandavij and Pramualratana 1998); "Adventures of Rama" (Beach 1983; Giteau 1965; Gaer 1954; Menen 1954); and "Fame of Rama" (Chuon 1967; Bernard-Thierry 1955).

Early scholars date Ramayana back to as far as 1500 BC. But recent studies have brought it down to about the 4th century BC, according to R. K. Narayan (1972: xi). Joseph Gaer wrote that Ramayana had existed for ages before it was gathered and written down in Sanskrit in a unified epic by the poet Valmiki in the 5th century BC (1954: ix). Jonah Blank said that Valmiki wrote the Ramayana story in the 3rd century BC (1992: ix). Aubrey Menen claimed that the original

[3]Valmiki was regarded as a hermit and a poet (Menen 1954: 85).

Ramayana was written 2500 years ago (1954: 3, 20). The Khmer book on Reamker indicated that Valmiki wrote it in Sanskrit in 750 BE (Buddhist Era) or 207 AD (*Reamker* (1964) 1: a). Michel Tranet concurred with the preceding source and wrote that Ramayana existed in the 3rd century BC but was written in Sanskrit by Valmiki in 750 BE (207 AD) (1999: 1). We can see that there have been discrepancies on the exact dates, when the Ramayana story was in fact written. But we can be sure that it is definitely a very old story.

Reamker, the Khmer version of Ramayana, has been said to have been a vast body of poem. Unfortunately, only a small part of it remains today. The earliest edition in Khmer was published by the Royal Library in Phnom Penh in 1937, comprising 16 booklets numbering 1–10 and 75–80. These booklets correspond with two manuscripts on leaves of latanier in the collection of HRH Prince Vaddhachhayavung. Therefore, about four-fifths of this invaluable work has been lost. We can surmise that Reamker is the grandest Khmer literary work, in language, style, and artistic imagination. François Martini speculated that the author must have been highly educated and a great poet that no other writer, who followed, has come close to this writer's facility and breath (1978: xv). This masterwork of vast battle scenes presents an extraordinary rich vocabulary and an extremely supple language. Its imagination is lively and complete in the details.

The Khmer Reamker is not in any way a mere translation from the original Sanskrit poems. It incorporates rich and detailed phenomena from the Khmer local folklore. Comparing the two versions—Sanskrit and Khmer—Martini even ventured so far to claim that the Khmer Reamker was an autonomous creation altogether and its author was inspired by other traditions other than that of Valmiki (1978: xvi). Indeed, the Khmer writer had used the Sanskrit masterwork as the model in composition and style. He continued to say that the Khmer version was closer to the Indonesian version than the Indian (ibid.).

However, there are differences and discrepancies in the different versions, for instance, in the birth of Sita. In the Indian version, Sita was born from the "furrow" while Janaka was plowing, after which Sita took her name. In the Indonesian version, Sita, the daughter of Ravana, was set afloat on a raft and was rescued by Maharikshikala. In the Thai version, Sita was parented by Totsakan (Ravana) and

Monto (Mando Giri) being the incarnation of Vishnu's consort. After her birth, Piphek (Bibheka), Ravana's brother and astrologer, predicted that Sita will destroy the demon race. Thus, Ravana placed Sita in a ceramic jar and set it adrift. Sita was later found and raised by Janaka, King of Mithila (Chandavij and Pramualratana 1998: 20). In the Khmer version, Sita was found during the royal plowing by Chonuok (Janaka) in the furrow, after which she took her name "Sita."

There are, in fact, two versions of the Ramayana found in Southeast Asia: the Sanskrit and Pali versions. Concerning the birth of Sita, the Jataka story entitled Sonandaraja Jataka tells of a miraculous little girl received by a hermit in a lotus, who was destined to be the wife of a Bodhisatva prince. As a Buddhist country, in Khmer interpretation, Preah Ream or Prince Rama is often portrayed as a Bodhisatva himself. Preah Ream is the seventh incarnation of Preah Neareay (Narayana), an *Avatar* (Avatara) of Vishnu.[4]

4.3.1 Content and Representation of Culture

Preah Ream or Prince Rama is often portrayed as a Bodhisatva himself, particularly from the view point of a moral character with supreme power in talent, renunciation, intelligence, energy, long-suffering, veracity, determination, love of justice, and equanimity, which the Bodhisatva must accomplish to attain the Buddha state.

The Khmer Reamker is an enormous moral tale epitomizing the wealth of Khmer literature and arts, equally reflecting the Khmer thinking and temperament as well as Khmer social justice; Preah Ream carrying true and just actions. Despite the miracles and marvels of the story, the Khmer Reamker is brought down to Earth to be relevant to and vibrant for the life reality of the Khmer people. It all can be felt through the plots and masterful writing in the expressions of fierce battles between the Pavilion and Lanka Armies, the rage and vivacious combats between the monkeys and demons,

[4]The 10 incarnations of Lord Vishnu are (1) Matsya, or fish with a human torso; (2) Kurma, or tortoise with a human torso; (3) Varaha, or man with the head of a boar; (4) Narasimha, or man-lion; (5) Vamana, or human dwarf; (6) Parasurama, or Rama with the axe, human form; (7) Rama, human form, hero of Ramayana; (8) Balarama and Krishna, the two brothers, human form; (9) The Buddha, human form; and (10) Kalkin, knight riding a horse, or horse (Boisselier 1989: 115).

as well as the expression of love between Preah Ream and Sita, Sita's faithfulness toward Preah Ream, the warm companionship of Preah Leak while accompanying his beloved elder brother Preah Ream in his exile, and the con of Kaikesey.

Reamker explores and presents every basic human emotion— love and hatred, joy and anger—as well as every aspect of love for nature. Khmer artists and commoners alike have kept Reamker alive in their hearts and imagination for centuries. It is not merely a story; it is a reflection of their lives. They draw examples, models, and practices from it. It is a story so beautiful, so lively, so relevant, and so vibrant that as we read it, we are completely taken by it emotionally, as if it were the story of our own that is being told.

The Khmer Reamker, indeed, has its deep roots in the Indian tradition, but the Khmer have Khmerized the Ramayana to suit their taste and temperament, responding to their national identity and character. Reamker is a moral tale and social justice reflecting the Buddhist laws of *karma* embedded true and just actions, love and loyalty, particularly justified by the protagonist Preah Ream, whose saintly acts include, for instance, the funerals of Peali and Reap. Being his enemies, Preah Ream stressed upon giving the deceased warriors (Peali and Reap) their proper royal funeral (Gaer 1954: 165–166). Preah Ream and Sita were destined to unite again on Earth, being the incarnations of Lord Vishnu and his consort Goddess Lakshmi.

The plots change their climax throughout the story. The Wedding Section, representing the earthly union of human incarnations of Preah Ream and Sita, is perhaps the most enchanting and fascinating episode of the story. The Peali Section is, perhaps, the most troublesome. In this part of the story, several questions are raised about Preah Ream's godly attribute of being just and humane. Following Sukrip's summons, Preah Ream killed Peali whom he never knew, and who was not his enemy; it was not even a fair face-to-face fight. Earlier, Preah Ream refused to slay Tarakakk, at the request of Eysey Visvamitt, for she was a woman. And that would have made him wrong to commit such an act against a woman.

Reamker is a Khmer classical masterpiece in its sense of form, content, and aesthetics. It exerts power, impact, and weight on the Khmer's life and society, serving as role model, good example, and morale, particularly, through the heroism of Rama, Sita, and Hanuman.

4.3.1.1 Preah Ream or Prince Rama

In Reamker, Preah Ream is brought down to Earth in the human form, instead of being god in heaven. The Khmer protagonist, Preah Ream, presents, feels, and acts as a human being. He often presented himself to be happy, sad, and tricky, at times, being a normal human. He wept when he saw the disguised corpse of Sita (Banhakay's disguise) floating in front of him. He tricked Sita, his beloved wife, into the Test of Fire to prove her faithfulness to him. He shot Peali (Green Monkey) from behind without a fair fight; Peali was not even his enemy. He did it at the request of Sukrip (Sugriva, the Red Monkey) to revenge his older brother Peali who scolded and slapped him earlier.

Reamker is a strong and powerful moral tale, serving as a role model, leadership in action, morality, and ideal. It is used as a basis for Cambodia's national education included in the curricula while serving as one of the main subjects for study, analysis, example, and contemplation.

Reamker has been adopted and has become a Khmer identity. It is representative reflecting the Khmer common interest, national identity, character, and pride. Overtime, it legitimizes and sanctions the formality and appropriateness and, thus, reaffirms the traditions and customs exemplified by the wide use of the theme and content of Reamker in many artforms and the Khmer life itself.

4.3.2 Culture of the Diaspora

4.3.2.1 The Khmer Rouge (1975–79)

The Khmer Rouge, meaning "Red Khmer," took over Cambodia on April 17, 1975, driving the city population to the countryside soon thereafter. They were Communist extreme left of Khmer peasant class, who were against the city dwellers. Under their iron grip of 3 years, 8 months, and 20 days, the shortest regime in Cambodia, they exposed their harsh revenge against city dwellers, intellectual class (they called "capitalist") imposing hard labors, punishments, tortures, and killings. They confiscated property, turning the capital city of Phnom Penh into a ghost town. It has been estimated that more than 2 million lives were lost in their bloody hands, including some 80–90% of artists, while systematically attempting to uproot

and demolish the Khmer culture. On January 7, 1979, the Khmer Rouge were deposed by the People's Republic of Kampuchea (PRK), installing Heng Samrin as Head of State.

4.3.2.2 Refugee Movement

Unable to endure the extreme hardship and torture, beginning around 1976, the world witnessed for the first time the refugee exodus in Khmer recent history to refugee camps along the Cambodian–Thai borders.

Khmer Refugees in the United States
There are now close to half a million Khmer refugees/immigrants in the United States with the largest concentrations in Long Beach (California) and Lowell (Massachusetts). They include the first wave, shortly before and after 1975, of diplomats, staffs, students, and other professionals and the second wave of the 1980s of general Khmer refugees who escaped the killing fields.

4.3.2.3 Challenges of the New Life on the New Land

Khmer refugees/immigrants on their new resettled land they call home face struggles and challenges in their new lives trying to cope with their physical and emotional states. They are challenged by the ideas of "Melting Pot" or "Salad Bowl," replacement of their traditional values and customs, complex of inferiority, and identity crisis, which affect and influence on the formation of identity. Within their own families and communities, the young Khmer individuals may also have generational gap and misunderstanding and sense of loss and confusion, leading some to resort to mental and emotional stress, and others to gang and violence.

4.3.3 Transmission

New and, perhaps, more relevant situations and demands have caused us to address "transmission" differently. While some still adhere to the traditional way of transmitting knowledge, the so-called "oral tradition," others adopt a new approach taking advantage of available printed, audio, and visual materials. As the older generation of artist dies, traditional performing arts subside because the young lack understanding and appreciation of their

traditional culture and thus do not see the need to carry on their precious legacy. Even the notion of what should be continued has also been challenged.

I address transmission here in two separate situations: outside and inside Cambodia. Outside Cambodia, in the United States, Khmer communities form community-based organizations and associations to help the new-coming refugees cope with their lives on the new resettling land. Khmer community leaders first create assistant, educational and cultural programs for their communities across America where there are clusters of Khmer refugee resettlements. They offer weekend and after-school extracurricular culture-related classes and activities as there are no formal schooling in Khmer arts in the United States. They offer language, music, dance, and theater classes, as well as longer summer programs and residencies with an attempt to turn "Gang to Gong" as we referred to it. Residencies were developed in partnership with institutions and universities, namely, Jacob's Pillow, George Mason University, UCLA, Connecticut College, and University of Washington. Furthermore, there have also been exchanges between artists in Cambodia and the United States. Certain local communities create mentorship–apprenticeship programs to pass on knowledge and tradition from the old masters to new students.

The second generation of Khmer–Americans is the culture and tradition carriers. They are our proud young individuals, with proper guidance from their parents, eager to learn the culture and tradition of their ancestors through the enculturation process. They learn language, poetry, music, singing, dance, and theater.

Inside Cambodia, what and how tradition is transmitted, I am looking at the "form" and "process" of transmission in direct response to the need, change of context, and relevancy of the constituents who are involved in the process. By form, I mean dance (court and folk), music, singing, shadow play, masked play, and so on.

The traditional approach to transmission is conducted in a non-formal environment, in which knowledge flows from master to pupil, or within a family situation, from father to son, mother to daughter. The father or mother can give his/her son/daughter the best knowledge, the keys to fast learning, and the secrets of the trade. It internalizes the knowledge; it makes students memorize the piece and finally perform a subjective interpretation. The

rendition of Khmer music, for instance, is perceived to be sensible, emotional, subjective, an interwoven fabric of Khmer music. This approach is slow at the start. But in the end, it pays off. It equips performing artists with better ways, more comfort, and more confidence in performance. It is a long-lasting process. More often than not, this process produces more committed and career musicians than otherwise. Oral tradition is time consuming, but ideal for performance and continuity. The disadvantage, however, is the shrinkage of repertoire provided artists do not learn all existing pieces in a timely manner.

Thus far, there has also been a new approach to transmission beyond the oral tradition. It occurs in a more formal educational environment, namely, at the Royal University of Fine Arts in Phnom Penh. This new approach relies on printed, audio, and visual materials. The approach takes less amount of time to learn. In a music situation, it gives musicians something tangible to hold on to, i.e., the scores. It is good for documentation and point of reference should musicians need to go back to check on, say, a forgotten passage. The drawback, however, is that musicians do not memorize pieces and depend on the scores all the time. Reading from scores does not free musicians' mind and attention from the printed pages, thus limit the ability of embellishment on the piece during rendition, an inherent characteristic of Khmer music. Some even go further to say that while oral tradition is fluid and subjective, the use of scores and notations are fragmented and objective. Scores and notations reduce music to formula.

Despite social, economic, and cultural adversity, Khmer performing artists strive to preserve their tradition and maintain their identity and pride. They hold onto it, desiring to impart its values to the younger generation and working fervently to do so.

4.3.4 Designation of Tangible Cultural Heritage (TCH) and Intangible Cultural Heritage (ICH)

Cambodia is rich in cultural heritage, having more than 1000 ancient stone monuments scattered across the country, more than 4000 ancient hills and ponds, and 27 performing art forms. Both tangible and intangible heritages, namely, Angkor Vatt temple (1992), Khmer court dance (2003), Khmer shadow play (2005), and Khmer masked

play (2018), which prominently use the theme and draw the essence on Reamker were designated as UNESCO World Heritages.

4.3.5 Contemporary Cambodia in the Globalized Era

Under Globalization, I shall allude to the process and effects of globalization upon the young Khmer individuals and the efforts to preserve their identity. I shall specifically look at the change in context, the consequences of globalization, the homogenization of culture, the replacement of the traditional values and customs, the effects and influences on the formation of identity, and the roles of education and cultural programs, which are created and implemented to help these young individuals and community.

Our challenges are phenomena, including change in context, living a new life, peer pressure/acceptance, freedom, and liberty.

We have invested in the future and made our utmost efforts in the preservation and maintenance of our priceless cultural heritage and identity. Culture and the arts help shape and form our positive mentality and attitude to be peaceful, respected, and responsible people. We intend to leave a better world for the next generations with a meaningful, colorful, and vibrant life.

In the trend of globalization, time often equates with money. The global societies gradually move away from a religious to secular and from a spiritual to materialistic world. Participating in and adapting ourselves to the global trend are both idealistic and realistic, and are, not only inevitable, but necessary. However, we can live a new life while preserving an old tradition. We can be an active player in the globalization process, while maintaining our identity and pride. It is the Khmer interest to be able to remain Khmer while living, not in the past, but the present in time and space, with both the physical and spiritual well-beings.

In Cambodia, there is a slogan: "Culture is the Soul of a Nation." Indeed, Khmer culture is the soul of the Khmer people. Consequently, we have every reason to preserve and maintain our culture.

4.3.6 Popular Culture

I start this section by way of some background on the introduction of Western music and the birth and development of popular culture

in Cambodia. Western music, for instance, first came to Cambodia during the 16th century with the Portuguese spice trade in Asia. However, recorded accounts only point to a 20th-century European presence and the introduction of Western classical music, including chamber music and symphonic works. By the 1950s, with the establishment of *l'Ecole Nationale de Musique* (National School of Music), Khmer musicians were learning Western classical music, its harmonies, and musical notations.

Western popular music and dances were introduced to Khmers by the Filipinos and the French. In the early 1900s, the Khmer court in Phnom Penh received the gift of a large band in residence from the Philippines. Filipino musicians taught marching music to Khmer royal fanfare, participated in court ensembles, and performed in jazz bands at night clubs. The musicians introduced Latin rhythms—cha-cha, bolero, tango, bossa nova, and rumba—as well as the waltz, fox trot, madison, twist, and other slow dances into Khmer dance, forming big bands that played at ballroom dances. This music came to be called *phleng Manil* or "Manila music."

Western music was also disseminated by French high school teachers, and in some military academies, high-ranking officers received formal training in European-derived dances. The madison, for instance, was in vogue by the 1950s, and the twist was introduced by a Khmer popular entertainer Chum Kem upon his return from France in the early 1960s.

Popular dance is ubiquitous in Cambodia, involving people of all ages and genders. Included in social events, it is accompanied by a modern popular band made up of electric guitars, electric basses, keyboards, drum sets, and vocals. Larger bands also include wind and string sections. Songs are often based on rhythms borrowed from Latin American music with Khmer melodies and lyrics written anew. Cover versions of Western popular music are also performed.

While Khmer traditional music struggles to survive, the music most popular in Cambodia is largely of Western origin. This is particularly the case among young people, who are willing to pay for this kind of entertainment. As a consequence, Khmer popular music produced by the Khmer music industry is in great demand and is easily available for purchase both in the home market and in the stores of Asian communities worldwide. Increased wealth and freedom among the general population have led to a liberalization of

the music market, with far less protectionism than in the early years of popular music in Cambodia.

4.3.7 Tourism Culture

Following the Khmer Rouge period (1975–79) and the decades of devastated civil wars, Cambodia has recovered tremendously well, economically, thanks to the peace and security in the country. Cambodia has joined ASEAN, being an active member, and has been well connected with the outside world, taking full advantage of the available technology and social digital media.

One of the most important economic sectors in Cambodia is tourism, which is a lifeline that feeds the country's economy and beyond. With rich resources in culture, nature, and biodiversity, Cambodia attracts tourists from every corner of the globe, particularly to its ancient stone monuments numbering in the thousands scattered across the country as well as pristine mountains and beaches. Ecotourism, green tourism, and cultural tourism are packaged as Cambodia's main attractions and destinations for tourists to visit and experience.

Tourism in Cambodia has been considered the "Green Gold," an important element of green economy. Sustainable and responsible tourism development contributes to the development, preservation, protection, and conservation of cultural, historical, and natural resources. Moreover, the progress of tourism enhances national prestige in the international arena. Economically speaking, the tourism industry in Cambodia has been growing rapidly for the last decades.

Cambodia witnessed a strong growth in tourism sector since the mid-1990. To fully capture the potential, cultural packages have been put in place to include shows and entertainments for the tourists, the rich forms of tangible and intangible heritages, several of those involve Reamker.

4.4 Significance of Reamker in Khmer Life

There is no doubt that Ramayana is one of the most popular and exciting stories in the world. Its popularity is attested by the

adoption and adaptation to regional and local stories, particularly, in the Indianized states of Southeast Asia. In India, where the story originated, Narayan claimed:

> Everyone of whatever age, outlook, education, or station in life knows the essential part of the epic and adores the main figures in it—Rama and Sita. Every child is told the story at bedtime. Some study it as a part of religious experience, going over a certain of stanzas each day, reading and rereading the book several times in a lifetime. (1972: xi)

The Khmer Reamker is a body of incredibly rich texts and literary vocabularies. It is so vividly told and written with great imagination by a great writer. The story and impulse are very profound, emotional, full of advice, love, and care. Readers can definitely picture and virtually feel what is really happening in the story.

The Khmer Reamker has served as the main theme for the development of many Khmer arts, including literature, sculpture, stone temple walls, wood panels, three-dimensional objects, painting and drawing, temple murals, canvases, scrolls, stampings, children books, weaving and silk screening, court dance drama, masked play, shadow play, epic singing, storytelling, and astrology.

4.4.1 Reamker in Khmer Court Dance

Khmer court dance was enlisted on the UNESCO World Intangible Cultural Heritage of Humanity in 2003. It has been associated with the royal court of Cambodia for over a thousand years. On the walls of the Angkor Vatt temples, 1787 *apsaras* (celestial dancers) were carved, reflecting a period of history in which Khmer performing art reached its greatest expression (Cravath 2007: 13).

Khmer court dance has been regarded as a female tradition. Women perform the roles of king, queen, prince, princess, and demon, except the role of monkey, which is played by men. The costumes, headdresses, masks, movements, and gestures identify the characters.

Dancers are trained from childhood in the royal palace. Traditionally, they went beyond the palace walls only to attend the kings. Dancers are trained from age six for a repertory, which includes romances, myths, pure dance pieces, and regional epics, such as Preah Chinnavung, Preah Chann Korup, and Reamker (Ramayana).

Since the overthrow of the Monarchy in 1970 and the genocidal regime of Pol Pot from 1975 to 1979, Khmer court dance has changed its image and status. It has leaked out of the palace walls to the Royal University of Fine Arts campus in Phnom Penh, and to the refugee camps along the Khmer–Thai border, then to Khmer communities in other countries: Australia, Japan, France, Belgium, Switzerland, Canada, and the United States. In this latest environment, the Khmer court dance is learned and performed widely by members, particularly children, of the Khmer communities and can perhaps now be viewed simply as "People's Dance" or "Traditional Khmer Dance."

This dance form is traditionally accompanied by the *pinn peat* ensemble of wind and percussion instruments. The choir, consisting of mostly female vocalists, sings texts that tell stories while dancers express the plots through dance movements and gestures.

The most popular Reamker excerpts for the Khmer court dance drama, for instance, are:

The Banishment of Preah Ream

Preah Ream's Exile

The Chase of Golden Stag

The Abduction of Sita

Suvann Machha

Preah Ream Reviewing His Troops

The Battle of Reap also known as The Battle of Lanka

Ream Leak Chup Leak also known as The Reconciliation of Preah Ream with His Children

Sita and the Test of Fire or Fire Ordeal

Preah Ream and the Test of Funeral Urn

4.4.2 Reamker in Khmer Masked Play

Reamker is the sole story which serves as the main theme for the development of Khmer masked play known as *lkhaon khaol*. However, never before has the complete story been performed. Only a few episodes are chosen and adapted for the play. The most popular ones for this theatrical form are:[5]

[5]For further details on Khmer masked play, see Tum Kravel Pich (1999).

Preah Ream Tying the Road (Preah Ream Chang Thnall)

Water Barrage of Kumphakar (Kumphakar Tup Toeuk), also known as the Battle of Kumphakar (Chambaing Kumphakar)

Virul Chambaing

Ream Leak Chup Leak

Preah Ream and the Funeral Urn (Preah Ream Chaul Kaod Banhchhaot Neang Sita)

Battle of Intrachitt (Chambaing Intrachitt)

Battle at Night (Chambaing Pel Yup)

While the Khmer court dance may be considered belonging to the court or royalty, the Khmer masked play is an art form of the Khmer country folks—a village tradition. It is developed around the sole epic of Reamker, for it is both functional and entertaining. Thus, specific episodes are usually chosen for the performances, for example, the most popularly staged episode of Kumphakar Tup Toeuk (Water Barrage of Kumphakar). This episode is sometimes referred to also as Chambaing Kumphakar (Battle of Kumphakar). In the village of Vatt Svay Andaet, Kandal province, the faithful home of this tradition, the aforementioned episode was presented not only for the enjoyment of the audience, but also to induce rainfalls during a drought or to ward off evil spirits during an epidemic. In that village, the annual performance and ceremony must strictly take place once following the Khmer New Year in April. The villagers believe that Kumphakar (a gigantic demon) sits with his legs stretched blocking rivers and streams from flowing, likewise signifying the drought. The episode would normally end with Kumphakar killed, so the barrage is removed, making way for the water to flow, and thus, so falls the rain.

4.4.3 Reamker in Khmer Shadow Play

There are three forms of puppetry found in Cambodia today: small-sized shadow play (*sbaek tauch*), medium-sized puppetry (*sbaek poar*),[6] and large-sized shadow play (*sbaek thomm*). The large-sized shadow play was enlisted on the UNESCO World Intangible Cultural

[6]I intentionally use the term "puppetry" in lieu of "shadow play" when referring to this medium-sized form, because this form is not necessarily a shadow play; its siblings, however, are.

Heritage of Humanity list in 2005. Its performance is based solely on Reamker. Although in today's practice, only one episode, the Floating Maiden, is often found staged, particularly by shadow play troupes in Phnom Penh, the surviving shadow play troupe in Sala Kansaeng, Siem Reap still occasionally put together the seven-night episodes of Reamker.[7] They are:

> Battle of Intrachitt and Preah Leak (Chambaing Intrachitt noeung Preah Leak), also known as Tying the Bridge (Chang Spean)
>
> Banhakay (Banjakaya), also known as the Floating Maiden (Banhakay Andaet Toeuk)
>
> Tangling or Twisting Arrow (Sar Poan)
>
> Battle of Kampann and Hanuman (Chambaing Kampann and Hanuman)
>
> Brahma Arrow (Sar Prummea)
>
> Sokkacha
>
> Lament of Intrachitt (Intrachitt Phdaim Moeurng)

4.4.4 Reamker in Khmer Sculpture

Among the over a thousand Khmer ancient stone temples of Cambodia, including Angkor Vatt—one of the Seven Wonders of the World—scattered across the region, Reamker is prominently carved, attesting to the importance of the story in Khmer lives.

Kah Ke Temple	10th Century
Banteay Srey Temple	10th Century
Ba Puon Temple	11th Century
Phnom Roung Temple (Thailand)	11th Century
Phimai Temple (Thailand)	11th Century
Angkor Vatt Temple	12th Century
Banteay Samrae Temple	12th Century
Thormanun Temple	12th Century

[7]In 2000, the National Museum of Ethnology in Osaka, Japan commissioned the shadow play troupe of Sala Kansaeng to perform the complete seven-night versions for their film documentation. The complete footage of this rare performance, some of which have been edited into a finished form, is now in the depository and archives of the Museum.

4.4.5 Reamker in Khmer Painting

The subject of Reamker has been prominent in Khmer painting. Along the walls of monastic shrine halls, including Vatt Bau (Siem Reap) and Vatt Chaktotih (Uddong, Kampung Spoeu), Reamker was ornately painted. In 1903, under the vision, initiation, and patronage of King Norodom, on the walls of the Preah Vihear Preah Keo Morakod (also known as the Silver Pagoda) of the Royal Palace in Phnom Penh; 177 scenes of Reamker were ornately and colorfully painted on panels 2.5 m high along the pagoda walls 616 m long.

While the subject matters for Khmer painting include nature, agriculture, Buddhism, and mythology, the themes and ideas drawn from Reamker are also used widely by Khmer painters on canvas and paper, including scenes and characters from the story.

4.4.6 Reamker in Khmer Astrology

Some Khmer still believe and practice astrology, even today. They may seek help from astrologers to foresee their future. For instance, should their cards be drawn on Rama or Sita, then they will have good luck. On the contrary, should their cards be drawn on Ravana or Khara, then it is an omen for their future will be cloudy, befalling upon bad luck and misfortune.

	YEAR	RACE	SEAT	
1.	Rat	God	Piphek	(Bibheka)
2.	Bull	Human	Preah Ream	(Rama)
3.	Tiger	Demon	Khar	(Khara)
4.	Rabbit	Human	Preah Leak	(Lakshmana)
5.	Dragon	God	Sita	(Sita)
6.	Snake	Human	Hanuman	(Hanumana)
7.	Horse	God	Reap	(Ravana)
8.	Goat	God	Piphek	(Bibheka)
9.	Monkey	Demon	Preah Ream	(Rama)
10.	Rooster	Demon	Reap	(Ravana)
11.	Dog	Demon	Preah Leak	(Lakshmana)
12.	Pig	Human	Sita	(Sita)

4.4.7 Reamker in Khmer Storytelling

Storytelling was once a popular form of entertainment and oral tradition in Cambodia. Stories were often told by parents or grandparents at mealtimes or bedtimes. During the cold season, bonfires were made where adults and children alike gathered around them to warm up their bodies while listening to an elderly who told different stories, entertaining and creating a warm and intimate atmosphere for the evening until the times they needed to retreat to bed.

Reamker has also been adapted by storytellers, namely, Ta Chakk and Ta Krud, the versions that were known as Reamker Ta Chakk and Reamker Ta Krud, respectively. They were very popular during the pre-1975 period.

4.5 Conclusion

There are, indeed, several versions of Ramayana, each with digression, omission, and addition with different beginnings and endings according to local relevancy. Most sources begin the story with the birth of Rama and end it with his coronation. So it goes the happy ending, with the beginning of the reign of King Rama and Queen Sita ruling what was known as "Rama Raja Golden Age." The City of Kosala was given a new name by Rama as the "City of Victory," where people lived happily in peace and prosperity, for one time, like a little heaven on Earth.

The added sections vary from the second parting of Preah Ream and Sita (the first being the abduction of Sita by Reap) and the birth of the two sons—Kusa and Lava—to the Test of Fire, to the return of Preah Ream and Sita back to heaven.

While the Indian Ramayana does not contain the episode of Banhakay, it is one of the highlights in the Khmer Reamker. While the Indian Ramayana merely passes through the episode of Suvann Machha, it is an important episode, particularly in the Khmer court dance tradition.

The Ramayana story is so great that it is said if Hermit Valmiki were alive, he would have chosen to write the Ramayana again. This great epic has indeed over the years influenced and touched

the hearts of millions. Jonah Blank once asked a young Indian man: "Who serves as your model in life?" The young man replied: "Lord Rama" (1992: 2). This is precisely it, when talking about the Khmer Reamker, its significance, meaningfulness, and impact on Khmer life.

I hope this small work has provided readers with useful information and clues to better understand and appreciate the Khmer Reamker when they again read, listen, and watch this incredible story rewritten, retold, and reset on stage and on screen.

Region: Cambodia

Names of main characters in this chapter:

Rama → Preah Ream

Ravana → Reap

Sita → Sita

Hanuman → Hanuman

Lakshmana → Preah Leak

Kumbhakarna → Kumbhakar

Indrajid → Intrachitt

Sugriva → Sukrip

References

Beach, Milo Cleveland. (1983). *The Adventures of Rama*. Washington, DC: Smithsonian Institution.

Bernard-Thierry, Solange. (1955). "Le Sens du Merveilleux et l'Héroïsme dans le 'Ramayana' Cambodgien," *France-Asie*, 114–115 (Numéro Spécial), pp. 451–455.

Blank, Jonah. (1992). *Arrow of the Blue-Skinned God: Retracing the Ramayana through India*. Boston: Houghton Mifflin Company.

Boisselier, Jean. (1989). *Trends in Khmer Art*. Ithaca: Cornell University Press.

Chandavij, Natthapatra and Pramualratana, Promporn. (1998). *Thai Puppets and Khon Masks*. Bangkok: River Books.

Chuon, Nath. (1967). *Khmer Dictionary*, 5th ed. Phnom Penh: Buddhist Institute.

Cravath, Paul. (2007). *Earth in Flower*. Holmes Beach, FL: DatASIA.

Gaer, Joseph. (1954). *The Adventures of Rama*. Boston: Little, Brown and Company.

Giteau, Madeleine. (1965). *Khmer Sculpture and the Angkor Civilization*. New York: Harry N. Abrams, Inc. Publishers.

Martini, François. (1978). *La Gloire de Rama Ramakerti: Ramayana Cambodgien*. Paris: Société d'Édition "Les Belles Lettres."

Menen, Aubrey. (1954). *The Ramayana*. New York: Charles Scriber's Sons.

Narayan, R. K. (1972). *The Ramayana*. New York: Penguin Books.

Pich, Tum Kravel. (1999). *Khmer Mask Theater*. Phnom Penh: The Toyota Foundation.

Rama I (King). (2002 [1807]). *Thai Ramayana*, 5th ed. Bangkok: Chalermnit.

Reamker. (1964). 5th ed., 16 vols. Phnom Penh: Buddhist Institute.[8]

Tranet, Michel. (1999). *Aperçu sur le Ramakerti*. Phnom Penh: Ministère de la Culture et des Beaux Arts.

[8]The Second Edition of Reamker was published by the Buddhist Institute in 1959.

PART II
DIVERSIFIED PERFORMANCE CONTEXTS

Chapter 5

Ramayana in the Performing Arts: Connection with the Government and Local/National/Global Indian Identity in Singapore

Yoshiaki Takemura
Department of Modern Society and Civilization,
National Museum of Ethnology,
10-1 Senri Expo Park, Suita, Osaka, Japan
yoshiakitakemura@gmail.com

This chapter examines how the Ramayana is received in modern Singapore, a multiethnic Southeast Asian nation with a strong Chinese population,[1] with a focus on the production of performing arts by an Indian diaspora dance company. It explores how the Ramayana is depicted in national culture, as well as in local culture among the Indian diaspora community, based on the government's art management policy in museum exhibitions and arts and culture events. It also examines the Ramayana's growth in the popularity in

[1]Singapore's population can be divided into four major ethnic groups: Chinese, Malays, Indians, and Others (e.g., Europeans; CMIO).

Ramayana Theater in Contemporary Southeast Asia
Edited by Madoka Fukuoka
Copyright © 2023 Jenny Stanford Publishing Pte. Ltd.
ISBN 978-981-4968-09-6 (Hardcover), 978-1-003-29095-7 (eBook)
www.jennystanford.com

Indian performing arts, with special attention on a recently staged production in Singapore and its representation in connecting global Indian identity.

5.1 Introduction: Ramayana and Indian Diaspora

The Ramayana was introduced to regions that engaged in trade and cultural exchanges with India and contributed greatly to the formation of their local cultures, especially Southeast Asian countries. It was also translated into the local languages of these regions and became well known among the local populations. Thus, it can be said that literature on Rama is Pan-Asian in nature. The story has permeated profoundly into the lives and traditions of the people of India, as well as other parts of Asia and Southeast Asia, and has indigenized itself (Krishnan 1997: 9). In addition to being enjoyed in its form of an epic, the Ramayana has been embraced in performing arts through mediums such as song, dance, drama, and shadow play, as well as art forms like painting, sculpture, and architecture; further, each region has shown its unique development. Over the years, the epic has influenced various ethnic groups in India and Southeast Asia to form the Ramayana cultural sphere.[2]

In India, the most significant regional Ramayana is the *Ramacharitmanas* of Tulsidas. In South India, it is the Tamil poet Kamban's Iramavataram (12th century), while in Bengal, it is Krittivasa's Bengali Ramayana (14th century). In the Jain Ramayana—Vimalasuri's *Paumacariya*—Ravana is considered as one of the 63 Jain wisemen, and Sita is his daughter, while the Adbhuta Ramayana by Valmiki,[3] based on Shakti (mother goddess) worship, focuses on Sita's birth, wedding, chastity trial, and killing of the 10-faced Ravana (Ramanujan 1991: 34–36). Furthermore, the tale of Rama, which is also known as Rama Katha, is widely performed in a variety of traditional dance drama productions. Around the 14th century, the Ramayana was introduced in various parts of India as a theater spectacle, such as *Ramlila*, followed by the rise and spread of the

[2]For South and Southeast Asian scholarship on the Ramayana, see Bose (2004), Iyengar (1983), and Richman (1991; 2000).

[3]The Ramayana is said to be the first *Kāvya* or poetic composition in Sanskrit, written by the legendary sage Valmiki.

Rama cult (Awasthi 1979).[4] Today, many modern dance drama styles have evolved in India from a combination of genres, and some of these styles specialize in popularizing the Ramayana. For instance, the *Ramalila* of New Delhi is staged by the cultural institution Shriram Bharatiya Kala Kendra, which employs dance, dialogue, pantomime, and theater, played to a full house for the entire two weeks of its staging. Even classical Indian dancers using eclectic dance and theater language are producing choreographed pieces of dialogue, music, and dance about the Ramayana (Krishnan 1997: 19).

On the other hand, the performance-based art form has assimilated into folklore and ethnic cultural spheres, where it has taken on a distinct shape, infused with local flavors and a range of regional types. Some of the famous local theatrical traditions representing the Ramayana are *Yakshagana* in Karnataka and Kerala, the *Chhau* mask dance in West Bengal and Odisha Jatra traditions, *Kathakali* in Kerala, and *Dashavataru* in Maharashtra. Various types of shadow puppet theaters, such as *Tolpava Koothu* in Kerala, *Tholu Bommalattam* in Andhra Pradesh, and *Togalu Gombeyatta* in Tamil Nadu and Karnataka, have also adopted performances based on the epic (Bhattacharya 2020). These types of performance practices display a clear current of interregional cultural diffusion; furthermore, their visual metaphors are created in particular social contexts, which address the variety of regional terms and styles.

Moreover, the Ramayana has also been reproduced on celluloid many times, but its most popular incarnation today remains the Ramayana serial television program by film director Ramanand Sagar, which brought together many versions of the Ramayana. For over 18 months in 1987 and 1988, *Ramayan* aired on India's National television channel, Doordarshan, on Sunday mornings; it quickly became a major success and the most popular television

[4]*Ramlila*, literally "Rama's play," is a performance of then Ramayana epic in a series of scenes that include song, narration, recital, and dialogue. It is performed throughout northern India during the Dussehra festival, which occurs every year in the autumn according to the ritual calendar. The most representative *Ramlilas* are those of Ayodhya, Ramnagar and Benares, Vrindavan, Almora, Sattna, and Madhubani. This staging of the Ramayana is based on the Ramacharitmanas, one of the most popular storytelling forms in the north of the country (UNESCO homepage, "Ramlila, the traditional performance of the Ramayana," https://ich.unesco.org/en/RL/ramlila-the-traditional-performance-of-the-ramayana-00110, accessed on 13 February, 2021).

show in Indian history, far beyond the producers' expectations. It was estimated that popular episodes were watched by 80 to 100 million viewers, or an eighth of the country's population (Lutgendorf 1995).[5] The serial attracted a lot of attention in the United Kingdom, Indonesia, Singapore, and other parts of the world as well. In 2008, a remake of the 1987 *Ramayan* television series was produced, which was dubbed and broadcasted in the local languages in Thailand and Indonesia. Additionally, the Ramayana provides the perfect opportunity for encountering popular Indian culture. The leading Indian comic book series *Amar Chitra Katha* conveys the Ramayana in the forms of an illustrative and easy-to-read comic book set, which helps children not only learn about duty and honor, good and evil, love and loss, jealousy, and destructive ambitions, but also grow their imagination and vocabulary.[6] The epic's global mass market penetration is further demonstrated by a joint Japanese–Indian group's development of a technologically genius, if distinctly Disneyfied, cartoon version, which was shown at international film festivals in the late 1980s and is now making the rounds in a DVD reincarnation (Bose 2004: 4).[7]

In Singapore, unlike other Southeast Asian countries, the Ramayana has mainly been passed down among the Indian

[5]Televisions were set up in public places or were shared with friends, family, and acquaintances; even people who had never watched television before fought to watch this epic drama. There are several accounts of important meetings and ceremonies being postponed for watching the Ramayana, trains being delayed because passengers did not board during the broadcast period, and people disappearing from bazaars during that time (Rajagopal 2001; Lutgendorf 1995). In 2020, this popular television series became the most watched Hindi serial during the nationwide lockdown that had been implemented to combat the novel coronavirus global pandemic. (*Blooberg*, April 3, 2020, "Ramayana" Rules as TV Viewership Hits All–Time High During Coronavirus Lockdown, https://www.bloombergquint.com/business/coronavirus-lockdown-tv-viewership-hits-all-time-high-ramayana-rules-screens, accessed on 5 March, 2021).

[6]*Amar Chitra Katha* (Immortal Picture Stories) is popular among the urban middle class in India and the South Asian diaspora. Sigh argues that contemporary visual culture in the domain of comic books has seen a gradual shift from *Amar Chitra Katha*'s knowledge-based conservative pedagogy to a more globalized entertainment-oriented, market-centered strategy (Sigh 2019).

[7]*The Legend of Prince Rama: Ramayana* was produced by Nippon Ramayana Films and directed by Yugo Sako and Vijay Nigam. This work is an international venture, and its DVD release is marketed by a Malaysian company from Kuala Lumpur and carries the tagline "Ramayana Goes Where Aladdin Never Dared!" (Bose 2004: 16).

community as a cultural tradition of the mother country. The tale of Rama is performed by Indian dance troupes during the annual festivals of India, such as Navaratri and Deepawali. In performing arts complexes, like theaters and black boxes, local Indian dance troupes subsidized by the government regularly perform Ramayana dance dramas. Additionally, bookstores in Singapore's Little India district sell the English, Hindi, and Tamil versions of the epic. While the tale has also been depicted via comics, illustrated textbooks for children, and DVDs of cartoons in the market, it is difficult to say that the Ramayana is gaining popularity. For many people of Indian descent, unless they have learned traditional dance or music, they only engage with and see the Ramayana performed at festivals and entertainment events; thus, as generations pass on, its transmission has been weakening. However, in the past two decades, the Singaporean government has been trying to preserve the Ramayana as a cultural heritage of the country, not just that of Indians.

Studies on the Ramayana have accumulated a great deal of literature, history, and propagation in South Asia and Southeast Asia (Iyenger 1983; Mandakranta 2004; Richman 1991, 2000). In recent years, there have also been analyses of its influence on the performing arts in Southeast Asia, and its connection to contemporary art has been discussed (Clark 2010; Miettinen 2018). While there have been some discussions of religious and cultural practices among the Indian diaspora (eg. Jayaram 2004; O'Shea 2007; Rai 2008) which has spread throughout India and the world in the midst of globalization, there has not been enough scholarship on the reception and practice of the Ramayana among these individuals. In seeking to make a modest contribution to this scholarship, in this chapter, I discuss the representation of the Ramayana in Singapore and its global Indian identity. Using data from interviews, archives, and online materials that I amassed from 2018 to 2020, first I present a brief account of Singapore's cultural policy and recent developments in the representation of the Ramayana in the country; then I consider its relationship to the Indian community and performing arts groups, in particular, Apsaras Arts and their Ramayana production, *Anjaneyam-Hanuman's Ramayana*. The concluding section of the chapter examines the characteristics and some critical responses to *Anjaneyam-Hanuman's Ramayana* internationally, with the local/global identity of the work also being discussed.

5.2 Arts Management and the Ramayana Events in Singapore

5.2.1 Cultural Policy in Singapore

Singapore has been artificially created by/formed through government-led developmental policies within the constraints of a small area, limited human resources, and virtually no natural resources. In the 30 years since its establishment, the country has advanced from being a developing to a developed nation by focusing on globalization and economic development. Government policies geared toward industrial and economic growth dominated the era from complete independence in 1965 to the early 1980s, with cultural development ostensibly receiving lower priority in terms of policy support and budget allocation.[8] Periodically, leaders and citizens articulated concerns about Singapore being or becoming a "cultural desert," but there were no significant attempts at developing an overall long-term cultural policy.[9] Since the mid-1980s, however, the second generation of political leaders has put a greater focus on cultural growth, partly in response to what was perceived as a "coarsening materialistic culture generated by the fixation on economic benefit or moneytheism" (Koh 1980: 239).

After several decades of false starts and unfocused efforts in cultural policy, the watershed moment in this area was marked by the formation of the Advisory Council on Culture and the Arts in February 1988. Only after the "Report of the Advisory Council on Culture and the Arts" was published in 1989 did the government begin to pay serious attention to the systematic growth of arts and culture. The report has been praised as a model for Singapore's cultural policy (Kong 2000). The National Arts Council, National Heritage Board,

[8]In the early days of the country's founding, however, the ruling People's Action Party was acutely aware of the urgent need to establish a national identity. As one of the concrete measures to accomplish this, the *Aneka Ragam Rakyat* program was organized by the Ministry of Culture as a way for Singaporeans to learn about and appreciate the diverse cultures of the people who make up the country's population. See Weiss (2020) for the details regarding the *Aneka Ragam Rakyat* and its relation to Singapore's identity and performing arts.

[9]For historical perspectives and contemporary dynamics on cultural policy in Singapore, see Kian-Woon Kwok and Kee-Hong Low (2002), and Terence Lee (2016).

and National Library Board were established as a result of the report, and the cultural landscape of Singapore was transformed during the 1990s by a building spree of cultural infrastructures, such as the Singapore Arts Museum, Asian Civilisations Museum, Esplanade—Theatres on the Bay, the new Drama Centre at the new National Library, and other infrastructure developments in the central business district, as well as the rehabilitation of disused government buildings for housing arts groups and cultural institutions (Liew 2015: 24).[10] In addition, the Department of National Heritage Board was founded by the Ministry of Culture as a center for the promotion of Chinese, Malay, and Indian cultural heritage (Velayutham 2007: 129).

The reason behind the rapid development of Singapore's arts policy in the 1990s was that arts and culture became closely linked to the economy due to the intensification of market competition in economic globalization. During this period, many regions of the world that advocated for global cities tended to develop their arts and cultural industries. Thus, Singapore also had to develop its arts field in order to compete with other global cities (Kawasaki 2010). Given this trend, during the 1980s and 1990s, when the discourse of Asian values in the political sphere rose in tandem with the economic rise of the Asia-Pacific region, there was a contemporaneous movement in the art world. Singapore became more accepting of Asian culture, and the emergence of productions devoted to the expression of "Asian-ness" began to reflect the expansion of Asian identity.[11] After Singapore had recovered from the Asian economic crisis and began to grow in confidence, Dance, in particular, as art was eventually recognized as an important aspect of a culturally vibrant society in the late 1990s (Carino 2014: 1). Today, arts and culture have become critical in transforming Singapore into a "Renaissance City" that attracts knowledgeable workers and highly specialized professionals as well as providing a brand for the nation. The city-state has made

[10]Kwok and Low provide a good overview of the activities of the Ministry of Information and the Arts and its subsidiary, the National Arts Council (Kwok and Low 2002).

[11]Carino argues that Asian identity is viewed by many scholars as strategic identity politics, i.e., to denote a difference from the West backed by new material conditions in the rise of the Asia–Pacific economic rim (Carino 2014: 6).

considerable progress toward being a significant hub for the arts in the Asia–Pacific region over the last two decades.[12]

5.2.2 Cultural Events and Ramayana

Interestingly, in the midst of these political and economic trends, there has been a movement in the last two decades or so to promote the Ramayana as a national cultural heritage in Singapore. The cultural infrastructures of the nation took the lead in this trend, and the exhibition "*Ramayana: A Living Tradition*," organized at the Asian Civilisations Museum in 1997, was most likely the catalyst for this movement. The exhibition, which coincided with the opening of the museum, portrayed the epic's geographical spread as well as the variety of ways it has been expressed in literature, visual arts, and performing arts. The exhibition included the existing Malaysian puppet collection as well as leather puppets from India, Java, Bali, and Thailand. Likewise, Indian textile and paper paintings depicting the epic in Madhubani, Kalamakari, Cherial, and Pahari styles; Kamasan paintings from Bali; and papier-mache masks from Cambodia augmented the reach and extent of the collection from highly refined to folk styles (Krishnan 2010: 12). For the first time, new and old content was displayed in the background of the story and its differences across continents, allowing for the exploration of regional flavors.

Several years later, in April 2010, the Peranakan Museum held the exhibition "*Ramayana Revisited: A Tale of Love and Adventure*," which featured approximately 100 artefacts, including shadow puppets, paintings, and photographs of ancient monuments that covered various historical and stylistic periods to demonstrate how the Ramayana was depicted throughout the ages in various societies. It was an effort to explain the Asian Civilizations Museum's collection through the different chapters of the story and return to the common imagination, where the Ramayana continues to captivate new generations. This year-long exhibition sparked an investigation into the role of the story as a cultural unifier for the

[12]Liew points out that today, Singapore's entire arts and culture ecosystem is well funded by a good network of state-run agencies and organizations such as the National Arts Council, National Heritage Board, National University of Singapore (NUS) Centre for the Arts, and NUS Museum. In addition, private art galleries, auction houses, professional and amateur arts groups numbering about 300, and professional Western and Chinese orchestras, all of which are supported by a large workforce of arts administrators, also provide support (Liew 2015: 25).

Asian region.[13] The museum also created a storytelling program in which six storytellers told consecutive episodes from the Ramayana in the exhibition room, which clearly exemplified the fact that the story has spread beyond regions and has become highly indigenous, with various elements evolving to fit local cultural ethos.

More recently, in August 2019, a cultural and tourism event, the *Singapore Night Festival 2019: Night Light*, was held in the commercial facilities area. The year 2019 was an important milestone in Singapore's history, as it marked the 200th anniversary of Sir Stamford Raffles' settlement in Singapore in 1819. The 2019 line-up for the bicentennial edition of the festival focused on Southeast Asia, with folklore and ethnic motifs conveyed through art and performances. The event's light installations were focused on the theme of transformation by illumination and included several large-scale projection artworks, such as *The Legend of Ramayana*, housed in the Banyan tree at the National Museum of Singapore. It was portrayed as a projection by the internationally renowned French group the Spectaculaires, which created quite a stir. This was inspired by the Asian Civilisations Museum's collection of Nakashi Venkataramaiah's paintings, a type of scroll painting that depicts scenes from mythology and folk traditions. *The Legend of Ramayana* transformed into a spectacular showpiece that brought the audience on a journey inspired by the epic. This multisensory experience was also the first time that the famous Banyan tree hosted both a visual projection and an audio presentation, which were complemented by a gamelan instrumental performance at the same time.[14] The audience stopped to take pictures with their smartphones and

[13]Basing the exhibition theme on the concept of storytelling, which is how the 17th century Awadhi poet Tulsidas renders his Ramacharita Manasa, the story is narrated in the form of a dialogue between Rama's two sons. To carry the epic into the modern era, a mosaic of video clips had been erected on a wall where visitors could watch film clips of Indian, Indonesian, Chinese, and cartoon animation renditions of the epic (Krishnan 2010: 12). Michael Koh, the acting director of the museum, explained, "Our curators have presented Ramayana Revisited through the youthful eyes of Rama's sons to extend the reach of this rich heritage to a broader audience. We are excited to be a part of retelling this ancient epic to yet another generation, and hopefully, inspire more to understand the diverse cultures within our shores" (*The Indian Express*, March 9, 2010, "Ramayana travels to New York, Singapore!").

[14]*The Straits Times* (August 6, 2019) reported: "Singapore Night Festival 2019 kicks off with three teaser installations over National Day weekend" by Amanda Chai (https://www.straitstimes.com/lifestyle/arts/singapore-night-festival-2019-kicks-off-with-three-teaser-installations-over-national, accessed on 21 March, 2021).

cameras, enthusiastically enjoying the fantastic sight projected by the latest technology in lighting and projection mapping.

5.2.3 Ramayana and Indian Dance in Singapore

A prominent Indian dance troupes in Singapore often performs productions based on the Ramayana and Mahabharata. For instance, since the 1960s, Mrs Santha Bhaskar, the artistic director of Bhaskar's Arts Academy, Singapore's first institution to offer Indian dance classes, officially has been developing works based on the Ramayana and Mahabharata. Bhaskar's Arts Academy has been involved in several Ramayana festivals in Angkor Wat, Cambodia in 1994, and subsequently, in Myanmar and India.[15] In 2016, Bhaskar's Arts Academy represented Singapore during the *ASEAN Plus Ramayana* festival held in Bangkok.[16] Their production, *Ramayana: Ashoka Vanam*, was based on the style of *Bharatanatyam*, a classical dance form from India, and it was noteworthy for the fact that all of their performers were female, and the characters of Rama and Hanuman were choreographed without the use of any special costumes. According to Mrs Santha Bhaskar, participating in such events inspired them to raise awareness of ASEAN traditional arts and culture and foster collaborations with their neighbors.[17]

In May 2017, Bhaskar's Arts Academy partnered with Gamelan Asmaradana and Sri Warisanto to present *Ramayana Extravaganza* at the Singapore Heritage Festival and the Indian Heritage Centre's second anniversary celebrations.[18] The Singapore Heritage Festival

[15]Bhaskar's Arts Academy is an Indian performing arts organization established in 1952 by the late K. P. Bhaskar (born in Kerala South India) during his transit in Singapore on his way to Australia. They are the pioneer in the classical Indian performing arts scene in Singapore.

[16]*ASEAN Plus Ramayana*, a staged performance that combined Ramayana performances from eight Southeast Asian nations and India took place during the ASEAN Cultural Expo 2016 as part of celebrations of the 234th Year of Rattanakosin City under Royal Benevolence. It aimed to promote ASEAN cultural diversity and create better understanding about the cultural similarities and differences between and among ASEAN member countries.

[17]Interviewed with Mrs Santha Bhaskar, March 12, 2020, Singapore.

[18]Sri Warisan is a performing arts company founded in 1977 by Madam Som Said, a renowned cultural Medallion recipient. Sri Warisan is a major figure in the Malay dance scene in Singapore, which is currently led by Mr Adel Ahmad, together with 30 performing artists and more than 200 student members committed to developing professionalism in the performing arts, reaching out to children, youths, and adults (Interview with Madam Som Said, Feb 20, 2020, Singapore).

showcased the country's multicultural landscape with a shadow puppet and dance presentation of the Ramayana. Festivalgoers were treated to a grand street procession leading up to a never-seen-before Ramayana fusion performance. This encompassed a sari-inspired art installation, a presentation of the Ramayana told in a cross-cultural way using *Wayang Kulit*; *Therkoothu*, a form of street theater from Tamil Nadu, India; and Indonesian gamelan and Indian music.

Moreover, in September 2020, the Indian Heritage Centre organized an online cultural arts festival, *CultureFest 2020: Digital Edition*. This event presented its audience with a rich and interactive fortnight of Indian arts, culture, and heritage amid the COVID-19 pandemic, despite treading on a previously unexplored digital platform. The event featured multiracial performers and various art forms from across Southeast Asian regions, and the festival programs focused on the richness of Indian arts, culture, and heritage as seen through the lens of the Ramayana.[19] At the event's opening weekend, various artistes showcased their interpretation of key characters of the Ramayana through Indian dance and martial art forms.[20] The event was mostly digital, in which performances premiered and were hosted on the Indian Heritage Centre's Facebook page, along with a few on-the-ground activities, workshops, and live performances. Ms Maria Bhavani Dass, general manager of the center, explained that as of 20 September, more than 1.4 million people, mainly from Singapore, but also from India, Malaysia, Australia, and other countries, had watched the video of the event, and many viewers sent positive comments and encouragement.[21] Despite being a hybrid festival with only a few on-the-ground

[19]For two weeks, more than 100 artists presented 40 cultural programs in an effort to highlight Indian art, culture, and heritage in Singapore through the lens of the Ramayana.

[20]The digital launch, for instance, featured a dance production titled *Sita* performed by Apsaras Arts, which was based on Raja Ravi Varma's Ramayana paintings brought to life and a dance drama by the Maya Dance Theatre that presented the common heritage of the Ramayana through the cross-cultural artistic journeys of seven Singaporeans.

[21]Ms Dass explained, "We are even more heartened to receive the positive feedback and comments from the participants, viewers, and community partners who shared that this year's Digital Edition was engaging, inclusive, and had given them the flexibility to enjoy the content at their own convenience" (*Connected to India,* "Indian Heritage Centre's first-ever digital edition CultureFest closes on a high note," September 29, 2020).

events, the festival created a buzz and an overwhelming sense of positivity among both the performers and the large online audience. Nevertheless, it is too early to say whether this move will have an impact on the prevalence of the Ramayana in Singapore, but it has raised further awareness of its representation as a cultural heritage.

Besides this, while not an obvious trend, but the Ramayana has also inspired Chinese practitioners in the performing arts scene of Singapore.[22] Dr Chua Soo Pong, a doyen and scholar of Chinese opera and president of the Chinese Opera Institute (COI) in Singapore, has blazed a different trail. He was interested in the diversity of Indian culture and the various art forms and even learned Bharatanatyam from Mrs Santha Bhaskar in the 1960s. Later, in collaboration with an Indian artist, he translated the stories of the Ramayana and the Mahabharata into Chinese Opera, and through his works, he has gained fame in the country and internationally. He presented the Ramayana with Indonesian puppets and Chinese dialogues for the first time. Further, he scripted the epic in Mandarin as a Chinese children's play in 1988, which he successfully staged in Singapore and later translated into Teochew, Hokkien, Cantonese, and Huang Mei operas (Rama 2015: 119).[23]

5.3 Performing the Ramayana and Its Representation among the Indian Diaspora Community

5.3.1 The Indian Performing Arts Scene in Singapore

In the past 50 years of nation-building in Singapore, Indians have contributed significantly to the visual and performing arts at the

[22]In terms of the Malay community, Malay artists have not been very active in the creation of works dealing with the Ramayana. In August 2016, the Ramayana Ballet was performed by a performance group from Solo, Indonesia, at the Malay Heritage Centre as part of the heritage and culture of the Javanese in Singapore.

[23]Following this, the Thau Young Amateur Musical Association, a musical and Han opera group formed in 1931, performed in Bangkok as part of the 1995 International Ramayana Performing Arts Festival in 1995. They also participated in the International Ramayana Festival 2013, which was held at the open-air theatre at the Prambanan Temple, Yogyakarta, in Indonesia. They performed the episode of Jatayu's heroic fight with Ravana in the form of a Chinese opera form (Chua 2016).

national and international levels. They have transcended beyond their Indian community to become national players and have integrated multiethnic and multicultural influences, resulting in a unique Singaporean sensibility (Mohideen 2016: 48).[24] While people from all of India's major ethnolinguistic groups are represented in Singapore, the Tamil community accounts for about 54% of the country's Indian population.[25] Therefore, Indian classical music and dance in Singapore are mostly representatives of South Indian forms, such as Carnatic music and Bharatanatyam. These are typically associated with Hindu tradition and have been performed in temples during religious festivals since the early 19th century.

The period from Singapore's independence to the turn of the century was one of progressive growth in the Indian performing arts scene of the country (Sykes 2015). Institutions such as the Singapore Indian Fine Arts Society (SIFAS), Bhaskar's Arts Academy, Apsaras Arts, and the Temple of Fine Arts, often identified as "the Big Four," have strengthened their status as the leaders of this industry, and governmental interventions are slowly starting to pay off, bringing momentum to the emerging Indian performing arts scene and valuable financial support (Rajan 2015: 52). The Big Four have made a number of large-scale productions over the years, and today, there are many other Indian performing arts institutions that often organize concerts and provide a stage to showcase the talents of performers. The Singapore government has been a major enabler in this regard, helping artists and institutions with grants and housing support and organizing events such as the Indian Festival of Arts, National Indian Music Competition, and Singapore Youth Festival as well as funding research and travel related to arts activities (Takemura 2016; Varaprasad, Rajan, Rajan, and Ramaswami 2015: 157). A female Bharatanatyam practitioner, an alumnus of the Singapore Indian Arts Society, who is a grant recipient says, "These grants signify that the state supports the arts, and more importantly,

[24]While Indians are a minority in Singapore, according to the 2010 census, 9.2% of the total population of 5.07 million are Indians. Indian culture and traditions have contributed a great deal to the building of a multicultural society and have even become a symbol of the same in Singapore.

[25]Punjabis account for about 51% of those classified as North Indians, which also includes Bengalis, Gujaratis, Marathis, and Sindhis.

that the state recognizes the different and diverse type of art forms in Singapore's culture" (Ibid., 159).

5.3.2 Rukumini Devi Arundale and the Ramayana Drama

Considering the relationship between the Ramayana and Indian classical dance, it can be said that practically all 20th century choreographers of dance and dance drama in India have attempted to present ballets based on the Ramayana. We must draw attention to the fact that there are important 20th century landmarks in Indian dance created by the pioneer dancer Rukmini Devi Arundale from Madras (presently Chennai) in South India. In the first half of the 20th century, Rukmini, a Brahmin from a liberal theosophical family background, created a new language of dance to communicate the ancient epics, using tradition and inventing new interpretations of tradition. She became the living symbol of the renaissance of an ancient art form, *Sadir* (performed by *devadasis* or "servants of god"), which was almost forgotten and had become marginalized in society. She played a significant role to revive *Sadir* and reconstruct it as *Bharatanatyam* at her own institution, Kalakshetra (Meduri 2005).[26] Her contribution to lending prestige and dignity to a style that had been banned by the alien rulers is unparalleled both in its sociocultural and purely artistic facets. In the 1940s, it was she who first thought of performing a *Bharatanatyam*-style dance drama on the new proscenium stage, rather than limiting her repertoire to the typical solo dance of the previous decades (Vatsyayan 2010: 175).

Rukmini was constantly looking for new texts to serve as bases for her performances. Vishwanathan assumes that Rukmini's fascination for a Ramayana dance drama may have been inspired by what she had seen in her visits to Indonesia.[27] She had also heard

[26]For a historical background of *devadasis* and *Sadir*, see Kersenboom (2011 [1987]). For a discussion on the creation and dynamics of *Bharatanatyam*, see Gaston (2005 [1996]), O'shea (2007), and Sonej (2010). For further details regarding Ruknimi Devi Arundale, see Meduri (2005) and Samson (2010).

[27]As relayed by Mr Aravinth Kumarasamy who heard from the founder of Apsaras Arts, the late Mrs Neila Sathyalingam, influenced by the Ramayana Rukmini had seen in Java, she adopted a Javanese style design for the Hanuman headdress in her own Ramayana productions, which is still used in Kalakshatra's today (Kumarasamy 2018).

and was drawn to the singing of Tulsidas's Ramayana. In 1954, she plunged into the world of the Ramayana. Her production of *Sita Swayamvaram* (Sita's wedding with self-chosen groom) seemed an auspicious beginning. The text was Valmiki's, with additional verses by Ananda Ramayana. This version of the tale had Ravana as a suitor for Sita in Janaka's court. At that time, Rukmini was sufficiently experienced to view poetry in poignant situations. Kalakshetara's young dancers were motivated by her to rise to the occasion. The story literally sailed through scenes of simple choreography, and Rukmini brought feeling to each episode, understanding the importance of the text (Vishwanathan 2014: 8). Speaking about the production in the course of the Ramayana Seminar in Indonesia in 1970, Rukmini expressed herself in the following words:

> In my production of the Ramayana, I have followed Valmiki, and Sri Vasudevacharya has set Valmiki's verses to music. In the very first episode of Sita Swayamvaram, however, thirty-one verses have been taken from the Ananda Ramayana. These verses relate to the actual wedding itself which is portrayed differently in Ananda Ramayana from Valmiki's. In no other place have verses other than Valmiki's been used. The dance style used has been Bharata Natyam. In the very powerful masculine portions, but rarely, Kathakali has been used. But in no instance have I allowed a mingling of Bharata Natyam and Kathakali styles in any dance. The Bharata Natyam has kept its purity and the Kathakali its own distinctive style. (Vatsyayan 2010: 175)

Rukmini also explained:

> I wish to make it clear that these dramas produced by me are not dance-dramas handed over from the past. But I have followed the rules of Bharata. I have used only the classical styles and technique; the music is purely classical and in the presentation itself I have tried to keep everything as representative of the age or the Ramayana as possible. I have been true to tradition in my attitude to the production, in my devotion to Sri Rama and to the Ramayana, in the classicism of the styles of the dances and music used. I fully believe that I have done no violence of any kind to the classical tradition. (Vatsyayan 2010: 178)

Vatsyayan points out Rukmini adopted the rules of directly linking the term to the gesture and rendering the rhythmic passages in pure dance sequences. Even so, the resulting dance drama is novel

when viewed in its entirety, both in terms of vision and execution technique. She broke new ground by deviating from the sanctity of not introducing more than one classical form in a single composition, which was contrary to the existing precedent in the tradition. She gave Bharatanatyam a new dimension by incorporating exquisite choreography by a corps de ballet. Furthermore, in comparison to the earlier epic storytelling form of the Ramayana presentation, she offered moments of dramatic climax by a selective responsive approach to the key episodes of the plot (Vatsyayan 2010: 178). Rukmini's works are still being undertaken in Kalakshetra today. Not just that, but their example has inspired other Kalakshetra alumni both national and global.

5.3.3 Apsaras Arts and Inheritance of Kalakshetra Style

Regarding the Indian dance scene in Singapore today, although many institutions teach Indian classical dance and music, most of them follow the Kalakshetra style of *Bharatanatyam*; Apsaras Arts is one of their major institutions. Apsaras Arts is a non-profit organization that receives an annual major grant from the National Arts Council. The important distinction between Apsaras Arts and other institutions that follow the Kalakshetra style is that the founder of Apsaras Arts specifically studied Bharatanatyam under the guidance of Rukmini at Kalakshetara in India. Apsaras Arts was founded in Singapore in 1977 by Mr S. Sathyalingam and Mrs Neila Sathyalingam, alumni and former faculty members of Kalakshetra.[28] Both of them belonged to Sri Lanka and were Sri Lankan Tamils, but they met each other at Kalakshetra and moved to Singapore in 1977. With over four decades of prolific international productions, Apsaras Arts has grown to be one of the leading Indian dance companies in the region and gained recognition in Indian dance theater. They also promote traditional Indian dance in multiracial Singapore through high standards in their teaching.

[28]Mrs Neila Sathyalingam was born as Neila Balendra in 1938 in Colombo, Sri Lanka. She began dancing at the age of five and trained in the classical Indian dance traditions of Bharatanatyam, Kathak, Kathakali, and Manipuri at the Shanti Kumar School of Dance and the Kalaya School of Dance in Colombo. At the age of 18, she enrolled in Kalakshetra under the tutelage of its founder Rukmini Devi Arundale. Neila completed her 5-year course in 2 years, graduating with a first-class honors diploma in Bharatanatyam and was appointed as one of the faculty members for dance at Kalakshetra.

Since 2005, under the leadership of Mr Aravinth Kumarasamy, Apsaras Arts has concentrated on mega developments to create new works that are performed at international festivals, as a major professional performing company. Innovative choreography, traditional dance vocabulary, and the latest technology in stage set design have been fused seamlessly with the creations of Apsaras Arts, redefining the limits of the Bharatanatyam ensemble. Mr Kumarasamy explained intrinsic factors:

> *Most Indian classical dance genres are solo based forms...... in Singapore, we have no sabhas (theatre), we have no Margazhi season (Music festival), we have no Pongal (Hindu Festival) season......we have nothing. So where is solo dancer look out for. So, number becomes a necessity and a necessity creates you to start thinking.* (Kumarasamy 2018)

The company has performed in over 40 countries with leading dancing firms, legendary dancers, choreographers, composers, and presenters, as well as Cambodian, Javanese, and Balinese dance artists. Aside from its productions, Apsaras Arts has organized the Dance India Asia Pacific (DIAP) education program since 2011, which offers students, teachers, and performing artists of Indian classical dance a thrilling and visionary dance training program with the Esplanade–Theatres on the Bay. The module was inspired by the activities of Milapfest, an arts development trust in the United Kingdom that, for the last 15 years, has held intense training programs in Liverpool and invites senior Indian dancers to train young Indian diaspora artists. The DIAP has succeeded in taking such courses in Singapore as well, with an increasing number of dancers. These program-takers are usually from India, Australia, the United States, and Malaysia, aside from local dancers. They spend a great deal of time with the well-known and experienced dancers to better understand classical styles of dance, their presentation, complexities, correct positions, gestures, the essence of the lyrics, interpretations, and improvisations.[29]

[29]*The Hindu*, "Veterans educate and entertain at Dance India Asia Pacific" by Sunil Kothari, June 17, 2019.
(https://www.thehindu.com/entertainment/dance/veterans-educate-and-entertain-at-dance-india-asia-pacific/article28177112.ece, accessed on 18 March, 2021).

The recent work of Apsaras Arts, based on the Ramayana motif, is *Anjaneyam-Hanuman's Ramayana*,[30] which has received international acclaim, including in India. This work was another mega production for Apsaras Arts after their first large-scale production *Angkor: An Untold Story (2013)*. *Anjaneyam-Hanuman's Ramayana* was presented at the Esplanade–Theatre in Singapore in partnership with the same, as the inaugural presentation of the Kalaa Utsavam - Indian Festival of Arts in 2017, as well as to commemorate Esplanade's 15th anniversary and Apsaras Arts's 40th anniversary. A portion of the work was also performed at the 2018 ASEAN Ramayana Festival in New Delhi as part of the India–ASEAN Commemorative Summit[31] and also in Singapore in August 2019 at the Singapore Night Festival 2019: Night Light; further, it was screened online during the Indian Heritage Centre's CultureFest 2020 in Singapore. As part of the event, the National Heritage Board also awarded Apsaras Arts for the Intangible Cultural Heritage Awards. Moreover, as I have mentioned earlier, Apsaras Arts marked the digital launch of the dance production of Sita's based on Raja Ravi Varma's Ramayana painting during at the same event. Raja Ravi Varma's painting was selected, and technology has been used to create a digital output of dancers and musicians so that the audiences can see the paintings as it comes to life with dancers assembled very similarly to what Raja Ravi Varma had painted in his canvas. It was the first attempt to make the first fully digital shorts of the painting.

5.4 Ramayana Production as a Representation of Global Indianness

The Ramayana has captured the imagination of Asia for centuries with its universal themes of righteousness, devotion, fidelity, and

[30]*Anjaneya* is another name for Hanuman, which means "the son of *Anjana*" (mother of Lord Hanuman). Mr Kumarasamy explains that Mrs Neila Sathyalingam wanted to have her own Ramayana production as an Indian dance company. Considering the fact that she was from Kalakshetra and took part in Rukmini's Ramayana production, she was inspired by them and felt that an Indian person at the glass company should have a Ramayana repertoire (The Making of Anjaneyam–Hanuman's Ramayana by Aravinth Kumarasamy and Chithra Sundaram, May 16, 2020, https://www.youtube.com/watch?v=lUm2rZOGl80, accessed on 18 March, 2021).

[31]The event was coordinated by the Indian Council for Cultural Relations (ICCR). The ICCR is doing a seminal job of taking Indian culture around the globe and bringing global culture to India.

frailty. Interest in the Rama tale is by no means confined to South or Southeast Asian populations and often crops up at unexpected places (Bose 2004: 4).[32] For Indians, however, the Ramayana is more than an ancient Indian epic. The Ramayana's impact on the general public stems from its successful use as a political reference point in India since the late 1980s (Rajagopal 2001). The epic appears to be on its way to becoming an instrument of identity formation, especially among the Hindus of Indian diaspora communities, where public chanting of the Tulsidas Ramayana has developed significantly over the years (Singh 2010). In this final section, I argue how performance of the Ramayana represents a global Indian identity by analyzing Apsaras Art's *Anjaneyam-Hanuman's Ramayana* production and the reactions to it in the Indian art world.

Let us begin with an overview of *Anjaneyam-Hanuman's Ramayana*. This production had been conceived, scripted, and directed by Mr Kumarasamy. He has explained the production as follows:

> *We, like [other] ASEAN countries, have a closer tight [or relationship] with Indian [in connection with] culture, religion, arts, and music and dance......we live in Singapore are sounded by our ASEAN neighbors, and in this production, we take inspiration from Javanese Ramayana practised in Indonesia. You will see the narrative bring it together Valmiki's original Ramayana text; Tulsidas's Ramayana; the Kamba Ramayanam [or Ramavataram] from Tamil Nadu, South India; and the Kakawin Ramayana from Java, Indonesia, coming together. This production brings together the narratives of these great Ramayanas and presents Hanuman as the central character.* (Kumarasamy 2018)

In this production, the story focuses on one of the most important characters in the Ramayana tales, Hanuman, the monkey god who plays a significant role in Prince Rama's campaign to rescue his wife Sita from the 10-headed demon king Ravana. The Ramayana is generally told from a man's point of view, and dance development with animals is rare in the Ramayana production. The reason why the main task is to take Hanuman has been given by Mr Kumarasamy as follows:

[32]For example, Bose reports that the distinctly off-the-beaten-path Salt Spring Island, off the western coast of Canada, has hosted an annual Ramayana performance exclusively for the enjoyment of the local community for many years (Bose 2004: 4).

> [Among all the characters in the Rayamayan], Hanuman is a favourite
> character, not only in India but also in Southeast Asia, and even in the
> Javanese Ramayana, Hanuman has a large influence, and we were
> thinking 'how do we tell our Ramayana?', so we thought we would
> take a different perspective of it, it's form of the life of Hanuman. Most
> Ramayana literary works do not talk about Hanuman's earlier life when
> he was young. They only start from when he meets Rama, and that is that
> till the end. So we thought we can tell the story from Hanuman's life point
> of view. (Kumarasamy 2020)

From Hanuman's birth to his encounter with the exiled Prince
Rama and the valiant fight against Ravana and his armies, the
production follows Hanuman's life and adventures. We witness the
birth of the Ramayana when Hanuman meets its author, Maharishi
Valmiki, as the tale unfolds through dance and music. *Anjaneyam-
Hanuman's Ramayana* gives the tale a distinct perspective that makes
this particular narrative unique among all the other versions of the
Ramayana ever told. During a conversation with Mr Kumarasamy on
the making of *Anjaneyam-Hanuman's Ramayana*, UK-based dance/
theater choreographer Ms Chithra Sundaram praised Kumarasamy's
new approach:

> I just have to say you know when modern Indian theatre really came
> back into force which is [when] people start writing and looking back
> to Indian traditions, you know, ... They all had to go back to their own
> traditions, in which they found multiple voices, multiple voices saying
> the same thing. All Puranas (or Indian genre of Hindu literature), all the
> same stories but see from how many different angles you can get it, and
> I think they are a great source for this multiple rare storytelling, and
> multiple viewpoints and voices. I think that is a really exciting thing for
> you to do. (Kumarasamy and Sundaram 2020)[33]

Anjaneyam-Hanuman's Ramayanu was cross-cultural and a
collaborative mega production that brought together different
institutions from across Asia, including Era Dance Theatre
(Singapore), Kalakshetra Repertory Theatre (India), and Bimo
Dance Theatre (Indonesia). More than 200 people were involved in
the production, and the work juxtaposed Indian and Southeast Asian

[33]A conversation on the Making of *Anjaneyam–Hanuman's Ramayana* by Aravinth
Kumarasamy and Chithra Sundaram, May 16, 2020.
(https://www.youtube.com/watch?v=lUm2rZOGl80, accessed on 15 March, 2021)

interpretations of the epic, as well as original music, lighting, and projection mapping, using Bharatanatyam and Javanese dance forms. The point we must raise here is that not only did two legendary Indian classical dancers—V. P. Dhananyanan (India) as Valmiki and C. K. Balagopal (India) as old Hanuman—make guest appearances, the main characters were mostly performed by non-Singaporean dancers, such as Hari Padman (Kalakshetra, India) as Hanuman, Malay dancer Osman Abdul Hamid (Singapore) as Ravana, Lavanya Ananth (India) as Sita, and Mohanapriyan Thavarajah (principal dancer of the Apsaras Arts, of Sri Lankan Tamil origin from Sri Lanka) as Indrajit.[34] As a matter of the fact, the ensemble scene of the production was performed by Singaporean dancers of Apsaras Arts and Kalakshetra dancers from India. In addition, the production's musical score was composed by Dr Rajkumar Bharathi (India) and his team, which blended Javanese Gamelan music with Carnatic and Hindustani ragas. Furthermore, the stunning visual graphics were created by Himanshu Gosh (India), and the effective lighting was designed by Gyan Dev Singh (India). Sai Sharvanam (India) was in charge of music co-direction and sound design. Noteworthily, 3D quadraphonic surround sound was used for the first time at the Esplanade. Not only that, the staging was one of the first times in which 3D projection mapping was used successfully in an Indian classical dance production.

There is no doubt that the director of the production intended to create a scenic design that mirrored the age-old traditional aesthetics of Indian art forms while integrating modern technology. The latest technology brought the audience a visual experience of the epic world. Singapore's art scene and its ecosystem are constantly evolving, with a diverse cultural scene that includes world-class museums, international galleries, including the Singapore International Arts Festival and the Singapore Biennale. Likewise, the visual arts industry has seen tremendous growth in recent years. It is clear that the Singapore art scene can provide a platform with advanced technology and high-tech infrastructure. From this point of view, Dr Sunil Kothari, a prominent Indian dance critic, made some comments on *Anjaneyam-Hanuman's Ramayana*:

[34]The choreography was enhanced by the collaboration of Malay and Indian choreographers, Mohanapriyan Thavarajah, Jayanthi Subrahmaniam (India), Osman Abdul Hamid, and Hari Padman.

It was amazing how Aravinth managed to mount this large-scale production featuring dancers and musicians from Singapore, Indonesia and India, convincing Esplanade to join hands and part finance it.
The story is well-known. Drawing from other Ramayanas and Javanese Kakawin Ramayana, Aravinth has woven the story, with flashbacks, at times narrated by musicians, palaces move and forests appear, sea waves roar and Hanuman flies, sets fire to Sri Lanka - lighting and sound create astounding effect. Such a large-scale production deserves to be seen in other cities in India, where the Ramayana is known to everyone and its performances are a living tradition. Even when we do not have anything to compare with Esplanade Theatre in Singapore, NCPA [the National Centre for the Performing Arts] in Mumbai, Sir Mutha Venkatasubba Rao Concert Hall in Chennai, and Siri Fort in New Delhi are venues where this production can be mounted. We wonder with all the wealth India boasts of why there is no national theatre comparable with Esplanade and its infrastructure. It is time those in power take this issue seriously and let us have in India, a theatre where we can enjoy such productions.[35]

Dr. Kothari praised the production not only for its quality, but also for the state-of-the-art facilities, while at the same time criticizing the infrastructure in India for the performing arts. *Anjaneyam-Hanuman's Ramayana* has truly shown the difference in infrastructure between India and the latest developed countries.

Apsaras Arts is based in Singapore, and *Anjaneyam-Hanuman's Ramayana* was funded by the National Arts Council and the Esplanade, both government-affiliated organizations. As we have seen, many of the main dancers and technical members of the production had been flown in from India. Even though the production was a multinational partnership and that even the Esplanade encourages international collaboration, *Anjaneyam-Hanuman's Ramayana* has demonstrated that the Singapore art scene acts as a hub to provide a platform for the Indian artists and diasporas to present global Indianness. Not only Singaporeans, but also many talented Indian artists and technicians have worked in Singapore's well-funded and technologically advanced theater productions that cannot be achieved in India,

[35]*NARTHAKI*, "Footloose and fancy free with Dr Sunil Kothari," December 11, 2017 (https://narthaki.com/info/gtsk/gtsk165.html, accessed on 19 October, 2020). Similar comments were made by him on the presentation entitled "The Modern Dance Ensemble" by Mr Aravinth Kumarasamy at the 38th Natya Kala Conference: Aneka, Day 2 December 27, 2018 in Chennai, India.

which had made these productions more reflective of global Indian culture than of Singaporean culture.

The culture of the people of Indian descent, who are minorities but have lived in Singapore since the earliest days of the founding of the country and contributed to the country's cultural, economic, and political growth, is regarded as both a local and national cultural heritage of Singapore as a multiethnic nation. The fact that the Ramayana is being performed in Singapore by Indians, including actors and technicians, demonstrates that the work is representative of Singapore as an immigrant country. At the same time, it serves as a sign of the Indian diaspora, as Indian culture that started in Singapore and is now circulating around the world. It expresses the identity of global Indians in this way.

5.5 Conclusion

The portrayal of the Ramayana and the evolution of Ramayana performances among the Indian community of Singapore are the subjects of this chapter. Since there is a glimpse of a strategy to place the Ramayana as a national cultural heritage as arts and culture policies develop in the country, I demonstrated how the Ramayana has been portrayed in artistic infrastructures, tourist and cultural activities, and how Ramayana performances by Indian groups are connected to global representations of Indians that originate in Singapore.

The Ramayana has influenced the developing literary worlds of Southeast Asian countries as well as their cultures through drama, puppetry, and other types of performing arts. From paintings to sculptures, literature to royal administration ethos, coronation rituals to cremation, from local dance to the grand ceremonies, the Ramayana's presence can be seen all over Southeast Asia. As discussed in Chapter 1 of this book, over the years, the ASEAN countries have begun to value the Ramayana as a common cultural heritage and have held numerous cultural events related to the Ramayana, including a performance by an Indian delegation from Singapore in 2016 in Bangkok. Furthermore, the Ramayana has recently emerged as a key soft power tool in India's current Union government's Act East Policy, when India hosted the 2018 ASEAN Summit with leaders from all 10 ASEAN member nations. The Ramayana is considered

a common heritage of the eastern world, and the saga is a familiar theatrical theme in ASEAN countries.[36] The Ramayana is now more than a reflection of Indian culture or the vernacular culture of Indian forces in these regions; it is also an arena where various agencies and political agendas collide. As the second, third, and fourth generations of Indian diaspora in Singapore grow older, they seem to have adopted a stronger Singaporean identity than an identity based solely on their Indian roots. For them, the Ramayana is a tale they see in Indian performing arts or at Hindu temple events, not a story or set of beliefs that they can relate to in their daily lives. On the one hand, the Ramayana is a cultural tradition in their own community, and it is also considered a national cultural heritage in Singapore. In other words, the Ramayana is not only a cultural resource for the Indian diaspora to join but also a cultural heritage for Singapore to create.

It is striking that in a casual conversation, *Terukkuttu*, Tamil street theatre, practitioner, who was invited to Singapore for a performance, said that as long as there are mountains on this earth, the Ramayana will be retold over and over again. We may say that the success of the Ramayana mega production created by new generations on the cross-cultural platform with advanced technology and high-tech infrastructure can be seen as the symbol of a global Indian culture that reflects the Indian diaspora around the world as well as the multinational state of Singapore. It has been 200 years since Sir Thomas Stamford Raffles landed with 120 Indian sepoys in Singapore in January 1819. The new generation of Indian Singaporean looks for meaning in the same source of sustenance that their forefathers did—the Ramayana.

Acknowledgments

This research was partially supported by Japan Society for the Promotion of Science (JSPS) KAKENHI grant number 19H01208 (representative: Madoka Fukuoka) and 17KK0038 (representative: Yoshiaki Takemura).

[36]*The Economic Times*, Politics "Asean artistes in big roles as Ramayana helps build bonds with the 10-nation bloc," January 25, 2018 (https://economictimes.indiatimes.com/news/politics-and-nation/asean-artistes-in-big-roles-as-ramayana-helps-build-bonds-with-the-10-nation-bloc/articleshow/62643526.cms?from=mdr, accessed on 18 March, 2021).

References

Bose, Mandakranta (2004) *The Ramayana Revisited* (Oxford University Press, UK).

Chua, Alvin (2016) Thau Yong Amateur Musical Association, *SingaporeInfopedia* (https://eresources.nlb.gov.sg/infopedia/articles/SIP_1690_2010-07-15.html).

Gaston, Anne-Marie (2005) *Bharata Natyam: From Temple to Theatre* (Manohar, India).

Iyenger, K. R. Srinivasa (1983) *Asian Variation in Ramayana* (Sahitya Akademi, India).

Jayaram, N. ed. (2004) *The Indian Diaspora: Dynamics of Migration*, (Sage Publications, India).

Kawasaki, Kenichi (2010) Singapore: A creative city, global cultural policies and new cosmopolitanism, *The Annals of Japan Association for Urban Sociology*, **28**: 75–86 (in Japanese).

Kersenboom, Saskia C. (2011 [1987]) *Nityasumaṅgalī: Devasasi Tradition in South India* (Motilal Banarsidass, India).

Koh Tai, A. (1980) The Singapore experience: Cultural development in the global village, *Southeast Asian Affairs*, **7**: 292–307.

Krishnan, Gauri Parimoo (1997) Introduction, Asian Civilizations Museum, ed., *Ramayana: A Living Tradition,* pp. 8–21 (National Heritage Board, Singapore).

Krishnan, Gauri Parimoo (2010) Introduction, Gauri Parimoo Krishnan, ed. *Ramayana in Focus: Visual and Performing Arts of Asia* (Asian Civilizations Museum, Singapore).

Kumaraswamy, Aravinth (2018) The Modern Dance Ensemble, the presentation at the 38th Natya Kala Conference: Aneka, Day 2 December 27, 2018 in Chennai, India.

Kumaraswamy, Aravinth (2020) Kalaa Utsavam-Indian Festival of Arts, Join us for a conversation with Aravinth Kumarasamy, the Artisitic Director for Anjaneyam-Hanuman's Ramayana, and Ramachandran, a producer at Esplanade, May 30, 2020. (https://www.facebook.com/watch/live/?v=567014130671300&ref=watch_permalink)

Kumaraswamy, Aravinth and Sundaram, Chithra (2020) The Making of Anjaneyam–Hanuman's Ramayana, Online conversation hosted by @samarpanafortheartsandwellbeing, May 16, 2020. (https://www.youtube.com/watch?v=lUm2rZOGl80).

Kwok, Kian-Woon and Low, Kee-Hong (2002) Cultural policy and the city-state: Singapore and the "New Asian Renaissance" in Crane, Diana, Kawashima, Nobuko, Kawasaki, Ken'ichi, eds., *Global Culture: Media, Arts, Policy, and Globalization* (Routledge, UK).

Lutgendorf, Philip (1995) All in the (Raghu) Family: A video epic in cultural context, Babb, L. A. and S. S. Wadley, eds., *Media and the Transformation of Religion in South Asia*, pp. 217–254 (University of Pennsylvania Press, USA).

Meduri, Avanthi ed. (2005) *Rukmini Devi Arundale (1904–1986): A Visionary Architect of Indian Culture and the Performing Arts* (Motilal Banarsidass, India).

Miettinen, Jukka O. (2017) Parallel narrative methods: Ramayana in the arts of Southeast Asia, in Long, Fiachara and Long, Siobhán Dowling, eds., *Reading the Sacred Scriptures: From Oral Tradition to Written Documents and their Reception*, pp. 282–295 (Routledge, UK).

O'Shea, Janet (2007) *At Home in the World: Bharata Natyam on the Global Stage* (Wesleyan University Press, USA).

Rajagopal, Arvind (2001) *Politics after Television: Hindu Nationalism and the Reshaping of the Public in India* (Cambridge University Press, UK).

Rai, Rajesh (2008) Positioning the Indian diaspora: The South-east Asian experience, Parvati Raghuram, Ajaya Kumar Sahoo, Brij Maharaj, Dave Sangha eds., *Tracing an Indian Diaspora: Contexts, Memories, Representations*, pp. 29–51 (Sage Publications, India).

Rajan, Shakar (2015) Post-independence: The awakening and maturing years—1965 to 2000, Ramaswami, Seshan and Alukar-Sriram, Sarita, eds., *Kala Manjari: Fifty Years of Indian Dance Classical Music and Dance in Singapore*, pp. 31–52 (Singapore Indian Fine Arts Society, Singapore).

Rama, Sri (2015) Bridging cultures: Implication of the Indian arts on multiracial Singapore, Ramaswami, Seshan and Alukar-Sriram, Sarita, eds., *Kala Manjari: Fifty Years of Indian Dance Classical Music and Dance in Singapore*, pp. 117–128 (Singapore Indian Fine Arts Society, Singapore).

Ramanujan, A. K. (1991) Three hundred Ramayanas: Five examples and three thoughts on translation, Richman, Paula, ed. *Many Ramayanas: The Diversity of a Narrative Tradition in South Asia*, pp. 22–49 (Berkeley: University of California Press, USA).

Ranaswami, Seshan and Alukar-Sriam, Sarita, eds. (2015) *Kala Manjari: Fifty Years of Indian Classical Music and Dance in Singapore* (Singapore Indian Fine Arts Society, Singapore).

Richman, Paula, ed. (1991) *Many Ramayanas: The Diversity of a Narrative Tradition in South Asia* (Berkeley: University of California Press, USA).

Richman, Paula, ed. (2000) *Questioning Ramayanas: A South Asian Tradition* (Oxford University Press, India).

Saklani, Dinesh (2013) Ramayana Tradition in Performing Arts, Agarwal, Ashwani, ed., *Legacy of Indian Art: Continuity in Change* (Aryan Books International, India).

Samson, Leela (2010) *Rukmini Devi: A Life* (Penguin Viking, India)

Singh, Sherry-Ann (2010) The Ramayana in Trinidad: A socio-historical perspective, *The Journal of Caribbean History,* **44**(2): 201–223.

Singh, Varsha (2019) Epics as cultural commodities: Comics books of the Ramayana and the Mahabharata, *The Journal of Commonwealth Literature,* OnlineFirst (https://journals.sagepub.com/doi/10.1177/0021989419881231).

Sykes, Jim (2015) Towards a Malayan Indian sonic geography: Sound and social relations in colonial Singapore, *Journal of Southeast Asian Studies,* **46**(3), pp. 485–513.

Soneji, Davesh, ed. (2010) *Bharatanatyam: A Reader* (Oxford University Press, India).

Takemura, Yoshiaki (2016) The importance of multi-dimensional aspects contributing to the development of traditional Indian dance in the nation of Singapore, *Choreologia,* **38**: 120–137 (in Japanese).

Vatsyayan, Kapila (2004) The Ramayana theme in the visual arts of South and Southeast Asia, Bose, Mandakranta, ed., *The Ramayana Revisited,* pp. 335–359 (Oxford University Press, India).

Vatsyayan, Kapila (2010) 20th century interpretation of the Ramayana in Indian Dance: Rukmini Devi and Shanti Bardhan, Gauri Parimoo Krishnan, ed., *Ramayana in Focus: Visual and Performing Arts of Asia,* pp. 175–181 (Asian Civilisations Museum, Singapore).

Velayutham, Selvaraj (2007) *Responding to Globalization: Nation, Culture and Identity in Singapore* (Institute of Southeast Asian Studies, Singapore).

Vishwanathan, Lakshmi (2014) Rukmini Devi: The intangible innovator, *Kalakshetra Journal,* **1**: 1–13 (Kalakshetra Foundation, India).

Wee, C. J. W-L. (2002) *Local Culture and the "New Asia": The State, Culture, and Capitalism in Southeast Asia* (Institute of Southeast Asian Studies, Singapore).

Weiss, Sarah (2020) Negotiating Singaporean identities: Observations from study at an Academy of Indian Music and Dance Performance, Sharif, Malik and Stepputa, Kendra, eds., *Understanding Musics: Festschrift on the Occasion of Gerd Grupe's 65th Birthday*, pp. 293–312 (Shaker Verlag, Düren).

Chapter 6

Ramayana Theater in Tourism Culture: The Story Presented in the Javanese Dance Drama Form, *Sendratari*

Madoka Fukuoka

Graduate School of Human Sciences, Osaka University,
Yamadaoka 1-2, Suita, Osaka, Japan
mfukuoka @hus.osaka-u.ac.jp

This chapter focuses on a theatrical form of Ramayana for tourists in Java, Indonesia. The region focused on in this chapter and the names of the main characters are as follows:

Region in this chapter: Central Java

Names of the main characters in this chapter, Sanskrit names are written in parentheses ():

Rama/Ramawijaya/Rama Wijaya (Rama)

Rahwana (Ravana)

Sinta/Shinta/Sinto (Sita)

Anoman/Hanoman (Hanuman)

Ramayana Theater in Contemporary Southeast Asia
Edited by Madoka Fukuoka
Copyright © 2023 Jenny Stanford Publishing Pte. Ltd.
ISBN 978-981-4968-09-6 (Hardcover), 978-1-003-29095-7 (eBook)
www.jennystanford.com

Leksmana/Laksmana/Lesmana (Lakshmana)

Kumbakarna, Kumbokarno (Kumbhakarna)

Sugriwa (Sugriva)

6.1 Introduction

This chapter focuses on Ramayana theater as one of the main objects in the tourism context where the cultural practices interact with the outsider's gaze as well as the local people's gaze. It considers the representation of Ramayana in the performing art forms directed toward the performance for tourists. The main research questions in this chapter are as follows: Why has Ramayana theater been positioned as the main object in the performing art forms for tourists? How has its representation been developed until today? What are the differences between the performances in the tourism context and the performance opportunities in the local community? Through the pursuit of these research questions, the multiple meanings of Ramayana theater where different aspects emerge depending on the contexts will be indicated.

The following description focuses on the story elements of the Ramayana and their representation in the dance drama form, *sendratari* in Java, Indonesia. The word *sendratari* is derived from *seni* (art), drama, and *tari* (dance). While *sendratari* narrates the story to the audiences, its most prominent characteristic is the exclusion of the verbal elements from the performances. The theatrical form was created and first performed in 1961 in Central Java. Since then, it has been continuously developed in various places in Java and Bali, especially as a performance form for tourists.

Through the analysis of the characteristics of the story elements in the dance drama form, the differences between the theatrical expression embodied in the performances in the tourism context and the local context will be considered. Currently, the major performances of *sendratari* focus on the linear, central plot of the Ramayana story, which is presented to the audiences through dancing, acting, and music; however, it excludes verbal expressions, such as line, dialogue, and narration. As the performance style uses almost no verbal expression, the genre is called "Ramayana ballet."

The way of presentation of the story in this art form, influenced by Western art forms, indicates the prominent differences from the presentation of the performing art forms in the local contexts that embodies the indigenous worldview of Javanese people.

The name *sendratari* is well known in Java and Bali, and there are many styles of *sendratari*, including the ones focusing on another Indian epic, Mahabharata, and other stories. In this chapter, the focus will be on the performance of *sendratari* Ramayana for tourists at the famous historical site Prambanan, Central Java.[1]

As the main subject of consideration, the most popular 2-hour performance for tourists would be examined. A comparative analysis between the stories of Ramayana in a *sendratari* performance in Prambanan and the traditional shadow puppet, *wayang kulit*, will also be considered.

As described in Chapter 1, Section 1.2.3, there are two main versions of Ramayana in Javanese theatrical performances: One version follows the original composition by the Indian poet Valmiki, and the other is derived from the 16th-century text titled "*Serat Khanda*" (*Serat Kandhaning Ringgit Purwa*). The latter text consists of 440 verses. From stanzas 22 to 80, it contains many stories disseminated at that time, including the stories of Prince Rama. A Japanese researcher, Toru Aoyama, classified them as "classical" or "Valmikian" version and "modern" or "non-Valmikian" version, respectively. The first Valmikian version appeared in the 9th century as the Old Javanese *Ramayana Kakawin*, a translation of the Sanskrit poem Bhattikavya composed by the 7th-century Indian poet, Bhatti, which itself is a condensed but faithful rendering of Valmiki's Ramayana. As this is the earliest written text of the Ramayana in Old Javanese, the work and works influenced by it in the later times may be regarded as "classical" for the Javanese audience. In contrast, non-Valmikian versions started appearing in the 16th century as texts in modern Javanese. However, elements of the non-Valmikian version must have existed earlier, probably in oral tradition, as found

[1]There are many tourist sites in Java. In the city of Yogyakarta, Central Java, the *sendratari* Ramayana is performed in the Prawisata open theater in the southern part of the city. Although the total performance time is rather short and the spectacles are small scale, the performance style is similar to that in Prambanan.

in the Ramayana reliefs in the Prambanan temple built in the 9th century. Thus, it would be more appropriate to name them simply "Valmikian" and "non-Valmikian" versions. While both versions have been disseminated among Javanese people, the "Valmikian" version has been adopted in the context requiring the representative traditions of Indonesia (Aoyama 1998: 150).

The tourism context to be focused on in this chapter can be positioned as one of the contexts requiring the "representative" tradition of Indonesia. The "Valmikian" version of Ramayana had been adopted as the main repertoire in the current *sendratari* performances for the tourists. In the following sections, the differences between the two main streams of the story will be considered.

The content of this chapter overlaps with the author's Japanese articles (Fukuoka 2008, 2016) in some parts, while the cases and discussions have been significantly revised.

6.2 Repertoire of the Stories in Shadow Puppet Plays and *Sendratari*

6.2.1 Ramayana Stories in Shadow Puppet Plays

The characteristics of the "non-Valmikian" version derived from the 16th-century text *Serta Khanda* can be seen in the complex plots and the intricate human relationships between the protagonists. It also embodies the Javanese belief system, including mysticism. Its episodes have become the main repertoire of the shadow puppet performance. During such a performance, a specific episode, or *lakon*, focusing on particular characters and the events related to them, is presented as a onetime performance. Each episode has a stylistic structure, including the opening, meeting scene, clown acting scene, battle scene, and closing. The presentation of one episode has no chronological connection with that of the other episodes. For the audience in the local communities, there are various opportunities to see performances such as the rites of passage (birth, circumcision, marriage, etc.), the rituals related to the rice cultivation (planting, harvesting, etc.), and so on. The

audience might have the opportunity to see the episode of *Rama Tambak*, which depicts Rama's construction of the bridge over the sea, in participation of a neighbor's ritual; however, after that, they might have another opportunity to see the previous episode *Anoman Obong*, depicting the monkey soldier Hanuman burning down the demon's kingdom, in participation of another event. The audience of the shadow puppet plays recognizes the story world of the epic by randomly experiencing these episodes.

The Ramayana stories depicted in a shadow puppetry can be roughly divided into two parts: the part describing King Harjunasasrabahu's control over the demon king Ravana before Prince Rama's birth and the main part describing Prince Rama's journey. The part describing Harjunasasrabahu includes the episodes about Ravana's birth, the episodes surrounding the Lokapala Kingdom, as well as the episodes on King Harjunasasrabahu and his vassal Sumantri. It also includes the genealogy of the monkey characters. On the other hand, the main part consists of the episodes describing Rama's marriage with Sita, their exile and abduction of Sita, and the battle between Prince Rama's army and the demon king Ravana. There are various episodes in the main part from Prince Rama's birth as the reincarnation of the god Vishnu, to his return to Ayodhya. Sunardi, the author of the Indonesian adaptation of Ramayana published in 1979, listed 18 episodes in the 36th and the 37th volumes of *Serat Padalangan Ringgit Purwa* as the source of his adaptation (Sunardi 1979: 7). Based on these 18 episodes, he indicated the 58 chapters of the main part of Ramayana story in his book (Sunardi 1979).

In the repertoire of Javanese shadow puppetry, stories in these two parts coexist. A Japanese researcher, Matsumoto, divided the episodes of Ramayana in Javanese shadow puppet into three parts instead of two mentioned earlier: Lokapala kingdom, King Harjunasasrabahu, and the main part, and cited around 20 episodes related to all of them (Matsumoto 1982: 246–247).[2]

The episodes in the part related to King Harjunasasrabahu embody the characteristics of the "non-Valmikian" Ramayana derived from *Serat Khanda*. These episodes form an important repertoire of

[2]On the other hand, Kathy Foley, a researcher on West Javanese rod puppet plays, indicated the existence of 23 episodes related to Harjunasasrabahu and 30 episodes related to the main part of Ramayana (Foley 1979: 270–274).

Javanese shadow puppetry.[3] They indicate the Javanese preference for intricate arrangement of stories and human relationships. Due to this complication, it is rather difficult for outsiders to share, understand, and appreciate these episodes.

6.2.2 Repertoire of the Stories in *Sendratari*

While the "non-Valmikian" Ramayana has become the main repertoire in shadow puppetry, the "Valmikian" version, which originated from Valmiki's version, has become the main subject of *sendratari*. This version depicts the stories related to Prince Rama and his adventures.

In many forms of dance drama in Java, *wayang wong* or *wayang orang* can be positioned as the basis of *sendratari*. Despite the similarities between the performance styles within the same dance drama genre, the repertoire of the stories in *wayang wong* that have similarities with the repertoire of *wayang kulit*, differs from that of *sendratari*.[4] The repertoire of *sendratari* featuring the stories on Prince Rama can be considered as the result of adopting the main plot of the "Valmikian" version of Ramayana according to the new context, tourism.

For many tourists who are unfamiliar with the Javanese texts, the "Valmikian" version can be more understandable than the episodes containing a complex plot and intricate human relationships between the protagonists. Moreover, comparing with the episodes of another Indian epic, Mahabharata, which contains many more characters and their complex relationships as well as many folk tales unrelated to the main story, the "Valmikian" Ramayana can be regarded as a more comprehensible story for tourists.[5] Besides the advantage of the clearly structured version, one of the reasons the epic Ramayana has become the main subject for tourism culture may be due to its popularity beyond Indonesia, including

[3]Also, if compared with the episodes of another Indian epic, Mahabharata, which includes a huge repertoire, the frequency and the total number of the episodes of Ramayana in the performance of shadow puppetry are relatively fewer.

[4]Jennifer Lindsay reported the episode in *wayang wong* that connects the Ramayana with the Mahabharata in her article. She described the episode, *Rama Nitis*, depicting Rama's incarnation (Lindsay 1991: 157–194). Moehkardi also pointed out the same situation (Moehkardi 2011: 35). The episodes that connect Ramayana with Mahabharata can be seen in the repertoire of shadow puppetry.

[5]Aoyama also pointed out the situation in his study (Aoyama 1998: 158).

the other tourism sites in Southeast Asia.[6] As described in other chapters in this book, Ramayana has been the main repertoire of theatrical play for tourists in various regions such as Thailand and Cambodia. Moehkardi pointed out that the Ramayana story had been disseminated internationally and the moral value between good and evil embodied in this story is universal (Moehkardi 2011: 50). Due to its familiarity and morality, the story derived from "Valmikian" version has come to be performed for tourists.

6.3 Creation of *Sendratari* Ramayana in Java

6.3.1 Creation

Sendratari was first performed in 1961 at the open theater in front of the temple Roro Jonggrang in Prambanan, a famous historical site in Central Java. The genre was created under Vice-admiral Jatikusumo's initiative, who was the Minister of Tourism at that time. The performances had been supported by the Department of Land transportation, Post, Telecommunication, and Travel (Departemen Perhubungan Darat, Pos, Telekomunikasi, dan Pariwisata, PDPTP) (Moehkardi 2011: 37). Moehkardi described that the performance by 475 dancers and 242 other performers was held in the open theater of Roro Jonggrang (Moehkardi 2011: 37).

The performance style includes two main Javanese art traditions, Surakarta and Yogyakarta styles, as many artists from these regions were involved in the creation process. The new genre can be positioned as an "eclectic Javanese form," containing the characteristics of these regional styles in various elements including the Javanese music ensemble, *gamelan*.

The creation of *sendratari* Ramayana intersects with the development of tourism culture in Indonesia that had developed gradually since the early 20th century.[7] It also intersects with the creative activities of the representative national performing art

[6]The story world of another epic, Mahabharata, has mainly been disseminated in Java and Bali in Indonesia. Its vast repertoire includes the main subject in Javanese and Balinese puppet plays.

[7]Dahles summarized the tourism policy in Indonesia that dates back to the colonial period (Dahles 2001: 27–34). According to the description, in 1908 the colonial government opened the tourist bureau in its capital city Batavia in order to promote the Netherlands East Indies as a tourist destination (Dahles 2001: 27).

forms in Indonesia.[8] Embodying the cultural elements based on the "Javanese" styles, the theatrical performances had been positioned as the representative objects both in cultural tourism and national culture. The researchers and specialists of arts from both regions have debated on the regional styles represented in the performance.[9] Being created as the art form for the tourism and national culture, *sendratari* has been the platform to consider about the elements of the representative art expressions for outsiders as well as local people.

In the report on Ramayana seminar held in Yogyakarta in 1970, Soeharso described that Jatikusumo was inspired to create a new dance drama form from a dance performance in Angkor Wat, Cambodia. He also described that Jatikusumo organized the performance based on the Ramayana story at the Prambanan temple after seeing its bas reliefs depicting the story (Soeharso 1970: 12).[10]

6.3.2 Stories

The story in the *sendratari* was directly derived from the literary text entitled *Serat Rama* by the Javanese court poet Yosodipro I (1729–1803) (Soeharso 1970: 17). The work is the modern Javanese translation of the ancient Javanese text *Ramayana Kakawin*, which is based on the Sanskrit *Bhattikavya*, which, in turn, originated

[8]Analyzing the situation of Special Province of Yoyakarta, Dahles described "The cultural heritage of the Yogyakarta area has shaped the (international) image of Indonesia, as government propaganda has used architectural structures like the temples and the sultan's palace and expressions of art like the Ramayana dance to promote Indonesian tourism world-wide" (Dahles 2001: 20). Here, Ramayana dance is positioned as the representative art expressions.

Examining the details how *sendratari* Ramayana had been created both in Java and Bali, Japanese researcher Mariko Koike also positioned *sendratari* Ramayana as one of the forms of Indonesian national culture (Koike 2009).

[9]Moehkardi described that *sendratari* in the early time was of the Surakarta style dominantly because of the participation of many dancers, specialists, and members of the committee from Surakarta; however, it gradually changed to the mixed style of Surakarta and Yogyakarta as a result of the participation of young students from the Yogyakarta arts academy, and the mixed style is called "Prambanan" style (Moehkardi 2011: 48).

[10]Moehkardi also described the process of creation in his study (Moehkardi 2011: 50–51).

from Valmiki's version.[11] Therefore, it can be categorized as the "Valmikian" version of the Ramayana from the point of view of the genealogy of the story.

Although the dance drama was based on the "Valmikian" Ramayana, the episode structures in the performances with stylized scenes were similar to traditional theatrical form such as shadow puppetry. Soeharso described the 1961 performance program in the open theater as follows (Soeharso 1970: 14):

- Episode 1 Abduction of Sita (*Hilangnya Dewi Sinto*)
- Episode 2 Hanuman as an envoy (*Anomoan Duto*)
- Episode 3 Hanuman burns Lankah (*Anoman Obong*)
- Episode 4 Rama reclaims the sea (*Pembuatan Jembatan di Samudera, Rama Tambak*)
- Episode 5 Death of Kumbhakarna (*Gugurnya Pahlawan Kumbokarno*)
- Episode 6 Sita tested in fire (*Ujian Kesetiaan Sinto, Sinto Obong*)

In the program composition, the beginning part that depicts Rama's birth and the background of his exile to the forest, and the last part that depicts Rama's return to his kingdom, were omitted (Soeharso 1970: 14). Despite these omissions, the structure indicated earlier corresponds to the mid-central part of the "Valmikian" Ramayana. Each episode was 2 hours long, including the climax scene, and all six episodes were performed for six consecutive nights during a full moon. Then, in 1967, these six episodes were reduced to four episodes, when episodes 2 and 4 were integrated with the rest. Thus, it became a performance for four consecutive nights (Soeharso 1970: 17).

The program composition has similarities with the episodes or *lakon* of the shadow puppet performance mentioned in Section 6.2.1. The episode titles, which focus on a particular protagonist and the incidents related to them, are similar to that of shadow puppetry. Although the "Valmikian" Ramayana was used, the program

[11]The source of the ancient Javanese *Ramayana Kakawin* was Sanskrit *Bhattikavya*, and it is positioned as the work derived from Valmiki's version. As the name of the author was described only as the title of "master of Yoga," the author/translator of *Ramayana Kakawin* is considered anonymous.

composition in *sendratari* was still like the traditional theatrical form in 1967.

However, the episode-dominant program composition had gradually been changed. Currently, popular *sendratari* performances for the tourists rely on plot-centered structures. The most popular performance for the tourists today, which is about the 2-hour-long version of the whole story, follows the linear plot of the "Valmikian" Ramayana.

6.4 *Sendratari* Ramayana as a Onetime Performance

For many visitors today, the performance at the open theater with Prambanan in the back is the most popular opportunity to watch the Ramayana. It is a onetime performance that presents the 2-hour-long version of the Ramayana's whole story. Next is the outline of the program composition in 2009, which consists of nine scenes. The outline is based on "The plot of Ramayana Full Story" leaflet distributed in 2009, by PT. Taman Wisata Candi Borobudur, Prambanan & Ratu Boko. The names of the protagonists are in Indonesian.

Introduction

King Janaka of the Mantili kingdom had held a competition to choose a husband for his daughter Dewi Shinta (Sita). In the end, the prince of Ayodya kingdom, R. Rama Wijaya (Rama) won the competition.

Prabu Rahwana (Ravana), the ruler of the Alengkadiraja (Langka) kingdom, had been pursuing the image of his eternal lover Dewi Widowati. Recognizing Dewi Shinta as the reincarnation of Dewi Widowati, he pursued her.

Dandaka Forest

Rama Wijaya, his wife Shinta, and Rama's younger brother Leksmana (Lakshmana) arrived at the Dandaka forest after the adventures. Fascinated by Shinta in the forest, Rahwana wanted to own her. To attract her attention, Rahwana ordered one of his followers named Marica to transform into a golden deer called Kijang Kencana. Transfixed by the deer's beauty, Shinta asked Rama to capture the deer for her. Rama left Shinta and chased the deer.

Shinta began to worry about Rama when he did not return for a long time. She asked Leksmana to follow and help Rama. Before leaving Shinta alone, Leksmana drew a magic circle around her to protect her from any possible danger.

Knowing Shinta was left alone, Rahwana tried to kidnap Shinta but he failed because of the magic circle. Then, he disguised himself as an old beggar and asked Shinta for her help. As soon as Shinta left the magic circle to help him, he abducted her and went back to the Alengka Kingdom.

Running after the Deer

When Rama shot the deer with his magic arrow, it turned back into the original form of the giant Marica. The two started fighting. Rama shot Marica with an arrow. Leksmana arrived and requested Rama to go back to Shinta's place.

The Abduction of Shinta (Penculikan Shinta/Shinta Hilang)

On the way to Alengka, Rahwana was stopped by a bird named Jatayu. Recognizing Shinta as the princess of his old friend Prabu Janaka, Jatayu attacked Rahwana to rescue Shinta. However, Jatayu was fatally defeated by Rahwana in battle.

Realizing that Shinta was missing, Rama and Leksmana started to search for her. They came across the fatally wounded Jatayu. Rama thought Jatayu had abducted Shinta, and decided to kill him but Leksmana intervened. Jatayu told them what had happened and, then, he died.

After that, a white monkey named Hanuman appeared. He was delegated by his uncle Sugriwa (Sugriva) to look for two heroes who would help Sugriwa to fight his elder brother Subali (Vali/Bali). Subali had robbed his brother's territory and his beloved wife, Dewi Tara by force. Learning about Subali's offense, Rama promised to help Sugriwa.

Kiskendo Cave (Goa Kiskenda)

With the help of Rama, Sugriwa attacked and defeated Subali and rescued his wife Dewi Tara. Sugriwa decided to help Rama look for Shinta. Hanuman was sent as an envoy to the Alengka Kingdom.

Argasoka Garden (Tamana Argasoka)

When Rahwana's niece Trijata was comforting Shinta in the garden, Rahwana arrived and asked Shinta to be his wife. Shinta refused to do so. Being angry, Rahwana tried to kill her but Trijata intervened and asked him to be patient. Moreover, she promised to look after Shinta.

As Shinta was feeling depressed, suddenly she heard Hanuman the white monkey, singing a beautiful song. Hanuman introduced himself, telling her that he had come to her as Rama's messenger. After that, Hanuman tried to find out about the total power of Alengka's army. Then he destroyed the garden. Indrajid, Rahwana's son, captured and tried to kill him. Wibisana, Rahwana's younger brother, adviced him not to kill the envoy, Hanuman. However, an angry Rahwana kicked out Wibisana from the kingdom. The captured Hanuman was set on fire, who then jumped around and burned down the kingdom's gardens.

Rama's Bridge

After Hanuman's departure as a messenger, Rama and the monkey army went to the sea and built a bridge to Rahwana's kingdom. When the bridge was finished, Hanuman returned and reported on Alengka's situation. Receiving the report, Rama thanked Hanuman. Then, he commanded Hanuman, Hanggada, Hanila, and Jembawan to lead troops to attack Alengka's army.

The Final War

When the giant troops of Alengka were guarding their country's boundary, they were suddenly attacked by the ape troops. Then, a fierce battle was fought between them. In this war, Indrajid was killed by Leksmana. Kumbakarna, the younger brother of Rahwana, died as a patriotic hero. After the death of Kumbakarna, Rahwana finally assumed the command of troops to face Rama. He was killed by Rama's arrow and Hanuman dropped Mount Sumawana on him.

The Meeting of Rama and Shinta

After the death of Rahwana, Shinta, accompanied by Hanuman, met Rama. He doubted her chastity, and rejected her. To prove her chastity, Shinta entered burning pyre. The God of fire saved Shinta and Rama finally accepted her.

(Based on the leaflet of the program by PT. Taman Wisata Candi Borobudur, Prambanan & Ratu Boko from the 2009 performance)

The characteristics of the story can be summarized as follows: Rahwana (Ravana) recognized Shinta (Sita) as the reincarnation of Dewi Widowati, his beloved. Before leaving Shinta, Leksmana (Lakshmana) drew a magic circle around her. When Rama was in mourning after losing his wife, he met Hanuman instead of Sugriva, and so on. These elements can be positioned as the influence of the Java-dramatized version of the Ramayana.

The abovementioned program composition is based on the whole plot of the "Valmikian" Ramayana. When compared with the 1961 program composition mentioned in Section 6.3.2, the plot before Sita's abduction contains more details. As a whole, the current program composition of a onetime performance can be positioned as a plot-centered structure that emphasizes the central part of the Ramayana story.

The performance progresses with the expressions of music, dancing, and acting. Besides some poetry recitations or songs, verbal elements such as lines or narrations are almost excluded from the performance. Narrative elements in the traditional theater form were replaced by visual expressions such as costumes, dancing, acting, and stage settings. The great number of the performers, including musicians and dancers, creates spectacular dramatic effects. In the scene with many dancers, their choreography and optimum positioning using the stage space is remarkable. In the battle scene, the actors actually shoot an arrow toward the antagonist who catches it. The most spectacular scene depicts Hanuman burning the Lanka kingdom using fire-lit torches in "Argasoka garden" in the sixth scene. After the scene, there is an intermission of 20 minutes to clean up the stage. Although the seventh to ninth scenes are considered important, compared to the fiery spectacle in the sixth scene, these scenes are less complicated due to the time constraint.

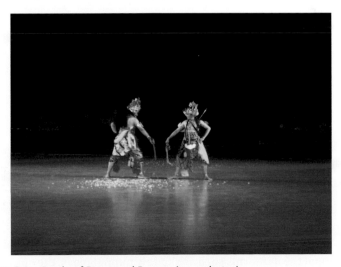

Figure 6.1 Battle of Rama and Ravana in *sendratari*.

The leaflets containing the story's summary described earlier, which are translated into various languages, are provided in the theater. Tourists can enjoy the performances through the linear plot, reading the summary in their own language.

Theatrical performances in *sendratari* focus on indicating the plot of Ramayana with specific theatrical elements. In tourism culture, tourists expect some extraordinary cultural experiences from these performances. As the plot unfolds through the spectacular performances it becomes, particularly, enjoyable for tourists.

6.5 Presentation of the Story in *Sendratari* Ramayana in Prambanan

6.5.1 Characteristics of the Story in *Sendratari*

As described in Section 6.4, the characteristics of the onetime performance of *sendratari* Ramayana are the indication of plot-dominant presentation. One of the important elements in *sendratari* is the presentation of Ramayana's central storyline as a whole through the theatrical performance. The composition of the scenes follows the linear flow of the story.

In his consideration of Balinese sendratari, Michel Picard pointed out the plot-dominant construction as its characteristic. In contrast to tourism performance, he also explained the presentation in Balinese traditional theater as follows:

> In Balinese (traditional) theater, the plot of a "story" is secondary, to the point of being almost unimportant, in the sense that a dramatic performance does not relate the lineal unfolding of a literary theme from its inception until its final denouement. Instead, it consists of a succession of discrete scenes, composes of a combination of independent elements, juxtaposed one after the other (Picard 1990: 52).

Regarding the relationship between the creation of the Javanese *sendratari* and the performances in traditional theater forms, we can see similar tendencies in Bali. In the performance of Javanese traditional theater forms such as shadow puppet plays, the emphasis

is on the stylized episodic structure rather than the plot. The episodic performances are stylistically constructed, consisting of definite scenes, such as the opening scene, the meeting scenes, the clown's scene, the battle scenes, the closing scene, where the protagonists act, dance, and cite lines in a characterized manner. On the other hand, the presentation of the Ramayana story in *sendratari* for the tourists can be positioned as a plot-dominant presentation. The important element of the performance is to indicate a comprehensible outline of the main plot, rather than the stylistic structures.

Picard also examined the idea of the Javanese *sendratari* as "to design a spectacle suited to a non-Javanese audience, unfamiliar both with the language and the dramaturgic codes of Javanese court theater" (Picard 1990: 52). The stylized constructions of the traditional theater can be considered as one of the most important "dramaturgic codes" mentioned by Picard (Picard 1990: 52). By eliminating the stylistic structure and presenting a linear plot, *sendratari* has become a form that even people who do not know dramaturgic codes can understand and enjoy. While the narrator in the Balinese *sendratari* is positioned as an important facilitator, there is no Javanese equivalent. Except for the song lyrics, there are few verbal elements in the Javanese *sendratari*.

The characteristics of the performance for tourists, who are unfamiliar with Javanese dramaturgic codes, lie in this plot-dominant presentation where the performance is designed to describe the entire plot without using verbal expressions.

The verbal elements are replaced by the spectacle of performance elements such as the magnificent Javanese *gamelan* music, dancing, acting, and costumes worn by the performers. During the performance, dramaturgic codes such as stylized acting, dancing, costume according to the character's type, and the stylized way of intertwining in the battle scene are used. In the scenes where the large numbers of dancers appear, effective choreographies that utilize the stage space are important; in the battle scenes, the techniques to make the arrows fly and hit the enemy are important. In the scene where Hanuman burns the gardens of Lanka (*Anoman Obong*), real torches are used and the actor playing Hanuman actually sets fire to some stacks of rice straw set on the stage. He performs dynamic acts such as jumping and somersaults. Tourists experience

the realism of burning fire on the stage. This spectacle is designed to bring memorable experiences to tourists.[12]

A plot-dominant performance featuring Javanese theatrical spectacles can be considered as one of the most prominent ways of presenting the Ramayana to the tourists.

6.5.2 Rejection of Local Cultural Elements

While the performance features some visible theatrical elements, it avoids certain Javanese cultural elements. Besides the Javanese language and the stylized episodic structure mentioned earlier, a complex version of the story and the Javanese thought process, including mysticism, has been avoided in the presentation.

One of the examples of the Javanese moral values can be seen in the episode of traditional theater featuring Ravana's birth. It includes the elements of Javanese mysticism, which is deemed important in the traditional shadow puppet play repertoire (Sears 1996: 55–74). The episode describes the background that led to the birth of Ravana, who looked like a demon, as the divine punishment for the improper disclosure of Javanese mystical knowledge by Ravana's father. Analyzing several versions, Sears positioned the episode as the result of Javanese mysticism's degradation from the Islamic viewpoint disseminated in the Javanese court during the 18th to 19th centuries (Sears 1996: 65). The episode embodies the contradictory situation where the importance and the degradation of Javanese mysticism coexist. The episode also embodies the peculiar sense of values as the Javanese people emphasize the complicated relationships of the characters that differ from the mere didactic dualism of good versus evil.[13] In the Javanese sense of values, Ravana can be positioned not only as the villain but also as the character punished for his parents' crimes. Moreover, Ravana can be positioned as the character with some high virtue. The gods granted him immortality because of

[12]Considering Balinese *sendratari*, Picard pointed out the adoption of Western style stage facing the audience (*panggung*) as one of the innovations in the performance (Picard 1990: 54). Adoption of a Western-style stage can also be seen in Javanese *sendratari*.

[13]The disclosure of Javanese mysticism (*Sastra Jendra Yuningrat*) by Ravana's father in this episode is positioned as an arrogant mistake to disobey divine authority. The god Batara Guru punished Ravana's parents with a son who looks like a demon (*raksasa*). Sears points out that the divine punishment for disclosing mystical knowledge can be interpreted as Islam's criticism of Javanese mysticism in the 18th and the 19th centuries (Sears 1996: 65).

his diligence of doing ascetic practice. In some versions of shadow puppet plays, Ravana would not die because of his immortality and had to be buried under the mountain thrown by Hanuman. Many discourses about Ravana being alive under the mountain can be seen in Java.

The examples of the Javanese recognition of the story world can be seen in the episodes connecting Ramayana to Mahabharata in traditional theatrical forms. In Javanese chronological recognition of the story world, Mahabharata is Ramayana's sequel. Therefore, some of the protagonists from the Ramayana would be incarnated as the protagonists in Mahabharata. The famous episode in *Rama Nitis* depicts Rama's reincarnation as Kresna in the Mahabharata.[14] In the Javanese traditional theater, Hanuman is also alive in the Mahabharata and can appear as a character.

While these examples embody the specific thought system of the Javanese people, it is difficult for tourists to understand these elements. In tourism culture, these indigenous cultural elements are not presented. The ending of the *sendratari* that indicates Rama's triumph over Ravana, or presenting the Ramayana without its connection to the Mahabharata, highlights tourists' inability to recognize the story world of the Javanese people reflected in the traditional theater.

6.6 Presentation of Ramayana Story in *Sendratari* Directed for Tourism Context

The situation mentioned earlier can also be related to the differences between the tourism context and the local context, including ritual occasions. The tourism context emphasized the presentation of "Javanese" tradition as the representative Indonesian tradition in front of the outsider's gaze. In his study of tourism, Urry pointed out the concept of "tourist gaze" and described that "People must experience particularly distinct pleasures which involve different senses or are on a different scale from those typically encountered in everyday life" (Urry 1990: 11–12). The performing art forms for the tourists can be positioned as the objects that respond to the "tourist gaze," as well as other objects such as various historical sites, the

[14]The puppeteer and animator Nanang Ananto Wicaksono created the animation work related to the story of Rama's incarnation for this book.

artifacts as souvenirs, and so on. In the theatrical performances, it is necessary to indicate the "distinct pleasures" in a comprehensible manner for tourists. In the *sendratari* performance, it is important to indicate the well-known plot of the Ramayana with the spectacle of Javanese theatrical elements. These elements of "Javanese-ness" are presented through the elements of *gamelan* music, dancing, costumes in the eclectic "Javanese" style. As the representative cultural style in Indonesia, this Javanese style of music, dancing, costumes can be also positioned as the elements of "Indonesian-ness."

On the other hand, Javanese indigenous cultural elements, such as the expression of Javanese language, Javanese thought reflected in the story world, such as mysticism, the morality of good and evil, and the intentionality of the complicated story, are kept at a distance. These elements can only be accepted in a situation where the local community members share the belief and moral values. The indigenous elements, such as Javanese mysticism and the sense of values, are difficult to be understood and shared by outsiders, including the tourists.

The presentation of the Ramayana story in a *sendratari* performance can be considered the result of the creativity directed to curate a distinct experience in tourism. It can be positioned as the result of the Javanese people's objectification of art forms to suit the expectation of tourists.[15] The performances of the Javanese *sendratari* are considered an important opportunity to narrate the main story of Ramayana with Javanese stage direction to larger audiences, including tourists.

The responses toward the three research questions mentioned in Section 6.1 can be summarized as follows: Firstly, the reason Ramayana has been positioned as the main source of performances for the tourists is the clear and comprehensible plot of the classical "Valmikian" version of Ramayana. Also the plot had been disseminated in other regions, including tourism sites in Southeast Asia. Secondly, the way of presentation of the story in the performances has been changed from the episode-centered manner to the plot-centered manner since 1961 to the present. By examining the

[15]Through considering some Japanese tourism culture, anthropologist Yoshinobu Ōta presented the concept of "objectification of culture" (Ōta 2010). The creation of *sendratari* in Java can also be positioned as one of the examples of the result of the "objectification of culture."

changes and the development of the representation of Ramayana, Javanese people's searching for the "effective" stage directions of the theatrical forms for tourists can be seen. Thirdly, the performance of *sendratari* can be positioned as one of the forms of tourism culture where the indication of the main story of Ramayana with the elements of Javanese art forms is important. It embodies universal moral values such as good and evil. On the other hand, the performing art forms in the local community, such as in shadow play, indicate the different versions of stories, including the complicated causal relationships with Javanese philosophy and mysticism, to the members of community. These elements are not indicated in the performance of *sendratari*. The performances within the local communities are premised on the embodiment of the shared moral values and the unique worldview of the Javanese people. These differences indicate the potential for multiple presentations and interpretations of the story.

The situation is not regarded critically in this chapter. It should not be considered as differences between the invented "pseudo" events[16] and the "sincere" or "authentic" performance. As many artists and researchers have argued about the representation of "Javanese" cultural elements in seminars on Ramayana, representation of Ramayana in Javanese *sendratari* is an important reality in the process of pursuit of optimal theatrical form for larger audiences, including tourists. Also, these different representations have been interrelated. Therefore, it should be considered as differences between the dimensions of the representation of Ramayana. The case study described in this chapter indicates the multiple meanings of Ramayana theater where multidimensional natures emerge depending on the different contexts.

References

Aoyama, T. (1998) *Cosmos of the Ramayana: Transmission and Ethnic Form* (in Japanese), eds. Kaneko, K., Sakata, T., and Suzuki, M., "Reception and transmission of Rama stories in Indonesia: Changes to stories and representations." (in Japanese) (Shunjusha, Tokyo), pp. 140–163.

[16]Refer to the concept of "pseudo events" by Daniel J. Boorstin (1992 [1962]). Boorstin described the "pseudo events"in tourism context in addition to the main considerations on media representations (Boorstin 1992: 118).

Boorstin, D. J. (1992) *The Image: A Guide to Pseudo Events in America* (Vintage Books, New York) (first published in 1962).

Dahles, H. (2001) *Tourism, Heritage and National Culture in Java: Delemmas of a Local Community* (Routledge, London).

Foley, K. (1979) The Sundanese *wayang golek*: The rod puppet theatre of West Java. Doctoral dissertation, the University of Hawaii.

Fukuoka, M. (2008) The tale of the Ramayana in the performance Javanese *sendratari* (in Japanese), *Toyo Ongaku Kenkyu: The Journal of the Society for Research of Asiatic Music*, 74, pp. 109–121.

Fukuoka, M. (2016) *Javanese Wayang: The Story World* (in Japanese) (Stylenote, Tokyo).

Koike, M. (2009) Creation of Indonesian national culture: A case of modern theater *sendratari Ramayana* in Java and Bali (in Japanese). *Language, Area and Culture Studies*, 15, pp. 163–184.

Lindsay, J. (1991) *Klasik, Kitch, Kontemporer: Sebua Studi tentang Seni Pertunjukan Jawa* (in Indonesian) (Gajah Mada University Press, Yogyakarta).

Matsumoto, R. (1982) *Consideration on Javanese Shadow Play* (in Japanese) (Mekong, Tokyo).

Matsumoto, R. (1993) *The Sunset Glow of Ramayana* (in Japanese) (Hachimanyama Shobo, Tokyo).

Moehkardi (Drs.) (2011) *Sendratari Ramayana Prambanan: Seni dan Sejarahnya* (in Indonesian) (KPG Kepustakaan Populer Gramedia with PT. Taman Wisata Candi Borobudur, Prambanan & Ratu Boko, Jakarta).

Ōta, Y. (2010) *The Thoughts of Transposition: Re-imagination of Cultural Anthropology* (in Japanese) (Sekaishishosha, Kyoto).

Picard, M. (1990) Cultural tourism in Bali: Cultural performances as tourist attraction. *Indonesia*, 49, pp. 37–74.

Sears, L. J. (1996) *Shadows of Empire: Colonial Discourse and Javanese Tales* (Duke University Press, Durham).

Soedarsono (1984) *Wayang Wong: The State Ritual Dance Drama in the Court of Yogyakarta* (Gajah Mada University Press, Yogyakarta).

Soeharso, F. I. C. S. (1970) *Sendratari* Ramayana Roro Djonggrang, in Laporan Seminar Sendra Tari Ramayana Nasional Tahun 1970 di Jogjakarta tg. 16s/d 18 Sept. 70 ed. by Panitia Penjelenggara Seminar *Sendra Tari* Ramayana Nasional Tahun 1970, pp. 1–72.

Sunardi, D. M. (1979) *Ramayana* (in Indonesian) (PN Balai Pustaka, Jakarta).

Urry, J. (1990) *The Tourist Gaze: Leisure and Travel in Contemporary Societies* (Sage Publications, London).

PART III
REPRESENTED RAMAYANA

Chapter 7

A History of Thai Intellectuals' Perceptions of *Khon*, the Masked Dance of Ramayana, on the Modern World Stage

Shinsuke Hinata

Graduate School of Humanities, Osaka University,
Senbahigashi 3-5-10, Minoh, Osaka, Japan
hinata.hmt@osaka-u.ac.jp

The chapter focuses on modern Thai public intellectuals' discourse on *khon*, the masked dance of Ramayana.

Region in this chapter: Bangkok, Thailand, and neighboring countries.

7.1 Whose Culture?

In 2018, the Ramayana-related cultures of Thailand and Cambodia were registered on UNESCO's Intangible Cultural Heritage list.

Ramayana Theater in Contemporary Southeast Asia
Edited by Madoka Fukuoka
Copyright © 2023 Jenny Stanford Publishing Pte. Ltd.
ISBN 978-981-4968-09-6 (Hardcover), 978-1-003-29095-7 (eBook)
www.jennystanford.com

These include Thailand's Khon (as Intangible Cultural Heritage of Humanity) and Cambodia's Lkhon Khol Wat Svay Andet (as Intangible Cultural Heritage in Need of Urgent Safeguarding). This sparked a debate on the Internet over which, *khon* or *lkhon khol*, was the original or "real" form.[1] According to UNESCO,

> Khon is a performance art that combines musical, vocal, literary, dance, ritual, and handicraft elements. Khon performances depict the glory of Rama, the hero, and the incarnation of the god Vishnu, who brings order and justice to the world. The many episodes depict Rama's life, including his journey in the forest, his army of monkeys, and his fights with the army of Thosakan, the king of the giants. On one level, Khon represents high art cultivated by the Siamese/Thai courts over centuries, while at another level, as a dramatic performance, it can be interpreted and enjoyed by spectators from different social backgrounds. Khon has a strong didactic function, reinforcing respect for those of higher age and status, the mutual dependence between leaders and followers, the honor of rulers, and the triumph of good over evil. Traditionally, Khon was transmitted in royal or princely courts, and in dance masters' households.[2]

The dispute between Thailand and Cambodia over the ownership of cultural traditions did not start with the case of *khon/ lkhon khol*. For example, when Cambodia's Preah Vihear Temple[3] was registered as a World Heritage Site in 2008, a decade before the recent registration of *khon* and *lkhon khol* on the Intangible Cultural Heritage list, nationalistic sentiment rose in both countries, developing into an international issue that resulted in casualties. As far back as 2003, the Thai Embassy in Phnom Penh was burned as a result of a rumor that a Thai actress had said the Angkor site,

[1]Especially on social networking sites, there have been many posts in Thai, Khmer, and English on this issue. *The Standard*, a Thai-language online media outlet, has published an excellent article (https://thestandard.co/khon-unesco-intangible-cultural-heritage-conflicts/) that provides a dispassionate analysis from a broad perspective.

[2]Excerpted from the UNESCO website (https://ich.unesco.org/en/RL/khon-masked-dance-drama-in-thailand-01385) with some modifications.

[3]Preah Vihear is a Hindu temple on the cliff of a mountain that forms a natural border between Cambodia and Thailand, constructed in the 11th century under the authority of Angkor. The temple has experienced a complex history since the border demarcation at the beginning of the 20th century. For details, please refer to Charnvit et al. (2013).

which was Cambodia's first World Heritage Site, rightfully belonged to Thailand.

Why does this kind of conflict occur? Like many other bordering countries, Thailand and Cambodia have a close historical relationship and share a considerable amount of culture. Historically, until the establishment of Sukhothai, "the first Thai Kingdom," in the 13th century, the region was under the authority of Angkor. As a result, Khmer-language inscriptions have been found at Sukhothai, the ruined capital of the kingdom, and large-scale Angkor-style buildings and building complexes—Phimai, and Panom Rung, for two famous examples—exist in the Northeastern part of Thailand today.[4] As renowned Thai historian Charnvit Kasetsiri states, "Among the neighboring countries of Southeast Asia, none seems more similar to Thailand than Cambodia.... Both nations share similar customs, traditions, beliefs, and ways of life. This is especially true of royal customs, language, writing systems, vocabulary, literature, and the dramatic arts" (Charnvit 2003). There is no doubt that Thai culture has historically been heavily influenced by Khmer culture, as evidenced by the fact that most of the vocabulary of the royal language (called *ratchasap* in Thai), which Charnvit cites as an example, is borrowed from Khmer. The two countries are in conflict not because they are different, but because they share a similar culture.

In terms of political history, the Thai kingdom of Ayutthaya, founded in the middle of the 14th century, began to invade Cambodia and conquered the royal capital Siem Reap around 1431. In turn, King Bayinnaung of the Toungoo Dynasty, of Burma (reign 1551–81), invaded Siam (the external name of Thailand until 1939) in the 16th century, and in 1564, Siam became a vassal of Toungoo. It was not until the end of the 16th century that Siam regained its independence. From the late 17th century onward, Siam and Vietnam fought for supremacy in mainland Southeast Asia and frequently interfered with Cambodia's affairs. Cambodia became a French protectorate in 1863, as Britain and France expanded into what is now mainland Southeast Asia in the 19th century. In 1953, Cambodia became an independent sovereign state equal in status

[4]For more information on Thai and Cambodian national identity in relation to archeological artifacts and sites, see the work of Keyes (2002).

to Thailand, and conflicts between them over the legitimacy of their respective claims to ownership of "culture" became apparent in the international community.

So, when and how does a particular culture, such as *khon*, come to be recognized as representing a particular country? An important moment in this kind of process is often the establishment of a modern nation-state. The introduction of the Western concept of "borders" into what is now mainland Southeast Asia was the result of the British and French colonial competition from the 19th century onward; prior to this, while the center of power was relatively clear, the political concepts of mapped borders and a single sovereign state were rare in the region, and it was common that the spheres of different polities overlapped. Even in the case of Thailand, which escaped direct European colonial rule, it was the colonization of neighboring areas that gave rise to a modern sense of nationhood (Winichakul 1997). That is, the ethnonational and/or national identity of the people who lived in the territorial state was formed after the prototype of the territorial state of the present was created. The idea that a particular culture represents "a nation" cannot be imagined without political developments along these lines.

As for Cambodia, according to Hideo Sasagawa, "Angkor" as a glorious site for and cultural symbol of Cambodian identity and national unity, was a "tradition" invented to justify French colonial rule. The historical view of Angkor as the "origin," the Angkor era as the period of "glory," and the post-Angkor era as the period of "decline" was a modern perception in conjunction with the discourse justifying colonial rule, in which France "protected" Cambodia during its "decline" (Sasagawa 2006: 229). According to French records from the 1880s, the Thai version of the Ramayana, the Ramakien (also written as Ramakian), was performed as a dance at the Cambodian court instead of the Cambodian version of the Ramayana, the Reamker. However, based on the historiography that glorified Angkor, Cambodian court dances that had been strongly influenced by Siam from the mid-19th century onward were reinterpreted as "traditions" directly related to the Angkorian period (Sasagawa 2005; 2006: Chapter 5).

This chapter traces the history of how mainstream public intellectuals of modern Thailand have perceived the Ramakien and *khon* in relation to neighboring countries that also share Ramayana

culture. The following discussion owe much to two major previous studies: a comprehensive study of the history of theater arts in Thailand by Rutnin (1996), and a pioneering study by Saichon (2007a; 2007b) on the political thoughts of modern Thai establishment intellectuals who played significant roles in constructing "Thainess." Interestingly, almost all of these commentators mention the Ramakien and *khon* in some way, indicating the status of the Ramakien and *khon* as essential topics in the public narrative of Thai culture.

Although *khon*, as a performing art, and the Ramakien, as a written text, are different in nature, the Ramakien is an indispensable element of *khon*, so both are the subject of analysis in this chapter.

7.2 Royal Perception during the Absolute Monarchy

From the names of kings and places in Thailand,[5] it is understood that the Ramayana was already known during the Sukhothai period. As mentioned earlier, in the territory of today's Thailand, the Khmer (and Mon) had formed a regionally hegemonic civilization earlier than the Thai people, who established their first dynasty of Sukhothai in the 13th century. Therefore, it is assumed that the Thai people also received the Ramayana and its dance culture from the Mon or the Khmer, and the word *khon* itself is said to be of Khmer origin (Rutnin 1996: 6). However, when the Ayutthaya dynasty, which had annexed Sukhothai, was defeated for the second time by Burma in 1767 and destroyed outright, most Thai-language documents preserved at the royal capital were lost, and there are few Ramayana-related written records in Thai before the first half of the 18th century. The oldest surviving cohesive text is part of

[5]For example, the name of King Ramkhamhaeng (reign 1279–1298), the famous ideal king of the Sukhothai period, and those of many kings of the Ayutthaya dynasty include the name "Rama." Also, the third side of the Ramkhamhaeng inscription—believed to have been recorded in the 13th century, making it the oldest record that can be traced back in Thai—states "Tham Phra Ram" ("Cave of Phra Ram"). (However, there are some theories regarding the Ramkhamhaeng inscription being fabricated by King Rama IV.) For more information on the influence of the Ramayana on various areas of Thai culture, see Singaravelu (1982).

the Ramakien narrative, compiled during the reign of King Taksin (1767–82), who restored Siam's independence and founded the new Thonburi dynasty (meanwhile, the surviving text of the Reamker, the Cambodian version of the Ramakien, is older and can be traced back to the 17th century (Sasagawa 2006: 27)). King Taksin also invited a dance troupe from Nakhon Si Thammarat, in southern Thailand, which had survived the Burmese attack, to Bangkok and revived the dance in his court (Rutnin 1996: 49).

The Thonburi dynasty, founded by King Taksin, died out after only one generation, and one of his generals, Chao Phraya Chakri, founded the current Bangkok dynasty in 1782 as King Rama I (reign 1782–1809). Following in the footsteps of King Taksin, King Rama I focused on the cultural revival of the Ayutthaya period and compiled a complete version of the Ramakien, in addition to the code of laws called the "Three Seals Law" based on the laws of the Ayutthaya period. His son, King Rama II (reign 1809–24), excelled in poetry and sculpture and wrote the standard version of the Ramakien as a script for Khon. His reign is called the "golden era" of the county's dramatic literature and classical dance drama (Rutnin 1996: 57). However, the next King, Rama III (reign 1824–51), did not encourage *khon* as his predecessor had done, and the dance troupes at court faced a temporary decline. The tradition was revived by King Rama IV (reign 1851–68). At a time when relations with Western countries were strengthening, for instance with the signing of the Bowring Treaty with Britain, King Rama IV revived *khon* drama in the royal palace and had it performed at an outdoor theater during the coronation ceremony. One of the objectives of doing so was to "create a respectable image of a civilized, peaceful, culture-rich country in the eyes of the Western Powers" (Rutnin 1996: 77). During the reign of King Rama V (reign 1868–1910), the borders between Siam and the empires of Britain and France were demarcated, and at the same time, the prototype of a centralized state, with Bangkok as its capital, was formed. In 1892, the central ministries were reorganized, and an absolute monarchy was established in which the half-brothers of King Rama V held almost all of the ministerial positions under the King.

In 1908, the government of King Rama V was invited to the International Exhibition of Industry and Labour, to be held in 1911 in Turin, Italy, and Prince Vajirāvudh, the son of King Rama V, became

the president of the Siamese commission for the event. However, King Rama V died on October 23, 1910, and the prince succeeded the throne on the same day as King Rama VI (reign 1910–25). Soon after his enthronement, the new King personally inspected the exhibits destined for Turin, on display in the Royal Museum (Peleggi 2002: 161).[6] Figure 7.1 (left) is a sketch of the Siamese Pavilion built for the exhibition of Industry, and Fig. 7.1 (right) shows *khon* masks, or "Masks employed in theatrical play based on the Ramayana" (Gerini 1912: 112), displayed in the central hall.

Figure 7.1 The Siamese Pavilion (*left*) and exhibition of *khon* masks in the middle of the Central Hall (*right*) at the Turin International Exhibition, 1911 (Gerini 1912).

Like his great-grandfather, King Rama VI was a lover of literature and theater, and he actively promoted the Ramakien and *khon* from the beginning of his reign. Figure 7.2 shows a part of a *khon* play performed at the coronation celebration held at Dusit Park, Bangkok, on December 5, 1911. The silhouettes of women dressed in Western clothes are painted underneath the Western-style theater, and the material clearly shows King Rama VI's attempt to present a

[6]For the history of Siam's participation in international exhibitions from the latter half of the 19th century to the beginning of the 20th century, refer to Peleggi (2002: Chapter 6). After the Turin International Exhibition, King Rama VI continued to underwrite Siam's participation in international exhibitions, in Leipzig in 1914, and in San Francisco in 1915, as a means of promoting Thai arts and winning worldwide recognition for them, and for Siam (Vella 1978: 233).

civilized image to Westerners, in the same manner as King Rama IV.[7] Incidentally, even the custom of calling the successive kings of the Bangkok Dynasty as "King Rama I, II, III" and so forth was invented by King Rama VI himself.

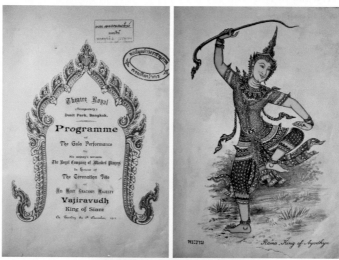

Figure 7.2 Programme of the Gala Performance (Anonymous 1911). (Courtesy of the Damrong Rachanuphap Library)[8]

[7]For a detailed account of the coronation of King Rama VI, see Vella (1978: Chapter 2).
[8]A branch of the National Libraries of Thailand.

In the same year as the coronation fête, a descriptive catalog of the Siamese section of the International Exhibition in Turin was published, edited by Gerolamo Emilio Gerini (1860–1913), an Italian who served in the Siamese army as a foreign advisor; its English edition was published in the following year. In this book, *Siam and its Productions, Arts, and Manufactures*, the King himself contributed an article titled "Notes on the Siamese Theater" (Vajirāvudh 1912), in which he explained Thai dances, including *khon*. The following year, in 1913, King Rama VI published the King Rama II Version of the Ramakien for the first time; in the same year, he wrote *Bo Koet haeng Ramakien* (The Origin of Ramakien) in Thai as a commentary. This was the first attempt to conduct a full-scale comparative analysis of texts on the formation of the Ramakien. Rama VI concludes that the Thai Ramakien has three origins: (1) the Sanskrit version of the Ramayana (and probably the Bengali version), (2) Vishnu Purana, and (3) Hamuman Nataka (Phramongkutklaochaoyuhua 1941: 147–148). The term *lakhon dueakdamban* ("ancient play") first appeared in the chronicles of the reign of King Ramathibodi II (reign 1472–1529), which is speculated to be similar to *khon* (Phramongkutklaochaoyuhua 1941; 150). No particular mention is made of *khon* in relation to neighboring countries at that time.

Another distinguished intellectual from the absolute monarchy period is Prince Damrong Rachanuphap (1862–1943), the half-brother of King Rama V and the uncle of King Rama VI. As the first Minister of the Interior (term of office 1892–1915), Prince Damrong led the reform of the centralized system of local governance; in the field of cultural policy, he established the foundation for today's library administration, museum administration, archaeological administration, and art history. He also left behind a vast number of writings on Thai history and culture and is known as the "Father of Thai History." Prince Damrong's ideas and views on history had a great influence on later generations of intellectuals, as will be discussed in the next section.

Khon is mentioned in the first part of Prince Damrong's book *Tamnan rueang Lakhon Inao* (A History of the *Inao* Play[9]), published in 1921. To summarize Prince Damrong's descriptions, there is no doubt that the Thai, like the Burmese and Javanese, learned this

[9]*Inao* is a Thai drama story based on the Javanese Panji tales.

dance from India. The Javanese performed *khon* in the same way as the Thai and in fact performed it for King Rama V when he visited Yogyakarta.[10] The King of Chiang Mai is said to have practiced it when he was a member of King Rama I's bodyguard. *khon* is performed by people of high rank, while *lakhon* is performed by ordinary people, for a living. Since *khon* was important for royal rituals, not everyone could perform it. It was an honor for the common people to be allowed to perform it (Damrong 1921: 1–15). Similar to King Rama VI's explanation of the origin of Ramakien, *khon* was recognized as a cultural form originating directly in India, and there is no mention of any influence from other countries. A mention of King Rama V's visit to Yogyakarta and attendance at a "*khon*" performance there is noteworthy, because it is likely that no previous kings of Siam had gone overseas to watch court dances. Interest in the neighboring colonial administration and the development of new means of transportation gave rise to a new phenomenon of increased cultural contact with Europe as well as with neighboring countries.

In his book *Nirat Nakhon Wat* (Journey to Angkor Wat), published in 1925, Prince Damrong mentions the dance dramas of the Cambodian court. During his visit to French Indochina from November 10 to December 13, 1924, Prince Damrong had an audience with Cambodian King Sisowath (reign 1904–27) at the Royal Palace in Phnom Penh, where he watched a Thai-language performance. According to Prince Damrong, Cambodian court dramas had been performed in the Thai language since Sisowath's father, King Ang Duong (reign 1840–60), invited a drama master there from Siam (Damrong 1925: 140–143). In fact, King Ang Duong had ascended to the throne with the backing of Siam, and his son and successor King Norodom (reign 1860–1904) and King Sisowath spent their childhood in the royal palace in Bangkok, and in general Cambodia from the mid-19th century onward was strongly influenced by Siamese court culture (Sasagawa 2005: 419; 2006: 145). Therefore, the description by Prince Damrong here is not considered to reflect any politically motivated exaggeration.

[10]King Rama V visited Java three times, in 1871, 1896, and 1901. In the travelogue, he wrote about his second visit (Phrachunlachomklaochaoyuhua 1925); there is a picture of *Royal Khon*, a play he saw in Yogyakarta.

7.3 Nationalist Discourses after the 1932 Revolution

The absolute monarchy of Siam was replaced by a constitutional monarchy with the revolution of 1932 by the People's Party (*Khana Ratsadon* in Thai), and the principles of electoral democracy were introduced. However, despite this drastic change in the system of governance, the mainstream intellectual climate was still influenced by that of the absolute monarchy (especially Prince Damrong), and the new regime also inherited the court culture's interest in the Ramakien and Khon.

The first important intellectual for views of *khon* after 1932 is Phraya Anumanratchathon (autonym Yong Sathiankoset, 1888–1969), who became interested in Indian classical literature after reading the writings of King Rama VI. Anumanratchathon was an employee of the Customs Bureau, favoring Prince Damrong and Prince Naris since the time of the absolute monarchy, and was regarded as their disciple (Saichon 2007b: 311–312). After the 1932 Revolution, he was transferred to the Department of Arts, where he was involved in various cultural policies, for instance related to the national anthem, writing contests, and monuments, and wrote extensively on Thai history, literature, and popular and local culture. His works related to the Ramakien and *khon* include *Uppakon Rammakian* ("Instruments of Ramakien") (1933) and *Phraram Malayu* ("Rama in Malay") (1934). *Phraram Malayu* expanded on the work of King Rama VI on the Ramakien, referring to recent works by Westerners such as Willem Frederik Stutterheim (1892–1942), Richard James Wilkinson (1867–1941), William Girdlestone Shellabear (1862–1947), and translated the three texts of the Malay version of the Ramayana, *Hikayat Sri Rama*, into Thai. In the introduction, after providing an explanation of the Malay Rama narrative, Anumanratchathon states the following:

> The Malay stories of Rama I have described so far, if they are not storylines derived from Valmiki's Ramayana, they have been derived from one of the peoples or languages. Many Western scholars have examined this point for a long time, but in essence, it is a story derived from oral traditions of various regions of India, with indigenous Indonesian stories also mixed in. This spread to Ramakien,

Rama Jataka, and Khmer Ramakien. This is due to the power of the interactions amongst people since ancient times, as discussed from the beginning (Sathiankoset and Nakhaprathip 1934: 11).

Unlike Rama VI, Anumanratchathon looks to the Malay version of the Ramayana as one of the origins of the Ramakien text. In addition, the fact that he did not see the Ramakien only as royal culture, but speculated that the power of people was behind it, shows a different way of perceiving the Ramakien than that of the intellectuals during the absolute monarchy, even though Anumanratchathon basically had a conservative ideology.

Like Anumanratchathon, Prince Dhani Nivat (1885–1974) was active as an educational bureaucrat during the absolute monarchy and was directly influenced by Prince Damrong. Prince Dhani left many writings on the Ramakien,[11] such as "The *Rama Jataka*: A Lao Version of the Story of Rama," in English in 1946, about the incorporation of Rama's story into Buddhist tale in Lao culture. We can see that both Anumanratchathon and Prince Dhani, starting from the study of the Ramakien, which began as a modern discipline during the reign of King Rama VI, did not perceive the Ramakien only in relation to India but also focused on various versions in neighboring regions and within the country.

Compared with Anumanratchathon and Prince Dhani Nivat, Thai dance culture was described with a stronger nationalist sentiment by Luang Wichitwathakan (autonym Kim Liang, 1898–1962). He had been one of the most influential ideologues since the 1932 Revolution up to the authoritarian dictatorship period in the 1950s and 1960s. Wichitwathakan was appointed the first director of the Fine Arts Department after the revolution (term of office 1934–42) and played a central role in the nationalistic cultural policy[12] during the first Phibunsongkhram administration (1938–44). It was also Wichitwathakan, who invited Anumanratchathon to join the Fine Arts Department.

[11]Prince Dhani added a short introduction to the abovementioned "Notes on the Siamese Theater" by King Rama VI when it was reprinted in the *Journal of the Siam Society* in 1967 (Vajirāvudh 1967).

[12]The policy (called *Ratthaniyom* in Thai) consisted of 12 edicts issued from 1939 to 1942, which aimed at inventing a new national culture. They include the country name change from Siam to Thailand, appropriate behaviors and dress code for the people, a new national anthem, respect to the Thai language, and so on.

Among the several sections of the cultural administration, respectively covering the fields of literature, archaeology, performing arts, and language, Luang Wichitwathakan set particular importance on the performing arts, and he set up a special dance drama school, created a national dance troupe, and wrote nationalistic plays (Barmé 1993: 116). In 1936, he published *Natthasin* as a cremation volume for distribution on the occasion of the funeral of Phraya Natthakanurak (autonym Thongdi Suannaphat, 1865–1935), director of the Royal Khon Department; it described the art of dance around the world. In Chapter 7 of the volume, which discusses the history of Thai dance, he states that *khon* was once performed only as a royal ritual, and that unlike in his time, one could not see it at any time. No particular mention is made of the history of *khon* or the Ramakien in relation to other countries or regions. However, in the last part of the book, where Wichitwathakan discusses Thai dance as a whole, he compares it to dance in other countries, saying:

> Thai dance is regarded as the best of all dances in the world. The Burmese, Khmer, Thai Yai [see below], and Thais on the left bank of the Mekong River regard the Thais of Siam as the teachers of this art. Just as Greek states praised Athens as a teacher state long ago. Just as Athens was the center of Greece, Siam is about to become the center of Suwannaphum [see below]. For this reason, those who are well educated, free from jealousy, fair-minded, and enthusiastic about creating useful things praise the dance as one of the honors of the people (Wichitwathakan 1936: 57).

Though it was true that Thai dance had attained worldwide fame and had some influence on Thailand's neighbors in the field of dance, it is obviously an exaggeration to say that it was "the best of all dances in the world" and that surrounding countries admired Siam as if it were ancient Athens; these statements illustrate Wichitwathakan's ethnocentrism and hypernationalism. In addition, the territorial expansionism advocated by the pre-war Phibunsongkhram regime, known as Pan-Taiism, which sought to regain the territories "ceded" to the British and the French through the territorial delimitation made during the reign of King Rama V, is also evident in the mention of "Thai" people outside the existing territory of Thailand, such as "Thai Yai people" and "Thai people on the left bank of the Mekong

River," as well as "Suwannaphum" (an elegant name for Indochinese Peninsula, which literally means "golden land").[13]

In the next generation, after Anumanratchathon and Wichitwathakan, Thanit Yupho (1907–2004) played a major role in the Fine Arts Department. Thanit joined the Fine Arts Department in 1934, after the Siamese Revolution, and served as a director for 12 years, from 1956 to 1968. Like Anumanratchathon, he wrote several books on Khon, actively incorporating the results of domestic and international research. *Khon* (Thanit 1957), published during his tenure as Director of the Fine Arts Department, provides a comprehensive account of *khon*, including its origins, the history of the royal Khon, masks, orchestras, and methods of appreciation.

Probably the most important public intellectual in the post-war history of *khon* in Thailand is Kukrit Pramoj (1911–95), a great-grandson of King Rama II, a politician who served as the 13th prime minister from 1975 to 1976, and was active in a wide range of fields—newspaper founder, journalist, and novelist.[14] Similar to King Rama VI, he was not only a politician and intellectual but also an avid performer—a stage artist who himself performed *khon*. One of his contributions to Khon tradition was the establishment of a theater company, Khon Thammasat, at the Thammasat University in 1973, to preserve and promote *khon* (Rutnin 1996: 195–196).

According to Saichon Sattayanurak, Kukrit intended for students to learn loyalty to the King and social hierarchy through the practice of *khon*. Furthermore, he wanted to make Chinese Thai students, who had considerable political and economic influence because they were disproportionately represented in the middle class, into "perfect Thais." The political background to this was the escalation of the Vietnam War in the 1960s and the 1970s, the successive communization of neighboring countries (Vietnam, Laos, Cambodia), and the normalization of diplomatic relations with China. Fearing the impact of communism due to the normalization of relations, Kukrit tried to educate Chinese Thais about traditional morals through learning and practicing *khon* as a discipline, a conservative cultural

[13]For the details of Wichitwathakan's ideas on cultural policy, Pan-Taiism and hyper-nationalism, refer to Barmé (1993: Chapters 5 and 6).

[14]Kukrit's *khon* dance master was Phraya Nattakanurak, Director of the Royal Khon Department, whose cremation volume, *Natthasin*, was written by Luang Wichitwathakan, as discussed previously.

form closely associated with the royal family (Saichon 2007a: 279–288).

In terms of relations with other countries, Kukrit recognized that *khon* originated in India and was a form of shared heritage with other Southeast Asian countries. At the same time, as other Thai intellectuals contended, he stressed that Thais did not merely accept culture from other regions but constantly infused it with what they had and eventually transformed them into Thai culture (Saichon 2007a: 278). In an interview about *khon*, the following exchange of words took place:

> QUESTION: I heard that Thai *khon* was received from Khmer. What do you think?
>
> Kukrit: Where did you hear the story from? Are you trying to tell me that we Thai have nothing of our own? You say that we have taken from Burmese, Khaek,[15] and Chinese. What makes you think we cannot come up with something of our own? ... The Khmer court certainly does not have *khon*, like Thailand (Sayamrat 1994: 32–33).

At least in this statement, Kukrit bluntly denied any influence from the Khmer or other peoples and regarded *khon* as a culture unique to Thailand. However, it must be noted that he did not deny all influence of the Khmer culture, as he elsewhere stated that the concept of divine kingship and much of the special vocabulary associated with the royal court "were derived from Cambodia" (Kasetsiri 2003).

7.4 From a Japanese Perspective

Finally, from a slightly different perspective, let us examine the perspective of Miki Sakae (1884–1966), a Japanese national who lived in Siam as a craftsman, a lacquerware specialist, from the reign of King Rama VI until just after the end of World War II, also known by his Thai name, Watthana Triphruekphan. Miki specialized in lacquerware at the Tokyo Fine Art School, and in 1911, a year

[15]*Khaek* is a Thai world whose primary meaning is "guest," and which also refers to Asian foreign people such as ones from India, Sri Lanka, Pakistan, Bangladesh, Afghanistan, Nepal, Java, Malaysia, and the Middle East, according to the definition given by the Thai Royal Institute.

after his graduation, he was dispatched to Siam at the invitation of the Siamese government. His first job was to make a throne for the coronation of King Rama VI, and after that, he was employed by the Siamese government to repair cultural properties and also taught at an art school. In addition, he served as president of the Japanese Association and the principal of a Japanese language school and wrote numerous books on Thailand. Miki was an acquaintance of Prince Damrong and Wichitwathakan, discussed in the preceding section, and it is useful to compare his views on Thai culture with theirs. He possessed Thai citizenship between 1939 and 1945, making him a modern "Thai" intellectual in both name and reality.

Figure 7.3 Front Cover of *"Journey to the West (Ramakien)" of Thailand* (Miki 1961).

After returning to Japan, Miki published a book, *"Journey to the West (Ramakien)" of Thailand*, in 1961 (Fig. 7.3). This was the first full-scale introduction to the Japanese. The book begins with an overview of the Ramayana, explaining its formation in India,

followed by its spread throughout Asia, including Thailand. After that, the content of the Ramakien is introduced in detail, as the main part of the book. Regarding the reception of the Ramayana, Miki noted that it had already been transmitted to Angkor before Thais established Sukhothai as an independent state, as a Khmer-derived archaeological relic existing in Thailand (Miki 1961: 9–10).

What clearly distinguishes Miki from the other intellectuals considered here is that he did not explain the propagation of the Ramayana within the scope of present-day India and Southeast Asia alone, but emphasized it as a pan-Asian cultural inheritance, including in China and Japan, as follows:

> Since ancient times, the Ramayana has been widely spread throughout the countries of the Orient, especially in the southern countries of Java, Sumatra, Siam, Cambodia, Bali, Malaya, Burma, Annam, and Laos, and in China as Jataka. It is also considered to have inspired tales like *Saiyuki*[16] and Japan's *Momotaro*.[17] Thus, Ramayana has been widely spread and become common throughout the Orient (Miki 1961: 6).

He also analyzed the characteristics of *khon*, as follows:

> Thai classical drama is very different from the European style, in a purely Oriental form without anything in common, and it is performed in elegant and graceful motions that advance and retreat in all directions with an unceasing effort of the limbs. The dance is performed as flexibly as possible, which gives it a uniquely Thai charm and beauty (Miki 1961: 24).

Miki was one of intellectuals under the influence of the Japanese "southward expansion" policy from the Meiji period to the mid-war

[16]*Saiyuki* (original Chinese name *Hsi-yu chi*) or *Journey to the West* is a story based on the travels of Xuanzang, a monk who visited India in the 6th century to study Buddhism and was adapted to incorporate various local legends. The oldest surviving version of the story was published in the 16th century. There is a theory that the monkey god Hanuman is the model for Sun Wu-kung, one of the characters in *Journey to the West*. Here, Miki sees Saiyuki in the connection to the Ramayana and Ramakien based on the theory.

[17]*Momotaro* (literally meaning "Peach Boy") or *Story of the Son of a Peach* is a popular Japanese folktale. Although it is difficult to identify the origin because it is an oral tradition, the earliest surviving text was established in the 17th century. There is a theory that the Ramayana is partly incorporated into the legend of Momotaro.

period (Nishida 2016).[18] Accordingly, he had a strong tendency to view Thai history and culture in terms of their connection with Japan in the context of "the Orient," as also reflected in his strong interest in Yamada Nagamasa,[19] a Japanese adventurer who was active in Ayutthaya in the 17th century and who was idealized as a symbol of Japanese expansionism from the Meiji period until World War II. It should be noted that the framework of "the Orient" used by Miki in explaining Ramakien and Khon is not adopted by the (other) Thai intellectuals discussed in this chapter. This is a good example of the multiple meanings of Ramayana, showing the difference in geographical perception is clearly reflected in the way of explaining a particular culture.

7.5 Summary

To summarize how modern Thai intellectuals have perceived the Ramakien and *khon*, we can say that what was maintained as a "royal court culture" since the early modern period became a "culture of the modern kingdom" under the gaze of the international community in the 19th century. After the Siamese Revolution of 1932, it was then transformed into a "national culture," widening its socio-political meaning. As the Ramakien and *khon* have strong ties to the royal court, this phenomenon parallels the process of visualization and nationalization of the Siamese monarchy. In terms of relations with neighboring countries, the sense of shared heritage with Cambodia is relatively weak, and there is a stronger perception that the Ramakien and *khon* are indigenous to Thai culture. It is not difficult to find similar sentiments between the conflict over the recent registration of *khon* and *lkhon khol* on the Intangible Cultural Heritage list, and sometimes nationalistic and adversarial discourses of Luang Wichitwathakan and Kukrit Pramoj as extreme examples.

[18]According to Nishida (2016: 181–182), however, Miki's ideal theory of "true southward expansion" did not include references to Japan's involvement in intrusive Japan-centrism such as the idea that Japan should be the leader of Asia, as was a strong thread in the arguments of southward expansionists and Asianists in the Showa period.

[19]Miki wrote many articles and books on Yamada Nagamasa before and after the war. An example is *Yamada Nagamasa* (Miki 1936).

However, to see the Ramakien and *khon* as "Siamese"/"Thai" traditions is not necessarily a misdirected perspective given that the Ramakien and *khon* were in fact promoted and protected by successive kings in Siam/Thailand since at least the late 18th century, when the Thonburi and Bangkok dynasties were established. Siam/Thailand is exceptional among Southeast Asian countries in that it did not experience direct colonial rule or major civil wars, and the monarchy in Bangkok has continued to function as a cultural center for over two centuries. Another important factor is that even after the 1932 Revolution, which reduced the authority of the royal family, intellectuals of the establishment, including the royal family members, inherited ideas from the absolute monarchy period almost intact.

As the importance of intangible culture is characterized by "the wealth of knowledge and skills that is transmitted through it from one generation to the next,"[20] the history of Siam/Thailand, which has maintained a relatively stable monarchy since the establishment of the Bangkok dynasty, has worked in favor of the inheritance of culture such as *khon*, which is closely related to traditional political power. In this respect, it is different from (the preservation of) archaeological artifacts, such as Preah Vihear Temple or other Khmer-derived heritages, which were not paid attention by the Bangkok Dynasty by the 19th century. In Siam, the management of archaeological artifacts and the establishment of museums in the modern sense began during the reign of Rama V (1868–1910), directly influenced by the West. They were developed into their present form by Prince Damrong in the 1920s. On the other hand, we have seen that the compilation of the Ramakien and the encouragement of *khon* were already prominent by the first half of the 19th century. The major distinction is that they were already under royal patronage long before the influx of Western ideas of "heritage protection."

If so, why did intangible heritage such as Khon become a source of conflict between Thailand and Cambodia, along with tangible heritage such as temple sites? The main reason is that the majority of the heritage protected by World Heritage Sites and Intangible Cultural Heritage originated in the pre-modern period, but its

[20]According to UNESCO's definition of "Intangible Cultural Heritage" (https://ich.unesco.org/en/what-is-intangible-heritage-00003).

application and registration are categorized by association with modern nation-states. As long as this fundamental contradiction persists of applying the nation-state framework to the culture of a time when borders and nationhood were not clear, similar fires will undoubtedly continue to spread.[21]

References

Thai Literature (authors' names are given using Thai naming conventions)

Damrong Rachanuphap, Phrachao Borommawongthoea Krom Phra (1921). *Tamnan rueang Lakhon Ina*. (Bangkok: Rongphim Thai).

Damrong Rachanuphap, Phrachao Borommawongthoea Krom Phra (1925). *Nirat Nakhon Wat* (Bangkok: Rongphim Sophonphiphatthanakon).

Phramongkutklaochaoyuhua, Phrabatsomdet (1941). *Bo Koet haeng Ramakian*. (Cremation Volume of Khun Ying Ratchaakson (Chuea Atsawarak)). (Bangkok: Rongphim Phrachan).

Phrachunlachomklaochaoyuhua, Phrabatsomdet (1925). *Rayathang Thiao Chawa kwa Song Duean*. (Cremation Volume of Somdet Phra'anuchathirat Chaofa Atsadangdechawut). (Bangkok: Rongphim Sophonphiphatthanakon).

Saichon Sattayanurak (2007a). *Kuekrit kap Praditthakam "Khwam Pen Thai" (Lem 2): Yuk Chomphon Sarit thueng Thotsawat 2530*. (Bangkok: Matichon).

Saichon Sattayanurak (2007b). *Prawattisat Withikhit kiaokap Sangkhom lae Watthanatham Thai khong Pan'yachon (Pho.So. 2435-2536)*. Unpublished Report, The Thailand Research Fund.

Sathiankoset and Nakhaprathip (1933). *Uppakon Rammakian: Phak Nueng Ton Ton*. (Cremation Volume of Phraworawongthoe Phraongchao Supphayokkasem). (Bangkok: Thaikhasem).

Sathiankoset and Nakhaprathip (1934). *Phraram Malayu*. (Cremation Volume of Nang Chaem Pankawong na Ayutthaya). (Bangkok: Thaikhasem).

[21]I do not want to argue here at all that UNESCO is instigating conflicts between nations. As UNESCO is literally an institution of the United Nations, the problem stems from the present global political system. It must be noted that UNESCO, for example, organized the international art exhibition, "The Many Faces of Ramayana," held in 2019, to "explore the vast range of contemporary and traditional interpretations of the epic, Ramayana, across national and cultural borders and generations" (https://bangkok.unesco.org/content/international-art-exhibition-many-faces-ramayana).

Sayamrat (special issue) (1994). *Khroprop 83 Pi Kuekrit Pramot: Kuekrit kap Khwam Pen Thai*. (Bangkok: Sayamrat).

Thanit Yupho (1957). *Khon*. (Cremation Volume of Phrachaoworawongtoea Phraongchao Chaloeamkhetmongkhon). (Bangkok: Rongphim Borisat Uppakonkanphim).

Wichitwathakan, Luang (1936). *Natthasin*. (Cremation Volume of Phraya Natthakanurak). (Bangkok: Rongphim Phrachan).

English Literature

Anonymous (1911). *Programme of the Gala Performance by His Majesty's Servants: The Royal Company of Masked Players in Honour of the Coronation Fete of His Most Gracious Majesty Vajiravudh King of Siam on Tuesday the 5th December 1911*. n.p.

Barmé, S. (1993). *Luang Wichit Wathakan and the Creation of a Thai Identity*. (Singapore: Institute of Southeast Asian Studies).

Dhani Nivat, H. H. Prince (1946). The Rama Jataka: A Lao version of the story of Rama. *Journal of the Siam Society* 36(1): 1–22.

Gerini, G. E. ed. (1912). *Siam and its Productions, Arts and Manufactures: A Descriptive Catalogue of the Siamese Section at the International Exhibition of Industry and Labour held in Turin April 29-November 19, 1911. Supplemented with Historical, Technical, Commercial and Statistical Summaries on Each Subject* (English Edition). (Hertford: Oriental Printers).

Kasetsiri, C. (2003). Thailand and Cambodia: A love-hate relationship. *Kyoto Review of Southeast Asia* 3. (https://kyotoreview.org/issue-3-nations-and-stories/a-love-hate-relationship/).

Kasetsiri, C, Pou Sothirak and Pavin Chachavalpongpun (2013). *Preah Vihear: A Guide to the Thai Cambodian Conflict and its Solutions*. (Bangkok: White Lotus).

Keyes, C. F. (2002). The case of the purloined lintel: The politics of a Khmer shrine as a Thai national treasure. ed. C. J. Reynolds, *National Identities and Its Defenders: Thailand 1939-1989* (Revised Edition). (Chiang Mai: Silkworm Books), pp. 212–237.

Peleggi, M. (2002). *Lords of Things: The Fashioning of the Siamese Monarchy's Modern Image*. (Honolulu: University of Hawai'i Press).

Rutnin, M. M. (1996). *Dance, Drama, and Theater in Thailand: The Process of Development and Modernization*. (Chiang Mai: Silkworm Books).

Sasagawa, H. (2005). Post/colonial discourses on the Cambodian court dance. *Southeast Asian Studies* 42(4): 418–441.

Singaravelu, S. (1982). The Rama story in the Thai cultural tradition. *Journal of the Siam Society* 70: 50–70.

Vella, W. F. (1978). *Chaiyo! King Vajiravudh and the Development of Thai Nationalism.* (Honolulu: The University Press of Hawaii).

Winichakul, T. (1994). *Siam Mapped: A History of the Geo-Body of a Nation.* (Honolulu: University of Hawaii Press).

Vajirāvudh, M. (1912). Notes on the Siamese Theater. ed. G. E. Gerini, *Siam and its Productions, Arts and Manufactures: A Descriptive Catalogue of the Siamese Section at the International Exhibition of Industry and Labour held in Turin April 29-November 19, 1911. Supplemented with Historical, Technical, Commercial and Statistical Summaries on Each Subject* (English Edition). (Hertford: Oriental Printers), pp. 83–111.

Vajirāvudh, M. (1967). Notes on the Siamese Theater (with a Brief Introduction by H.H. Prince Dhaninivat, Kromamun Bidyalabh). *Journal of the Siam Society* 55(1): 1–30.

Japanese Literature

Miki, S. (1936). *Yamada Nagamasa.* (Tokyo: Kokon Shoin).

Miki, S. (1961). *"Journey to the West (Ramakien)" of Thailand.* (Tokyo: Heibonsha).

Nishida, M. (2016). Sakae Miki's Southward Advancement Thought and Japanese Cultural Diplomacy in Thailand during World War II. *Studies of Japanese-Thai Languages and Cultures* (Special Number): 177–200.

Sasagawa, H. (2006). *Modernity of Angkor: Culture and Politics in Colonial Cambodia.* (Tokyo: Chuo Koron Sinsha).

Chapter 8

Exhibiting Ramayana in a Japanese Museum: Activities of National Museum of Ethnology, Japan

Fukuoka Shota

National Museum of Ethnology, Japan, 10-1 Senri Expo Park,
Suita, Osaka 565-8511, Japan
fukuoka@minpaku.ac.jp

The National Museum of Ethnology, Japan (hereafter Minpaku, its Japanese abbreviation), is a national research institute of cultural anthropology and its related disciplines, which has a museum exhibiting world cultures based on anthropological research. One of the sections of Southeast Asia Gallery in Minpaku is "Entertainment and Recreation," where performing arts using puppets and masks occupy the central part. While Ramayana, along with Mahabharata, is well known in Japan as an epic poem from India, our exhibition also treats them as key elements representing Southeast Asian performing arts traditions. In this article, we examine Ramayana's role in understanding Southeast Asian culture in Japan via the example of Minpaku's exhibition and research activities.

Ramayana Theater in Contemporary Southeast Asia
Edited by Madoka Fukuoka
Copyright © 2023 Jenny Stanford Publishing Pte. Ltd.
ISBN 978-981-4968-09-6 (Hardcover), 978-1-003-29095-7 (eBook)
www.jennystanford.com

Through the 20th century, the Japanese people's interest in Ramayana has increased. First, it has been introduced and discussed as literature representing ancient Indian belief and philosophy, and its influence found in Japanese and Chinese Buddhist scriptures has been explored. As Japan expanded to the south and many Japanese emigrated to Southeast Asia around the 1930s and early 1940s, people also began to know about Ramayana performed in shadow puppet theaters, dances, and theaters in Southeast Asia. In the latter half of the 20th century, there were more opportunities to directly appreciate Southeast Asia's performing arts in addition to the knowledge of Ramayana through books. The number of Japanese who study performing arts in Southeast Asia has increased, and groups of Japanese who perform Southeast Asian performing arts began to emerge in Japan. It is noteworthy that people came to understand Ramayana as expressed in visual images, acting, dance, music, etc.

Minpaku was founded in such a circumstance where the vibrant images of Ramayana in Southeast Asian performing arts were becoming more familiar to the Japanese. Through the exhibition of masks and puppets, the production of video programs, and holding public performances, Minpaku has helped people understand Ramayana in performance. Besides showing Southeast Asian culture to visitors, Minpaku also seeks to contribute to research and transmission of Southeast Asian performing arts tradition based on a network with Southeast Asian researchers and artists. One of the goals of museums today is to fully make use of their resources for cultural inheritance and creation.

8.1 Reception of Ramayana in Japan

Though it is not clear when Ramayana was first brought to Japan, some scholars believe that music and dances depicting scenes from Ramayana were performed in eighth-century Japan. Between the fifth and eighth centuries, various performing arts from Asia were imported into Japan. At its height in the eighth century, brilliant international culture flourished. Diverse music and dance were performed in governmental ceremonies like the Buddhist ceremony to consecrate the Great Buddha of Tōdaiji Temple held in 752. The origin of those performing arts includes three ancient Korean

kingdoms, the Chinese Tang dynasty, Bohai kingdom of southeastern Manchuria and northeastern Korea, and Lin Yi kingdom (the old Chinese name for Champa) [5, pp. 24–25]. In addition, music and dance called *toragaku* were also played. Its origin is not certain, but Dvaravati, a kingdom that flourished in the Chao Phraya river basin region between the seventh and eleventh centuries, has been cited as one of the candidates [5, p. 42]. Some scholars believe that the dances of *toragaku* depicted scenes from Ramayana [10]. There is also a theory that Ramayana was orally brought to Japan in the year 736 by the Buddhist monk Buttestu (Fozhe in Chinese) from Annam, who came to Japan accompanying Indian Monk Bodaisenna (Bodhisena) [2, p. 531]. However, the tradition of *toragaku* was interrupted, and Ramayana was not transmitted to later generations.

We can find the first Ramayana text in Japanese in the *Hōbutsushū* (collection of Buddhist narratives) compiled by Taira no Yasuyori in the 12th century. A brief summary is as follows:

This was a tale of Tathagata Sakyamuni when he was the king of a great kingdom in India long ago. Upon hearing that a neighboring country was attacking, the Great King, who wanted to avoid killing, surrendered his kingdom and took his wife to a mountain to practice Buddhism. Then, a Brahman came to the mountain and kidnapped the Queen. While the Great King was searching for his Queen, he came upon a large bird with broken wings on the verge of death. Before dying, the bird said, "I saw the Brahman kidnap the Queen, and I tried to stop him, but the Brahman turned himself into the Dragon King and broke my wings." The Great King buried the bird and headed south, where he encountered many monkeys making a great fuss. They asked the Great King to be their general as the neighboring country was on the attack and brought a bow and arrows. When the enemy saw the Great King draw the bow, they fled without attacking. The monkeys were filled with joy and accompanied the Great King until they finally arrived at the seaside. Seeing what was going on, Brahma Taishaku transformed into a small monkey and suggested that they cross the sea by fashioning a raft out of boards and grass. When the raft arrived at the Dragon Palace, the Dragon King was enraged and released a light. This caused the monkeys to fall to the ground, drunk with mist and afraid of the snow. The small monkey climbed the snowy mountain, cut down a branch of a medicinal tree with curative effects to stroke the monkeys, which awoke them from their drunkness and gave them the courage to attack the Dragon King. The Great King released an arrow that struck the Dragon King, who then fell at the monkeys'

feet. The monkeys recovered the Queen, seized the seven treasures, and returned to the mountain. Then the king of the neighboring country died, and The Great King became the ruler of both countries. The details are recorded in the Rokuharamitsu Sutra.

Although proper nouns such as "Rama," "Sita," "Jatayu," and "Ravana" do not appear in this narrative, the story indicates that it is apparently based on Ramayana. The fact that the Great King is described as a previous incarnation of Buddha and that Yasunori stated that further details are contained in the *Rokuharamitsu Sutra* suggests that Ramayana was introduced to Japan with Buddhist scriptures via China around this time.

Folk tales on the subject of *oni taiji* or exterminating demons have been told in Japan. Among them, most widely known is the story of Momotarō, who is said to have been born out of a peach, kills demons with the help of his loyal dog, pheasant, and monkey, who make up his entourage. This story contains motifs that partially overlap with Ramayana, and some believe that they are related. Certainly, it is possible to imagine some kind of influence in the story's motifs. Still, it cannot be considered that Ramayana itself as a long epic has taken root in Japan.

It was not until the end of the 19th century that Ramayana began to be introduced to Japan in earnest. In 1896, the scholar of Buddhism Watanabe Kaikyoku reported on Ramayana found in Chinese translations of Buddhist scriptures, and in 1914, the naturalist and ethnologist Minakata Kumagusu wrote about Ramayana found in old Japanese and Chinese books [7]. Around this time, interest in Ramayana was increasing among researchers and the literati. Interest in Ramayana as a work of literature, philosophy, and religion was mainly in the original Indian work, but from the 1930s to the early 1940s, when Japan had expanded toward the south, the existence of Ramayana in Southeast Asia became known in Japan. One of the characteristics of this renewed knowledge of Ramayana was the fact that it had been used as the subject material for performing and visual arts.

In the post-WWII era, translations of Ramayana increased. Many of them were abridged translations or re-translations from English. No complete translations from the original Sanskrit were attempted at first. Later, Iwamoto Yutaka, a scholar of Buddhism and Indian classical literature, began to work on a complete translation of the

Ramayana, but was unable to complete it and died after publishing the second volume [13]. Subsequently, from 2012 to 2013, the translation of the "Bombay Edition" [12] of Ramayana was published [14]. Concurrent with this work's publication was an effort to describe and research Southeast Asian versions of Ramayana in great depth. It is noteworthy that while the Indian version of Ramayana was made available as a work of translated literature, Southeast Asian Ramayana was mainly introduced to Japan through performing arts based on it. Matsumoto Ryō's work, which retold Ramayana and Mahabharata's episodes performed in Javanese shadow puppet theater *wayang kulit* in great detail, left a significant influence. Captivated by the allure of *wayang kulit*, he used sound recordings of performances of *wayang kulit* made in Java and, with the help of Javanese living in Japan, translated the stories of Ramayana and Mahabharata as told by *dalang* (puppeteers). One of his major works is *The Evening Glow of Ramayana* [6]. He also founded the Nihon Wayang Kyōkai (Japan Wayang Association) and initiated the activity of showing *wayang kulit* performance, first to the recording made by Javanese *dalang* in Java and later with live gamelan music played by groups in Japan. Since the 1980s, Umeda Hideharu, one of the authors of this book, has played Balinese *wayang kulit* in Japan with his groups. In recent years, several Javanese artists, together with the Japanese, perform Javanese performing arts, including *wayang kulit*. The activities of these people have aroused interest in the Ramayana in the Southeast Asian performing arts.

8.2 Ramayana in the Southeast Asian Gallery at National Museum of Ethnology

8.2.1 Historical Background of the Exhibition on Southeast Asian Culture in Minpaku

Minpaku opened its museum in 1977. One of the driving forces behind this was the growing interest in different cultures symbolized by the World Exposition held in Osaka in 1970 (hereafter Expo '70). Artist Okamoto Tarō, who served as the producer of the theme pavilion at the Expo, planned to display various masks as a part of its exhibition. With the cooperation of cultural anthropologist Izumi

Seiichi and Umesao Tadao, who later became the first Director-General of Minpaku, 20 young anthropologists were organized to form the Expo '70 Ethnological Mission (EEM). The EEM collected artifacts from around the world and used them in exhibitions held at Expo '70 [16, p. 94]. The materials gathered at that time are now in the collection of Minpaku.

Some of those involved in EEM have since become affiliated with Minpaku. The EEM collection constitutes an integral part of the Minpaku's exhibit. However, the EEM's collection did not achieve much in Southeast Asia. Instead, the materials collected by the First Comprehensive Survey of Southeast Asian Rice Cultures, which surveyed Vietnam, Cambodia, Laos, and Thailand between 1957 and 1958, and the materials collected by museum staff members prior to the opening of Minpaku occupy an essential position [3]. The Survey Team's work is important for understanding the development of Southeast Asian studies in Japan. As the name suggests, the survey focused on rice cultivation. Rice cultivation also occupies a significant place in Japanese culture. The researchers sought to capture the characteristics of Southeast Asian rice culture in relation to and in comparison with Japan. It is a characteristic of the early days of Southeast Asian studies in Japan.

One of the reasons why the EEM's Southeast Asia collection was not very successful had to do with the university dispute that was raging in Japan at the time. In the late 1960s, there was a widespread movement in universities across the country against the authoritarian university system and regime, as well as the Japanese socio-political system. In this context, Expo '70 and its related EEM were also subject to criticism as a move in line with the business community's aggressive expansion overseas in the wake of economic recovery. During this, the member of the EEM in charge of Southeast Asia withdrew from participation [3, p. 59]. As a result, a person who was not a scholar of Southeast Asia suddenly took on the role of collecting materials.

Criticism against Japan's expansion into Southeast Asia was not restricted to Japan alone. During Prime Minister Tanaka Kakuei's visit to five ASEAN countries in 1974, anti-Japanese demonstrations broke out in Bangkok and Jakarta. A large-scale riot accompanied the demonstration in Jakarta in particular. It has been pointed out that these demonstrations had the aspect of anti-

government movements in their respective countries. Still, there is no doubt that Japan's growing economic dominance was behind the demonstrations. The impact of these events led to a further increase in Japanese interest in Southeast Asia. On the one hand, it led to a growing interest in Southeast Asian studies. The book *Invitation to Southeast Asian Studies*, edited by Yano Tōru, was published in 1975, based on a 1975 TV program broadcast over the NHK educational channel entitled "Southeast Asian Society" [15].[1] On the other hand, politically, it led to the three principles of Japan's ASEAN diplomacy, known as the "Fukuda Doctrine," set forth by Prime Minister Fukuda Takeo in 1977. The principles were: (1) to deny that Japan would become a military power, (2) to build "heart-to-heart" relations, and (3) to treat Japan and ASEAN as equal partners. It provided an opportunity for the active promotion of cultural exchange through the Japan Foundation and others. These events form the background to the increased interest in Ramayana through the introduction of Southeast Asian performing arts, which was mentioned in Section 8.1.

8.2.2 Changes in Southeast Asia Gallery in Minpaku

Minpaku divides the world into nine regions and holds exhibitions on each region's culture.[2] One of these is the Southeast Asia Gallery. Initially, the Southeast Asia Gallery consisted of three main sections: rice cultivation culture, the world of belief, and crafts and performing arts. The central part of the performing arts section was *wayang kulit*, a shadow theater of Central Java. Among the items on display were *kelir* (the screen onto which the shadows are projected), *gedebog* (banana tree trunks placed horizontally across the front of the screen, representing the earth), many puppets set up on the *gedebog* extending to the right and left of the screen, *kothak* (the puppet box) placed on the left of the puppeteer's seat with many

[1]Yano ed. [15] is a revised version in which the two volumes originally published in 1975 were published in a single volume.

[2]The museum opened to public, with the exhibitions of Oceania, the Americas, Europe, Africa, West Asia, Southeast Asia, and East Asia. Subsequently, exhibitions on Central and Northern Asia, and South Asia were added. The exhibition of East Asia is subdivided into the Culture of Korean Peninsula, Regional Cultures of China, Ainu Culture, and Culture of Japan. In addition to the regional culture exhibbitions, there are also two cross-cultural exhibitions on music and languages.

puppets inside, and the music ensemble *gamelan* that accompanies the play from the rear. Although Ramayana was not particularly emphasized or explained, a whole set of *wayang kulit* puppets used in the performance was on display, which includes characters from Ramayana. The costumes worn in the dance drama *wayang orang*, which features actors on stage, were also displayed on mannequins. The *wayang orang* exhibit showed the characters selected from Ramayana, i.e., Rama, Sinta (Sita), Dasamuka (Ravana), and Jatayu.

The Southeast Asia Gallery underwent a major change in 1996, 19 years after the museum opened to the public. A section named Wayang Square was installed to exhibit puppet theaters and masked theaters. On the islands of Java and Bali, there are varieties of performing arts known as *wayang*. These include picture-storytelling *wayang beber*, shadow puppet theater *wayang kulit,* rod puppet theater *wayang golek*, dance drama *wayang orang* or *wayang wong*, and masked dance drama *wayang topeng*. Using the term *wayang* as a clue, the Wayang Square attempted to show the diversity and interconnectedness of Southeast Asian performing arts. *Wayang kulit* from Central Java continued to be the centerpiece of the exhibition. A new feature of the section was the projection of moving images of *wayang kulit*'s shadow filmed in Central Java on the screen as if you were watching a shadow play on the spot, and the video of *dalang* manipulating the puppets on a monitor so that you could watch them together. In addition, from a comparative perspective, we exhibited Burmese (Myanmar) puppet theater *yoke the pwe* with accompanying instruments, Vietnamese water puppet theater *mua roi nuoc*, Balinese shadow puppet theater *wayang kulit*, Balinese masked dance drama *topeng pajegan*, West Javanese masked dance *topeng Cirebon*, and Central Javanese masked dance drama *wayang topeng*. Although Ramayana was not explicitly featured in the exhibition, the museum's guidebook mentioned that it is a common theme in the diverse Southeast Asian performing arts that represent their historical connection.

In 2015, a further 19 years later, the Southeast Asia Gallery was once again redesigned. As one of the four sections that make up the new Southeast Asia Gallery, a section called "Entertainment and Recreation" was established. It mainly focuses on performing arts and continues to display various puppets and masks. However, Central Javanese *wayang kulit* has significantly been reduced to present a more diverse range of puppet theaters and masked theaters.

Among the new exhibits of puppets and masks are Cambodian and Thai large shadow puppet theater *sbaek thomm* and *nang yai*, small shadow puppet theater *sbaek tauch* and *nang talung*, Malaysian shadow puppet theater *wayang kulit siam*, Cambodian masked theater *lkhaon khaol*, and Burmese Ramayana masked dance drama *nandwin Rama*.

In the new exhibition, in addition to the diversity of puppets and masks, we also took into consideration the variety of the stories being performed. One of the characteristics of various *wayang* genres of Indonesia is the diversity of the stories performed. Episodes from Mahabharata are most commonly performed in *wayang*, but Ramayana episodes are also performed. There are also special episodes for purification rituals. The episodes to be performed also differ depending on the type of *wayang*. In *wayang golek cepak* of the north coast of West Java, the historical stories of the region are staged. Most of the masked dance dramas in Java perform the *Panji* stories set in the Kediri kingdom that flourished in East Java in the 11th century, whereas Balinese masked dance drama *topeng* often performs the historical story *babad* of the kingdom that flourished in Bali. Reflecting this situation, the Javanese *wayang kulit* puppets were selected from the characters of Mahabharata, the West Javanese *wayang golek* and the Malaysian *wayang kulit siam* puppets were characters from Ramayana, and the Balinese *wayang kulit* puppets were characters from stories performed in the purification ritual, *sapu leger*.

In contrast, Mainland Southeast Asian large shadow puppet theaters and masked dance dramas are more strongly associated with Ramayana and do not feature any other stories. Meanwhile, Myanmar's puppet theater is distinctive in that it performs stories related to Buddhism, such as *Jatakas*. The Cambodian *sbaek tauch* plays more popular stories such as local folk tales, and the performance of Vietnamese *mua zoi nuoc* often consists of short sequences of familiar themes such as scenes from people's daily lives.

As the display of puppets and masks shows, Ramayana has become a widely shared tradition in Southeast Asia. However, it is not performed in every performing arts genre but primarily in the classical genres developed in the royal palaces. It is probably related to the fact that the characters in Ramayana are restricted to the royal families, the monkeys who assist them, and the Rakshasas who fight

against them, and the focus is on the struggle between kingdoms. Ordinary people are not depicted in the Ramayana. However, since the latter half of the 20th century, Ramayana has been recognized as Southeast Asia's cultural heritage, and new works have been created that feature Ramayana as a national art form, and characters as heroes of the common people (see Chapters 1 and 2).

8.3 Visual Representation of Characters from Ramayana as Seen from the Exhibit

What can we lean about Ramayana from the exhibition of masks and puppets? As one example, let's take a look at the visual representations of three characters of Ramayana.

Although the stories performed by *wayang* are diverse, the visual representation of the *wayang* characters in one region varies little from story to story. The style of expression is determined by whether it is gentle or muscular male royalty, female royalty, rakshasa, or the clown. Even if the stories are taken from different sources, the style of expression remains basically the same. In many cases, puppets and masks from the same region share the same style of expression. Therefore, it can be said that the visual characteristics of puppets and masks vary more from region to region than from story to story.

The visual characteristics of the characters in Ramayana are not always clearly described in Valmiki's Ramayana, nor are they represented in the same way in different versions of Ramayana. For example, in Ramayana in Southeast Asia, Hanuman is commonly portrayed in white. However, it is not always expressed in white in India, and there is no description that Hanuman is white in Valmiki's Ramayana. The diversity and commonality of Ramayana found in Southeast Asian puppets and masks indicate that in the process of accepting Ramayana, the visual expressions were devised by interpretation in each region. At the same time, common expressive styles were adopted in certain aspects. The historical background of this process has not been clarified in detail, but comparing the visual representation of the characters in Ramayana at Minpaku's exhibition will be one of the clues.[3]

[3]It is not possible to show photos of all the examples here, but you can find photos of the artifacts in the database of the National Museum of Ethnology. You can see the photos by searching the corresponding artifact number in the Artifact Catalog database on the National Museum of Ethnology website (http://www.minpaku.ac.jp/).

8.3.1 Hanuman

In Southeast Asia, Hanuman is colored in white, with a few exceptions. In Malaysia's wayang kulit siam, Hanuman is often depicted with a red face. According to Khor Kheng Kia, the puppeteer Omar Hassan stopped painting Hanuman's body because the white paint would cast a black shadow on the screen. Instead, he painted only the face red to make it look more colorful [4, p. 93].[4] Osnes also notes that the puppeteer Hamza painted his face red to represent Hanuman's aggressive nature [9, p. 63; 4, p. 93]. However, even in Malaysia, Hanuman is considered to be white, as indicated by the name Hanuman Kera Putih (White Monkey Hanuman). In contrast, Shanti Lal Nagar wrote that the color of Hanuman's hair is described as golden in the Ramayana of Valmiki and yellow in other texts [8, p. 89]. There is no consensus on Hanuman being white, at least in the Indian written texts.

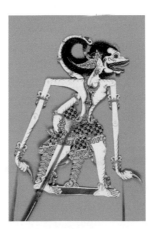

Figure 8.1 Hanuman in Javanese *wayang kulit*. Artifact No. H0202088.

Nagar also mentions the visual representation of Hanuman in Southeast Asia, describing his face as "terrific" [8, p. 157]. Perhaps this has something to do with the fact that Hanuman is often rendered close to a human figure in India. In Southeast Asia, Hanuman is portrayed as a white monkey with tusks and is

[4]The *wayang kulit siam* puppet in the Minpaku collection is recorded to have been used by the puppeteer Omar. The body of the Hanuman puppet of H0005072 is painted white, but the face is painted red.

represented as an agile monkey with fierce acrobatic movements in performance. In addition, in the *wayang* of Malaysia and Indonesia, Hanuman is depicted with sharp claws. Particularly in Javanese and Balinese *wayang*, Hanuman is described as the son of the wind god Vayu and has single powerful claws in both hands like Vayu. In Indonesia, Hanuman is usually shown with large round red eyes. These examples show that different regions express the character of Hanuman in different ways. While the representation of Hanuman as white is shared throughout Southeast Asia, the visual characteristics that express the nature of Hanuman are different in each region. It can be said that the visual representation of personality is not specific to a particular story but rather to a genre of performing arts and to the culture of the region.

One of the most popular iconographies of the Hanuman character in Southeast Asia is that of Hanuman seducing a woman, as seen in *sbaek thomm*, a Cambodian shadow theater using large leather puppets.[5] The episode of Hanuman tempting a mermaid on the sea crossing to Lanka is a common theme in classical dance in Mainland Southeast Asia. Hanuman stands out as one of the most important heroes in Ramayana. In Southeast Asian Ramayana, Hanuman takes credit for great deeds in various places, but each time he seduces a woman.

8.3.2 Ravana

Ravana is described as having 10 faces, but there are various ways of depicting them in different regions. In Cambodian masks, faces are drawn on the lower and upper parts of the crown in addition to the regular face. However, the total number of faces is not exactly 10, and the mask of Ravana (artifact No. H0217206) from the collection of Minpaku shows seven faces. In Mainland Southeast Asia, this expression is relatively widespread and is also observed in shadow puppets. A similar expression is sometimes seen in Insular Southeast Asia, such as *wayang golek* in West Java (artifact No. H0149049) and *wayang kulit siam* (artifact No. H0005104), but they are usually

[5]Hanumān seducing Bunhakay (artifact No. H0224407 and others), etc.

depicted with only one face.[6] In the story, it is told that Ravana has 10 faces, but the puppet is often shaped in the same way as other puppets. In this case, the 10 faces are shown through narration and acting.

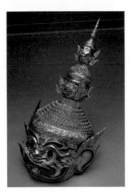

Figure 8.2 Ravana in Cambodian Ikhaon khaol. Artifact No. H0217206

Ravana, carved in reliefs at Banteay Srei (10th century) and Angkor Wat (12th century), is depicted in two tiers of four faces, with two faces piled on the top tier. It is possible that the drawing of the faces on the mask's crown is connected to this expression. In comparison, the Indian dance drama masks in the collection of Minpaku are characterized by a horizontal row of Ravana's faces (H0089956). Also, in Telugu shadow puppets, the faces are lined up in a row (H0085932).

The color of Ravana's face varies according to region. In the *wayangs* of Indonesia and Malaysia, his face is often painted red or brown, reflecting Ravana's temperamental nature, and the eyes are drawn round and large, often painted red. In contrast, in Mainland Southeast Asia, Ravana is usually colored dark green while some masks are gold because he is determined to make himself attractive for Sita [1, p. 128].

[6]For example, H0004127, H0067659, and H0067807 for Javanese *wayang kulit*, H0148920, H0148985, and H0229681 for Sundanese *wayang golek*. Even in these examples, a hair clip with the face of a garuda, called a garuda mungkur, is sometimes seen. This is often depicted on other characters as well, and is not Rāvana's face.

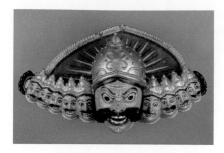

Figure 8.3 Ravana in Indian dance drama. Artifact No. H.0089956.

8.3.3 Rama

The iconography of Rama has a specific pattern in each region. Being male royalty and an avatar of Vishnu is often visually represented. Being human royalty is often portrayed in contrast to the roughness of the rakshasa. It can be said that more human-like forms are characteristics of royalty. In mainland performing arts, Rama often does not wear a mask, which is possibly related to the more humanistic depiction of royalty.

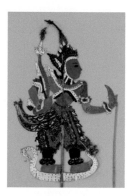

Figure 8.4 Rama in Malaysian *wayang kulit siam* with dark green color. Artifact No. H0005079.

The royal family wears costumes, jewelry, and crowns suitable for them, although the specific expressions vary from region to region. Rama, as a prince, has the same attributes as his brother Lakshmana, and the two are often shaped very similarly. The clue

to distinguishing the two is often color. The face of Myanmar's Rama mask is painted green (H0090097). Rama of Kelantanese and Balinese *wayang kulit* is also represented in green (H0237431, H0149310, etc.). The color green symbolizes that Rama is an avatar of Vishnu and has divinity [9, p. 63]. For the same reason, Rama is often said to have a blue skin color in India. In contrast to Rama, Lakshmana is often painted in gold in Mainland Southeast Asia and red in Malaysia's *wayang kulit siam*.

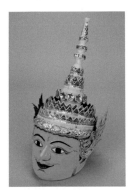

Figure 8.5 Rama in Myanmar masked dance drama with green color. Artifact No. H0090097.

In the representation of male royalty, Javanese *wayang* has distinct features compared to others. One of the indicators of a sophisticated royal character is the long, slit eyes. This expression is not seen in the rakshasa, clowns, or the more muscular royal characters. Some *wayang* practitioners believe that the slit-eyed form originated in China. In Indonesia, the long, slit eyes are considered one of the characteristics of the Chinese and other East Asian people. The word "*sipit*" (thin) is used to describe such a shape, and one Indonesian dictionary includes the example sentence, "Japanese people generally have narrow eyes." Perhaps it is connected with this image. There is no solid evidence for the origin of the narrow-eyed shape, and we can only imagine for now. However, we can see some similarities between the expressions of eyes in *wayang* and Chinese shadow play. In Javanese *wayang kulit*, Rama's face is often painted in black, which is different from the Hindu symbolism of color. In this respect, too, we can see that Javanese *wayang kulit* has developed its own unique way of expression.

8.4 Visual Recordings of *Sbaek Thomm*, the Large-Scale Shadow Theater of Cambodia

Through its exhibitions, Minpaku has helped museum visitors deepen their understanding of the cultures of the world's peoples. However, Minpaku's activities as a research institution for cultural anthropology do not stop there. One of the missions of Minpaku is to collect, preserve, and pass on to future generations materials related to human cultures based on cultural anthropological research. Furthermore, museums have begun to actively seek to contribute these materials to cultural transmission and creative activities in recent years. How, then, can Japanese museums contribute their collections related to Ramayana in Southeast Asia to the handing down or recreation of Ramayana performing arts? We would like to examine the case of *sbaek thomm*, a Cambodian large shadow theater that is on the Representative List of Intangible Cultural Heritage of UNESCO.

Minpaku's collections include not only physical artifacts but also visual recordings. In handing down music and performing arts, which have become increasingly known as intangible cultural heritage, the role of video documentation is vital in addition to physical artifacts. Since the opening of the museum, Minpaku has had a dedicated video staff to produce video programs. We often make video recordings while collecting artifacts. From November to December 1999, with the cooperation of the Cambodian scholar Sam-Ang Sam, I visited Cambodia along with my colleague Terada Yoshitaka and audiovisual staff members to collect artifacts and record performing arts in Phnom Penh and Siem Reap.

In 1977, when the museum opened, the Khmer Rouge led by Pol Pot ruled Cambodia, forcing urban residents to move to farming areas to work, and abusing and massacring the wealthy and intellectual class. After the Vietnamese army invaded Cambodia at the end of 1978 and the Pol Pot regime collapsed, the country was in a state of civil war, with the People's Republic of Kampuchea, supported by Vietnam, and the opposition Coalition Government of Democratic Kampuchea standing side by side. As a result, it was impossible to conduct research or gather artifacts in Cambodia, and Minpaku, therefore, has only a small number of artifacts from this country. After

the Paris Peace Accords of 1991 and the general election of 1993, Sihanouk was reinstated as king, and the Kingdom of Cambodia was established with international cooperation. Then, at the end of the 1990s, it finally became possible to conduct research and collection.

This visit aimed to collect artifacts related to the performing arts of the Khmer people and record their performances. The main sites visited were Phnom Penh and Siem Reap. In Phnom Penh, with the cooperation of the staff of the Royal University of Fine Arts and the Ministry of Culture and Fine Arts, we filmed various genres of performing arts that they usually teach and perform. We also collected related artifacts such as musical instruments, dance costumes, and masks and recorded some of the production processes. In Siem Reap, we filmed the performances of two types of shadow puppet theaters and the activities of the people involved in them, the music ensemble accompanying the procession of offerings to a temple. We also collected shadow puppets and their production tools and filmed the puppet production process.

Through this collection and filming, we learned that although *sbaek thomm*, a large shadow puppet theater that had once been performed in Siem Reap, was being revived, the repertoire was in danger of being lost due to the decline in health of the group's leader, Ty Chien. After returning to Japan, we lobbied various parties to document the whole repertoire of *sbaek thomm* in earnest. In March 2000, we received support from the Japan Foundation to revisit Cambodia. We recorded the performance of six episodes out of a total of seven, except for one, which was recorded four months earlier. We also recorded an interview with Ty Chien about how he learned and performed *sbaek thomm* and interviews with the former Minister of Culture and Fine Arts, Chheng Phon, and other people involved. Unfortunately, Ty Chien passed away in July of that year. He refused to go to the hospital, saying that it was the will of the spirits, and passed away at home.

The video footage we shoot has become invaluable. Video documentation of the performing arts is significant as a record of human creativity. However, it is nothing more than a record of a performance given by particular performers at a particular time and place. Although it is useful for remembering and learning the art of Ty Chien, it would be a disservice to watch this video instead

of attending the performances of the group that has continued to perform *sbaek thomm* in Ty Chien's spirit. We realized that we had a responsibility to figure out how to use the video recordings to pass on and develop *sbaek thomm*.

First, we produced a video program in Japanese to introduce *sbaek thomm* to the museum's visitors. Also, with the help of Fukutomi Tomoko, who learned *sbaek thomm* from Ty Chien and supported the group's activities, we made programs with Japanese subtitles for all seven episodes. In general, such videos should be made available to the widest possible audience. However, there are times when the release of video programs poses problems. When several groups compete with each other, the release of a program documenting the art of a master may be perceived as leading to the "stealing" of the art. According to Fukutomi, Ty Chien consciously avoided leaving his narrative in written form and making it public because of his experience with a group of people who did not learn *sbaek thomm* properly but instead performed a superficial imitation, ignoring the tradition. In Japan, too, there is a concept of secrecy of the art. Sometimes, it is precisely because of this secrecy that the art becomes valuable, and the incentive to inherit it increases. Such thinking is not merely selfish but often stems from the beliefs and values that support the art. In that case, we cannot simply dismiss such ideas. However, this was resolved through discussions with Chean Sophan, Ty Chien's grandson, who had taken over the group's leadership, and his group when we revisited Cambodia in 2009. They watched the videos we had produced and said they wanted more Cambodians, especially children, to see it. In response, we also produced a Khmer version of the program introducing *sbaek thomm*.

We need to make this video available to a broader audience. In particular, we should promote its use in education. It is to deepen the understanding of the performing arts in the society and build a climate of support for the traditional arts. Some may learn about the performing arts through the video and choose to join the performers. As long as the performing arts are carried on by people, we cannot and should not force them to inherit them. What we can do is to provide more opportunities for young people to come into contact with traditional performing arts and to provide them with the

means to acquire relevant knowledge if they wish. It would be best if they could be exposed to live performances, but it is important to use video as one of the ways to get there.

Moreover, it is necessary to make the videos available to people outside the community where the performing arts are transmitted. Today, many communities find it difficult to pass on their traditions for social and economic reasons. It is up to the people of the communities who pass on the traditions to make decisions about the future of these arts. However, there is considerable room for outsiders to contribute to creating an environment that allows for a variety of options. Interest from the outside can be a great stimulus to the people who pass on the arts. In a world where the monetary economy has spread to every corner of the globe, it may be impossible to maintain performing arts activities without receiving some compensation for their performances. Performing outside of one's own region can help to maintain the group financially. It is safe to say that the traditional performing arts of our time would not be able to survive without a relationship with the outside world.

Museums were once considered to be graveyards for the things we had used in the past. They were no longer of any use, but they were too good to throw away, so we tried to keep them in museums as historical memories. However, it is even more important in today's globalizing world to know one's own history, build relationships with different people, and explore the foundations on which one stands. Ethnological museums like Minpaku serve to connect the past with the present, as well as to connect people living in different societies. Although we are not directly involved in the transmission of the Ramayana tradition in Southeast Asia, we are responsible for enhancing the understanding of Ramayana in Japan and connecting the people of Japanese society with Southeast Asia. We believe that this is the very reason why museums in Japan today have exhibitions on the Ramayana in Southeast Asia.

References

1. Chandavij, N. and Pramualratana, P. (1998). *Thai Puppets and Khone Masks* (Thames and Hudson, London).

2. Hara, M. (1978). *Studies Dedicated to Professor Atsuuji Ashikaga on the Occasion of his Seventy-seventh Birthday*, ed. The Society for the Near Eastern Studies in Japan, "Ramayana and Momotarō tale," (Kokusho Kankōkai, Tōkyō) pp. 523–539 (in Japanese).

3. Hirai, K. (2018). *A 'Tower of Sun' Collection: Expo'70 Ethnological Mission*, ed. Nobayashi A., "Southeast Asia," (National Museum of Ethnology, Suita) pp. 57–61 (in Japanese).

4. Khor, K. K. (2014). *Digital Puppetry of Wayang Kulit Kelantan: A Study of Its Visual Aesthetics*, Ph.D. Diss. (University of Malaya, Kuala Lumpur), Retrieved from http://studentsrepo.um.edu.my/id/eprint/4692.

5. Kikkawa, E. (1965). *A History of Japanese Music* (Sōgensha, Ōsaka) (in Japanese).

6. Matsumoto, R. (1993). *The Sunset Glow of Ramayana* (Hachimanyama Shobō, Tokyo) (in Japanese).

7. Minakata, K. (1971 (1914)). *The Complete Works of Minakata Kumagusu*, Vol. 2, "Prince Rama Legend in Old Japanese and Chinese Books," (Heibonsha, Tōkyō) pp. 379–386 (in Japanese).

8. Nagar, S. L. (1995). *Hanumān in Art, Culture, Thought, and Literature* (Intellectual Pub. House, New Delhi).

9. Osnes, B. (2010). *The Shadow Puppet Theatre of Malaysia: A Study of Wayang Kulit with Performance Scripts and Puppet Designs* (McFarland, Jefferson, N.C.).

10. Tanaka, O. (1974). *Suikashū: Indology Articles and Translated Poems*, "*Toragaku*," (Shunjūsha, Tōkyō) pp. 14–37 (in Japanese).

11. Watanabe, K. (1933 [1896]). Kogetsu Zenshū, Vol. 2, ed. Kogetu Zenshū Kankōkai, *Rāmāyana and Its Characters in the Buddhist Sctiptures*, (Kogetu Zenshū Kankōkai, Tōkyō) pp. 252–258 (in Japanese).

12. Vālmīki. (1909). *The Rāmāyana of Vālmīki with the Commentary (Tilaka) of Rāma*, 3rd Ed, ed. Pansīkar, V. (Tukârâm Jâvajî, Bombay).

13. Vālmīki. (1980–1985). *Rāmāyana*, trans. Iwamoto, Y. (Heibonsha, Tōkyō) (in Japanese).

14. Vālmīki. (2012–2013). *Rāmāyana, New Translation*, trans. Nakamura, R. (Heibonsha, Tōkyō) (in Japanese).

15. Yano, T. (ed.). (1977). *An Invitation to Southeast Asian Studies*, Rev. ed. (NHK Shuppan Kyōkai, Tōkyō) (in Japanese).

16. Yoshida, K. (2001). *Japanese Civilization in the Modern World XVII: Collection and Representation* (Senri Ethnological Studies 54), eds. Umesao, T., Lockyer, A., and Yoshida, K., "'Tōhaku' and 'Minpaku' within the History of Modern Japanese Civilization: Museum Collections in Modern Japan," (National Museum of Ethnology, Suita) pp. 77–102.

PART IV
COMMISSIONED ART WORKS

Chapter 9

Art Works

Madoka Fukuoka

Graduate School of Human Sciences, Osaka University,
Yamadaoka 1-2, Suita, Osaka, Japan
mfukuoka @hus.osaka-u.ac.jp

Synopsis of Works:

Didik Nini Thowok, dancer of cross-gender, comedian, and actor; Yogyakarta, Java, Indonesia

Nanang Ananto Wicaksono, puppeteer (*dalang*) and animator; Osaka, Japan

Ken Steven, composer and conductor of choral music; Medan, Indonesia

9.1 Introduction

Three Indonesian artists have created and contributed the original works inspired by Ramayana for this book.

A master of cross-gender dance, Didik Nini Thowok created the masked dance drama based on the story of a mermaid and monkey soldier, inspired by the Cambodian Savann Macha story. He

Ramayana Theater in Contemporary Southeast Asia
Edited by Madoka Fukuoka
Copyright © 2023 Jenny Stanford Publishing Pte. Ltd.
ISBN 978-981-4968-09-6 (Hardcover), 978-1-003-29095-7 (eBook)
www.jennystanford.com

plays the role of the mermaid and shows off his skills as a female impersonator dancer. Two dancers play the role of the monkey hero and the monster crayfish.

An active animator/*dalang*, Nanang Ananto Wicaksono created the animation work based on the story of Rama's explorations of life in his later years, which is positioned at the final stage of Ramayana.

A young composer of choral music, Ken Steven created the work of choral music and performance based on the episode of Sita's fire ordeal named as "Sinta Obong."

Ingenuity to make the art works visible in this way is one attempt to effectively present both the textual description and the actual performances in the study of art forms. In addition, it is an attempt to seek a way for presentation of art works in the pandemic situation of COVID-19.

To publish the art works online, it is also necessary to consider the copyright of the creator. Best of all, in this project, we have listed works specially created for this book as commissioned works. I would like to express my heartfelt gratitude to all of the three artists. This project was made possible by JSPS KAKENHI (19H01208) research funding. I would also like to thank JSPS for their support.

The synopsis written by each artist and the artist's profile for each work are as follows.

The works can be viewed by opening the limited You Tube video clip from the QR code and URL indicated on the following pages.

9.2 Dance Drama Created by Didik Nini Thowok: *Urang Rayung and Anoman Vs. Rekatha Rumpung*

Dance work by Didik Nini Thowok

Urang Rayung and Anoman vs. Rekatha Rumpung

Idea and concept of the work: Didik Nini Thowok

Music composition: Anon Suneko

Choreography and dance: Didik Nini Thowok, Agung Tri Yulianto, and Jatmiko Vadhjendrata Rino Regawa Capricornusa

Costume design: Didik Nini Thowok, Jatmiko VRRC

URL: https://youtu.be/SixvfNlsDZk

QR code:

Synopsis of the Dance Work by Didik Nini Thowok

First, I was inspired by the dance performance of Savann Macha and Anoman (Hanuman) in traditional Cambodian dance. In my search for data and materials about various similar stories in Java, several different versions of this story were found. After data collection, we interviewed several artists: Manteb Sudarsono, a famous puppeteer in Surakarta region; Supono, a mask maker and specialist on the stories of *wayang*'s puppeteer; and Jatmiko VRRC, a young artist who is familiar with traditional stories. In Indonesia, there are several versions of the story about Anoman and his wives, and some similarities and differences among the versions in Cambodia. Therefore, I decided to create a dance drama (*sendratari*) work based on the following story:

> Dewi Urang Rayung is the daughter of Dewa Baruna, the god who lives in and controls the ocean world. She is intoxicated with the beauty of nature on the beach. Rekatha Rumpung, a monster shrimp crab, who is a vassal of Rahwana (Ravana), the demon king of the Alengka kingdom, appears there. Fascinated by the beauty of Urang Rayung, Rekatha Rumpung scares her as he tries to block her path and takes her away. Anoman (Hanuman), a monkey warlord, appears there, helping her, fighting Rekatha Rumpung and defeating him. Urang Rayung is grateful for his help. Anoman falls in love with the beauty of Urang Rayung, and she accepts his love and they live happily ever after.

This story is positioned as one of the repertoires of "*carangan*" in shadow puppetry, *wayang*. "*Carangan*" means a story developed or created by the artists or puppeteers based on the general *pakem* repertoire. Unlike the general *pakem* that forms the basis of the story, we can see the creativity and imagination of the artists and puppeteers in *carangan* stories.

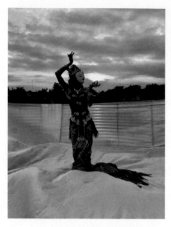 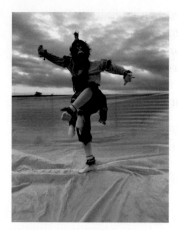

Urang Rayung Anoman (Hanuman)
©Didik Nini Thowok Entertainment

Music of the dance work

Music with Bali-style nuances colors the opening part of this dance drama. Beautiful music featuring a fusion of Java and Bali idioms gives the happy atmosphere of Urang Rayung playing in the sea. The sound of the ocean waves combined with the music draws the audience into a deeper and more integrated state, setting the atmosphere of the opening of the dance drama.

The dynamic and colorful performance created by the change from a rapid tempo to a slow tempo shifts to a part of Sunda-like (West Java style) music. The atmosphere of Sunda music is like Urang Rayung dancing happily. This part concludes with a poem about Urang Rayung, about a beautiful woman playing happily in the sea.

Risang westri ing	Beautiful maiden
Nusup silem samodra	Playing in the ocean
Lelumban tirta	Flying in the water of
Sgara	Sea
Risang kekasih	Dear lover
Urang Rayung	Urang Rayung

The appearance of Rekatha Rumpung is expressed by the sudden change with emphasized accents and the laughter of Rekatha Rumpung. The music changes into a tense atmosphere,

which combines the tones of orchestral and *gamelan* instruments, depicting the competitive atmosphere of Urang Rayung and Rekatha Rumpung. Finally, Anoman appears to help Urang Rayung from the threat of Rekahta Rumpung.

Paralang's recitation of *macapat Paŋkur*'s poem describes the battle between Anoman and Rekatha Rumpung.

Keparat Rumpung Rekatha	Evil Rekatha Rumpung
Aywa mbacut amuruseng pawestri	Trying to catch the maiden
Kethek ala ja rusuh, dahwen mring arsana	Brave monkey here appeared to rescue
Urang Rayung maremana karsaningsun	Urang Rayung in the crisis
Sun bakal dadi pepalang	I will confront this monster
Majua tandhing mring mami	Come and face me

Rekatha Rumpung was killed by Anoman, and Urang Rayung was rescued from danger.

Urang Rayung thanks Anoman, when the two fall in love with each other. A romantic atmosphere is expressed by Javanese songs accompanied by gamelan instruments and music with sharp tones.

At the end of the dance, the tempo gradually rises, and the music of the intricate musical instrument performance marks the end of this dance drama.

Tembang Love Dance (Song of Love Dance)

Wusnya jaya sang Anoman mangsah yuda	Anoman defeated the enemy
Anjeng Sahakaryanipun mring Urang Rayung	You are the one who saved Urang Rayung
Tumuli......	And soon
Tuwuh rasa sengsem sajroning nala	Spring up the feeling of love
Sakarone tumiba ing ujana	As if the flowers were scattered
Ing ujanasmara among soka rasa	with love and hesitation
Pepasihan andhon rasa jatining tresna	Lovers fall in love

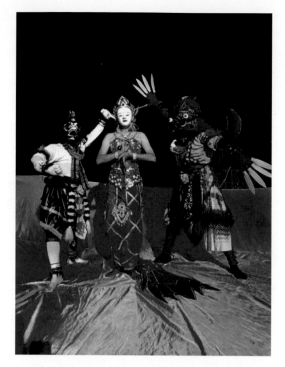

Anoman, Urang Rayung, Rekatha Rumpung
©Didik Nini Thowok Entertainmment

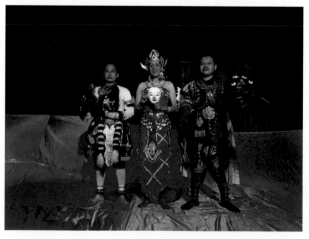

Agung Tri Yulianto, Didik Nini Thowok, Jatmiko VRRC
©Didik Nini Thowok Entertainment

Profile of Didik Nini Thowok

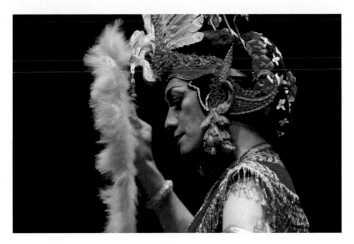

Photograph ©Hitoshi Furuya

Didik Nini Thowok was born in 1954 in Tumanggung, Central Java. He entered the National Dance Academy Yogyakarta (ASTI Yogyakarta) in 1974, and for 8 years studied traditional Javanese dance as well as other kinds of Indonesian dances. After his graduation, Didik focused on the management of his dance studio "Natya Lakshita." Didik became deeply interested in creating female dance works during the late 1970s and produced several female dance performances for students at his studio. After these works had been performed at an Indonesian dance contest and received excellent reviews, he was encouraged to establish his career as a cross-gender dancer. Based on the experiences of studying various Indonesian and Asian dances, he has created many unique works for cross-gender dancers. Until today, Didik has been engaged in artistic activities and the education of dancers of the next generation.

His name has been known widely with his representative works of *Dwimuka* serial dances. Didik has been praised everywhere he has gone, including at his repeated overseas performances. He has also created various unique dance works such as *Bedyaya Hagoromo, Panca muka, Panca Sari, DewiSarak Jodag*, etc.

In 2014, he held a cross-gender symposium and a dance concert to commemorate his 60th birthday and presented his representative work *Bedyaya Hagoromo* to Sri Sultan Hamengkubuwono X (10th) of Yogyakarta. In recent years, he has collaborated with artists from Asia as well as Hong Kong director Danny Yung and Singapore director Liu Xiaoyi, to create contemporary dance works and has performed in the various parts of Asia.

9.3 Animation Work by Nanang Ananto Wicaksono: *Ramayana: The Last Mission*

Animation work by Nanang Ananto Wicaksono

Ramayana: The Last Mission

Director and Digital Dalang (Animation): Nanang Ananto Wicaksono

Vocal Casts: ILBONG, Hitomi Mouri, and Nanang Ananto Wicaksono

Music and Sound Treatment: Enami Taisuke

Gamelan Player: Rofit Ibrahim

Songs: "Lancaran Bala Wanara" composed by Sumanto Susilomadyo

Special Thanks to: Hedi Hinzler and gallery yolcha

Producer: Yuri Nishida

Production: Magica Mamejika

In Memory of Wayang Ukur Sigit Sukasman

Copyright: ©2020 LABORATORIUM WAYANG. All Rights Reserved.

URL (English version): https://youtu.be/10Es0SKnnBA

URL (Japanese version): https://youtu.be/LkLldK44B2Y

QR code:

Synopsis of the work by Nanang Ananto Wicaksono

The story depicts King Rama's later years. He lives a quiet and lonely life and sometimes loses his mind and goes into illusions, reminiscing about the story of Rama in his youth.

> When spending time alone, he recalls the fierce battle with the Demon King Ravana, also known as Dasamuka (ten faces). Ravana left saying that he will not die and that Avatar will be revived in posterity.

> When Rama is suffering from illusions, the shadow of his beloved late wife, Sita, then appears. In his illusion, Rama apologizes to Sita for not believing in her chastity, but Sita, who has been deeply hurt by Rama's actions, does not accept his apology. Rama's apology will not be accepted unless Sita finds his reincarnated human.

> When Rama awakes from the recollection, Anoman (Hanuman), a faithful servant, stands there. At the direction of the gods, Rama himself cannot die until he finds a proper rebirth. Old Rama orders Hanuman to look for a new incarnation human to end his duty in this world as the incarnation of the God Visnu. With sorrow, Hanuman, who has received his master's orders, sets out to find a new reincarnated human being. He plays the dance of departure.

The story in this animation work is inspired by the story of Ramayana in a traditional Indonesian shadow play titled *Rama Nitis* and the novel titled *Kitab Omong Kosong* written by the Indonesian novelist Seno Gumira Ajidarma. The story can be positioned as the very last part of Ramayana story that connects the story world of Ramayana and that of Mahabharata.

The episode entitled *Rama Nitis* had been known as one of the *carangan*, or created episodes based on the setting of "trunk" episodes, *pakem*. Its origin can be traced back to the era of Sultan Hamengkubwono VIII (1921–1939) in Yogyakarta. The episode is still popular and is often performed by many puppeteers inside and outside of Yogyakarta.

The episode entitled *Rama Nitik* can be positioned as the beginning part of *Rama Nitis*. *Rama Nitik* narrates Rama's direction to Anoman (Hanuman) to search for someone qualified to be his

incarnation. In the version of Surakarta (Solo) region, *Rama Nitik* is called *Semar Boyong*.

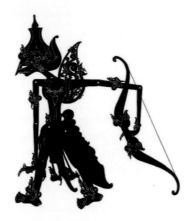

Ramawijaya ©Laboratorium Wayang

The stories depicting Rama's late years are very different from the original versions in India. In addition to the novel and episodes of shadow plays, the collection of the various stories from Asian countries have been reflected in the production of this animation work.

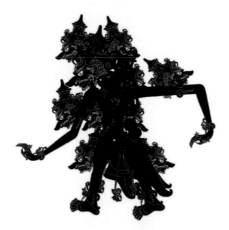

Dasamuka Tiwikrama (Ravana, dasamuka = ten faces) ©Laboratorium Wayang

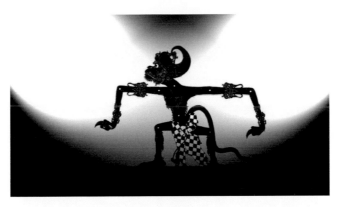

Raden Anoman (Hanuman) ©Laboratorium Wayang

This *wayang* animation video work was created using the method of the *Silhouette Animation* genre and has similar characteristics as the performance of a shadow play that casts shadows, but with a fantastic background peculiar to animation works which combines visual effects. The sculptures of the individual characters were created with reference to the characteristics and rules of traditional shadow puppets and Wayang Ukur by Ki Sigit Sukasman. The movements of the characters follow those of traditional Javanese shadow puppets. While the created music uses the creation of digital music, in some scenes it also uses the *gamelan* music used in traditional shadow puppetry, *wayang*.

The scene of Anoman's (Hanuman's) dancing is accompanied by Javanese *gamelen* music. The tune is titled *lancaran "Bala Wanara"* (Monkey army in *lancaran* form). The tune had been very popular because it was used in a flash mob for a promotion event by Yogyakarta court in 2019. In the scene of Anoman's flight, there is the narration called "ada-ada" derived from the poets in the old book titled *Serat Rama*. The old book was written by Raden Ngabehi Yasadipura, the second generation of the famous court poet of Surakarta in the 18–19th century. The narration is used in the shadow puppetry and the theatrical form called *wayang orang*. Another special element of this animation work that was derived from shadow play is the use of *Janturan*, or narration, in the beginning part. *Janturan* or narration in this scene follows the style of traditional performances of shadow puppetry in the Yogyakarta style.

Process of Making Animation ©Laboratorium Wayang

Three languages, Javanese, Indonesian, and Japanese, are used in this work. While the lines of the Demon King Ravana are spoken in Javanese, Rama and Sita speak Japanese language, and Hanuman, the monkey soldier, speaks Indonesian. The opening narration and song lyrics are in Javanese. This *wayang* animation video work was created with the aim of making the difference between traditional shadow puppets and animations stand out by having *wayang* performed on digital media, with its own characteristics, styles, and colors.

Profile of Nanang Ananto Wicaksono

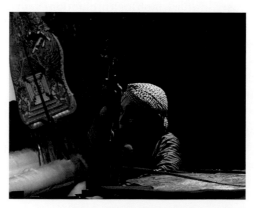

©Noer Budi Prasetyo

Born in Yogyakarta, Java, Indonesia, Nanang Ananto Wicaksono has performed on numerous stages since childhood as *dalang* (a puppeteer of shadow plays or *wayang*). Together with his grandfather, Ledjar Subroto, a puppeteer, he has created original *wayang* works that are not bound by traditional methods, such as *wayang kancil*, which is based on folk tales with animals as the main characters. In 2010, the Sultan of Yogyakarta commended him for his contribution to cultural preservation.

He also continued to work on animation production using *wayang*, and in 2008 he produced an animated work titled "*Wayang Revolusi*" based on the theme of the Indonesian independence, and in 2011 he produced an animated work titled "*William the Duke of Orange*" based on the history of The Netherlands. It was screened at a museum in The Netherlands.

From around 2015, he started his activities in Japan in earnest. He is active in multiple groups such as the shadow puppet troupe Magica Mamejika and Wayang x Electronic music x Video unit CORONA, opening up new horizons for traditional performing arts.

As a member of the "Shadow-Colors of *Wayang* Project," he won the P New Face Award 2016 in February 2017 (for the shadow play *Yashagaike*), and in March 2018, at the 21st Japan Media Arts Festival. His works are recommended by the Japan Media Arts Festival Judging Committee (for the shadow play *Ama*).

9.4 Choral Music Work by Ken Steven: *Sinta Obong*

Choral music work by Ken Steven

Sinta Obong

Composer: Ken Steven

Artistic Director: Eto Tagur

Performance: Voice of Bali

Orchestrator: Renardi Effendi

Location: Politeknik International Bali

Video Editor: Cato Production

Sound Mastering: Nano Edon

Lighting: Dore Production

Costume: Sampik Costume and Makeup

Makeup: Abhinaya Wed, Ayuningbali, Cyntiapratiwi MUA; Deuls Beauty MUA, Diahayusawitri_03; and Jegegbagus Makeup, Puspitamakeup14

Voice of Bali:

 Rama: Pande Kana

 Sinta: Keisha Palar

 Soprano: Chintya, Dewi, Eka, Keisha, Lala, Maria

 Alto: Anin, Indah, Laras, Marcelina, Marina, Mitha, Riris

 Tenor: Alfin, Alfonsus, Nata, Juniardi

 Bass: Budi, Chris, Daru, Depa, Molo, Tamu

Special Thanks to: Geg Istri, Mario, Bernard, Chrisna, Marce, Betrand, Carlos, Erik, Inton

Copyright: ©2021 Ken Steven. All Rights Reserved.

URL: https://youtu.be/oqownc8EpDs

QR code:

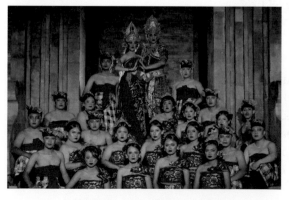

Behind the scene ©Voice of Bali

Synopsis of the work by Ken Steven

The story of Sinta Obong is an excerpt from the Legend of Ramayana, which tells about the loyalty of Sinta. It begins with a joyful meeting between Sinta and Rama because they have been separated for a long time. However, conflict arises when Rama questions Sinta's purity and loyalty. Hearing this, Sinta becomes sad and disappointed with Rama. Sinta swears that she is still pure and loyal to Rama, and to show her purity, Sinta is willing to undergo "pati obong" or the fire ordeal. Sometime later, when the flames had receded, a shadowy figure of a beautiful woman appeared amid the scattered embers. Sinta survives and was not burned at all by the fire. This shows that Sinta is still pure and has not been tainted. After that, Sinta and Rama were reunited with feelings of deep emotion and happiness.

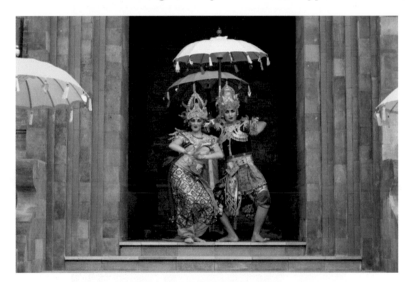

Rama and Sinta ©Voice of Bali

Based on the Balinese traditional musical idioms and cultures, I focused my writing on capturing and bringing out the story's emotions. The climax occurred when Sinta decided to undergo the fire ordeal to prove her purity as the story progresses. I set this section into the dramatic kecak dance, one of the most captivating Balinese Hindu tradition dances. Enjoy!

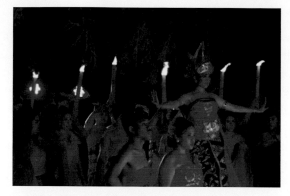

Sita's fire ordeal 1 ©Voice of Bali

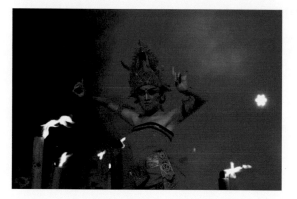

Sita's fire ordeal 2 ©Voice of Bali

Profile of Ken Steven

©Ken Steven

Hailing from Medan, composer Ken Steven is known for his fusion of Indonesian colors and elements with modern techniques and harmonies. He received his undergraduate degree in church music from the Asian Institute for Liturgy and Music, Philippines, and completed his Master of Music degree from California Baptist University, USA.

Since returning to Indonesia, his creative activity and work have made important contributions to the development of choral music in Indonesia. His music is picking up and starting to make an impact on the international choral music scene. Currently, he serves as the Director of Studies at SMK Methodist Charles Wesley Music Vocational School in Medan, North Sumatra, Indonesia. He is also the conductor of Medan Community Male Choir, founded in 2015, and has led the choir to achieve many international awards in choral festivals and competitions.

Comissioned by Prof. Madoka Fukuoka as part of her book project
"RAMAYANA THEATER IN CONTEMPORARY SOUTHEAST ASIA"

Sinta Obong

For SATB div. chorus a cappella

Based on the Ramayana Epic | Words and Music by: *Ken Steven*

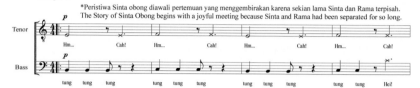

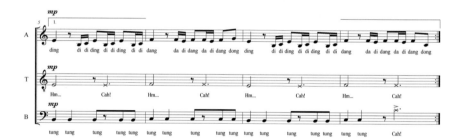

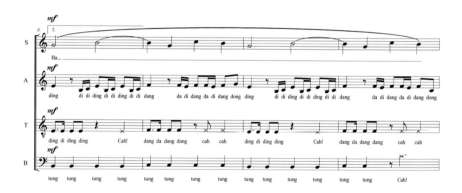

2

Sinta Obong

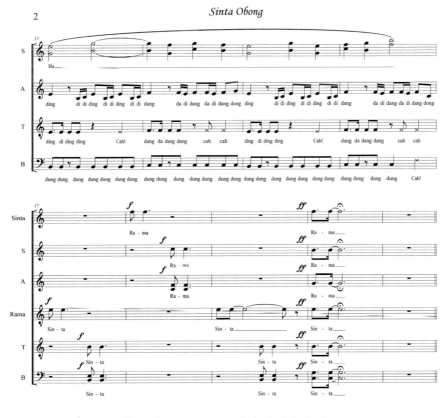

Inquieto ♩ = 65

*Konflik muncul setelah Rama mempertanyakan kesucian dan kesetiaan Sinta.
The conflict arises after Rama questions Sinta's purity and loyalty.

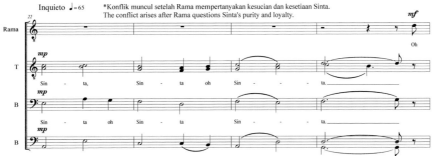

Sinta Obong

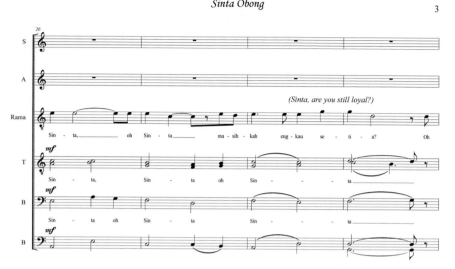

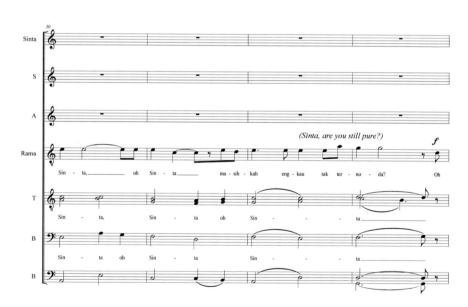

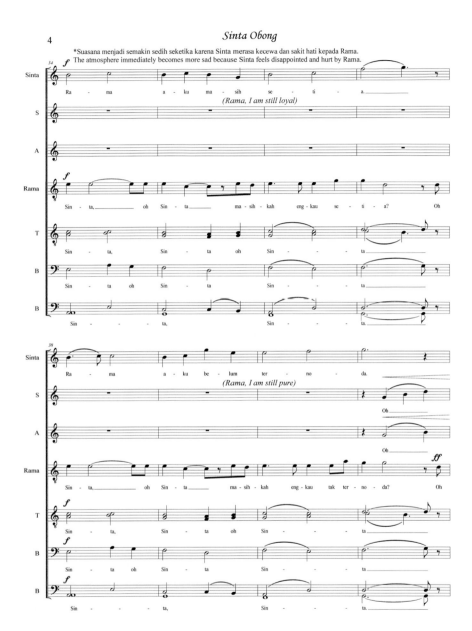

Sinta Obong

Sinta Obong

(Rama, please believe in me)

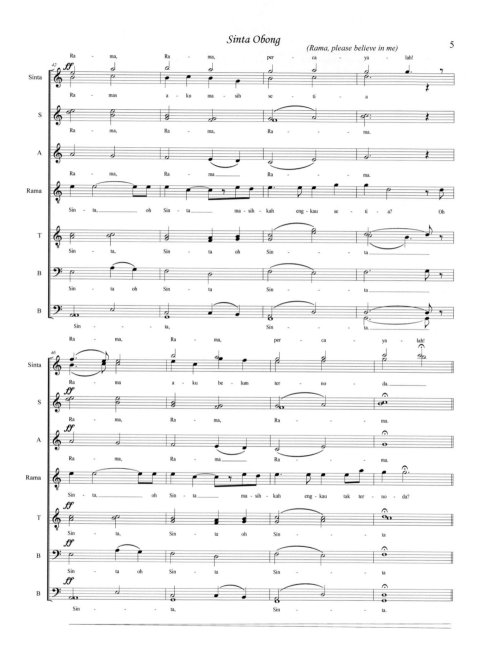

Sinta Obong

Untuk menunjukkan kesucian dan kesetiaannya, Sinta melakukan upacara membakar diri.
To show her purity and loyalty, Sinta is willing to perform the fire ordeal.

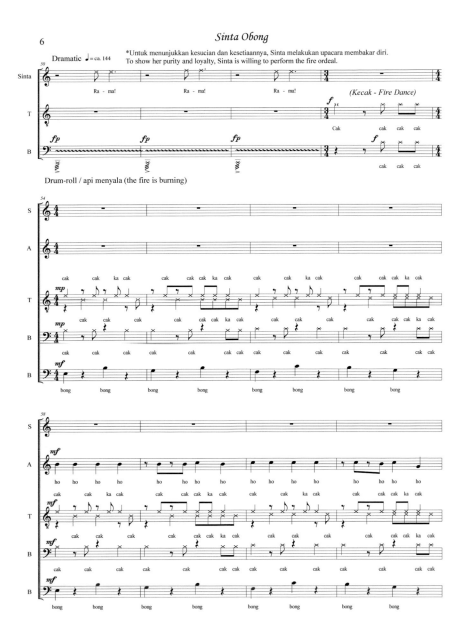

Drum-roll / api menyala (the fire is burning)

Sinta Obong

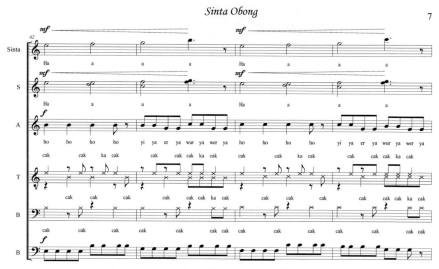

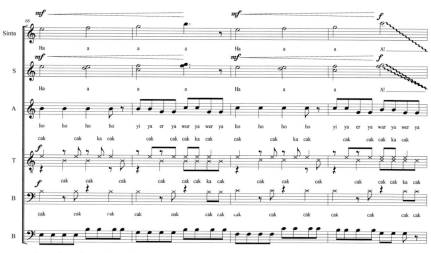

8

Sinta Obong

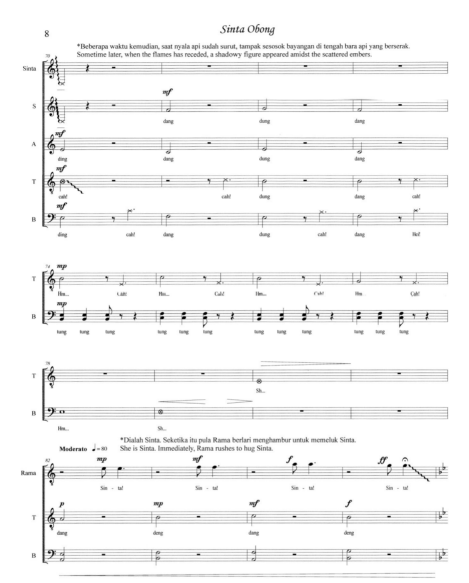

*Beberapa waktu kemudian, saat nyala api sudah surut, tampak sesosok bayangan di tengah bara api yang berserak.
Sometime later, when the flames has receded, a shadowy figure appeared amidst the scattered embers.

*Dialah Sinta. Seketika itu pula Rama berlari menghambur untuk memeluk Sinta.
She is Sinta. Immediately, Rama rushes to hug Sinta.

Sinta Obong

*Sinta dan Rama pun berpelukan dengan perasaan haru, bangga, dan bahagia.
Sinta and Rama then hug each other with feelings of emotion, pride, and happiness.

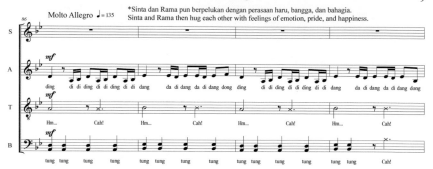

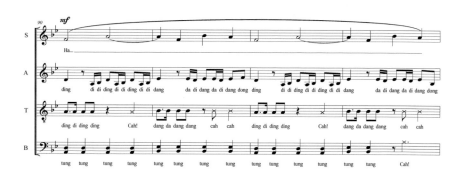

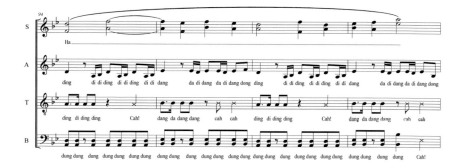

10

Sinta Obong

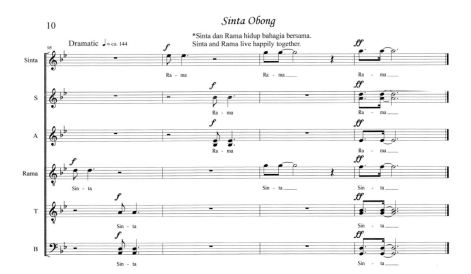

Sinta dan Rama hidup bahagia bersama.
Sinta and Rama live happily together.

Index

abduction of Sita 105, 109, 147,
 151, 153
abject poverty 24
absolute monarchy 169–171, 173,
 175, 176
absolute monarchy period 183
adaptation 7, 19, 46, 47, 104, 147
 contemporary 4
 free 67, 68
 live-action 61
adventure 1, 8, 92, 122, 134, 148,
 152
Aesop's fables 92
aesthetics 96, 135
Alengka 74, 75, 82, 84, 153, 154
Alengka kingdom 74, 82, 153, 211
Amar Chitra Katha 118
Angkor-style building 167
Angkor Vatt Temple 107
animation 4, 19, 21, 27, 159, 210,
 216–221
animation video work 219, 220
animator 27, 209, 210
Anjaneyam-Hanuman's Ramayana
 119, 132–136
Anoman (*see also* Hanoman and
 Hanuman) 39, 72, 74, 80, 147,
 157, 210–214, 217, 219
Anoman's flight 219
Apsaras Arts 119, 125, 127, 128,
 130–133, 135, 136
Aranyakanda 33
archaic smile 59
Argasoka Garden 153, 155
art exhibition 4
art form 2, 6–9, 11, 14–16, 18, 25,
 26, 116, 125, 126, 128, 145,
 150

ancient 128
contemporary 2, 4, 9
contemporary dramatic 5
dramatic 2, 5
indigenous 3
martial 125
performance-based 117
popular 4
artifact 160, 192, 196–203
 archaeological 183
 archeological 167
artist 4, 16, 19, 22, 24, 27, 28,
 97–100, 125, 149, 210, 211,
 216
 comic 9, 18
 contemporary 4
 dance 131
 Indian diaspora 131
 performing 100, 124, 131
 post traditional 4
 post traditional shadow puppet
 4
art work 25, 66, 210
ASTI Yogyakarta 215
asura 54
Aswamedha sacrifice ritual 32
audience 3, 5, 46, 63, 123, 125,
 132, 135, 144, 146, 147, 158,
 160, 161, 204
avatar 66, 84, 95, 200, 201, 217
Ayodhya 8, 31, 32, 35, 92, 117, 147
Ayodhyakanda 32
Ayodiya 74, 75
Ayodya kingdom 152
Ayutthaya dynasty 51, 169
Ayutthaya kingdom 46, 50
Ayutthaya period 170

Badung dynasty 85
Balakanda 32
banana tree trunk 193
Bangkok dynasty 170, 172, 183
battle 34, 36, 61, 63, 71, 75, 77, 78, 80, 83, 85, 86, 92, 95, 153, 154
battlefield 32, 34, 64, 77, 79, 80, 82, 83
battle scene 36, 76, 79, 80, 83, 94, 146, 155, 157
Bharatanatyam 124, 126–131, 135
Bhaskar's Arts Academy 124, 127
Bhattikavya 7, 73, 150, 151
Bibheka 95, 108
Big Four 127
Bimo Dance Theatre 134
biodiversity 103
Black Sun 22
Blowin' in the Wind 87
Bohai kingdom 189
Brahma Arrow 107
bridge 9, 34, 36, 107, 147, 154
Buddhism 11, 12, 14, 54, 56, 57, 108, 190, 195
Buddhist law 57, 96
Buddhist scripture 190
Burmese attack 170

capitalism 14
carangan 211, 217
catastrophe 77
Cato Production 221
Chaiyo Studio 49, 53, 54, 59, 62, 67
Chaiyo Studio production 54, 61, 63, 67
Chakri dynasty 50
chariot 77, 86
choir 105, 225
choral music 5, 27, 209, 210, 225
choreographer 24, 131
choreography 27, 129, 130, 135, 155
cinematography 54
comics 4, 21, 67, 118, 119

comic work 2, 18, 19, 21
community 9, 14, 21, 22, 98, 99, 101, 119, 138, 161, 192, 205
 diaspora 2, 5, 17, 18, 21, 26
 international 168, 182
 local 23, 99, 133, 144, 146, 161
 regional 10
composer 24, 27, 131, 209, 210, 221
composition 21, 54, 76, 80, 87, 94, 116, 130, 145, 152, 156
conflict 49, 87, 92, 167, 168, 182, 183, 223
coronation 93, 109, 170–172, 180
costume 2, 6, 11, 19, 22, 62, 155, 157, 160, 194, 200
 Balinese influenced 27
 dance 203
 ethnic 14
 luxurious 12
creative work 9, 10, 19, 28
creativity 160, 203, 211
crown 58, 64, 198–200
cultural elements 2, 3, 13–15, 21, 23, 150, 158–161
 authentic 25
 regional 25
 traditional 5
 visual 14
cultural heritage 2, 3, 17, 23, 26, 100, 101, 119, 121, 122, 126, 137, 138, 150, 196
cultural imperialism 16
cultural infrastructure 121, 122
cultural policy 26, 119, 120, 173, 175, 176, 178
cultural practice 17, 119, 144
cultural situation 6, 13–17
cultural tradition 21, 22, 119, 138, 166
culture 5, 13–17, 24, 25, 99, 101, 120, 121, 123–126, 137, 160, 165, 167–169, 179, 182–184, 191–193, 202, 203

court 3, 12, 15
dance 169, 176
Dvaravati 51
foreign 14
global 132
human 202
Indian Tamil 50
indigenous 14
intangible 183
international 188
Lao 176
local 115, 116, 175
materialistic 120
national 115, 150, 176, 182
royal 176
vernacular 138
visual 118

dalang 26, 72–74, 76, 79–82,
 84–88, 191, 194, 209, 210, 221
dance drama 2–4, 8, 11, 12, 19, 22,
 104, 105, 125, 128, 129, 144,
 148, 150, 151, 194, 210–213,
 215
 masked 3, 5, 12, 28, 194, 195,
 201, 209
dancer 24, 104, 105, 131, 132, 135,
 136, 149, 150, 155, 157, 210,
 215
 celestial 104
 classical 135
 classical Indian 117
 contemporary 4
 female impersonator 210
 king's 49
 legendary 131
 non-Singaporean 135
 viceroy's 49
dance troupe 49, 119, 124, 170,
 177
dance work 2, 4, 26, 27, 212, 215,
 216
Dandaka forest 33, 152

dasamuka 194, 217, 218
Dasaratha 32, 33, 74
Day of Great Sorrow 59
Deepawali 119
demon 49, 75, 93, 95, 104, 158,
 190
demon king 1, 7, 8, 10–13, 27, 32,
 71, 74, 147, 211, 217, 220
demon race 93, 95
devotion 10, 26, 64, 66, 129, 132
Dewa Baruna 211
Dewi Tara 153
Dewi Widowati 152, 154
director 63, 123, 124, 135,
 176–178, 216, 225
discourse 121, 159, 165, 168
 adversarial 182
 cultural 15
diversity 3, 13, 126, 194–196
 cultural 13, 18, 124
 religious 18
Dore Production 222
Dragon King 189
drama 6, 12, 116, 129, 137, 144,
 170, 181, 194
 classical dance 170
 epic 118
 masked 8, 12, 26, 46
 non-masked dance 2

enemy 63, 77, 82, 85, 96, 97, 157,
 189, 213
epic poem 1–11, 15, 17, 18, 20, 21,
 24, 25, 27, 31, 73, 76, 93, 187
evil 8, 54, 93, 118, 149, 158, 160,
 161, 166
exhibition 5, 22, 27, 122, 171, 187,
 191–195, 202, 205
expression 7, 80, 84, 87, 95, 96,
 104, 150, 155, 160, 196,
 198–201
 comic 63
 cultural 15, 16

indigenous art 16
representative art 150
theatrical 2, 5, 6, 144
verbal 6, 144, 157
visual 155, 196

festival 3, 5, 23, 24, 26, 119, 123,
 124, 126, 131
 choral 225
 cultural arts 125
 hybrid 125
 international film 118
 religious 127
film 9, 21, 22, 25, 46, 47, 52–55, 60,
 62, 63, 67
folklore 94, 117, 123
folk tale 50, 51, 148, 190, 195, 221
forest 9, 32, 33, 35, 74, 136, 151,
 152, 166
Fukuda Doctrine 193
Funeral Urn 105, 106

gamelan 22, 23, 72, 76, 80, 149,
 157, 160, 194, 213, 219
genre 2, 3, 117, 144, 149, 195, 203,
 219
 artistic 26
 classical dance 131
 contemporary 26
 cultural 15
 hybrid art 14, 16
 traditional 26
globalization 15, 101, 119–121
god Brahma 34, 35
god Narada 35
god Vishnu 1, 7, 11, 20, 32, 35, 36,
 95, 147, 166, 200, 201, 217
god Visnu 217
god Wisnu 84
Golden Stag 105
Green Monkey 97

Hanoman (*see also* Anoman and
 Hanuman) 39

Hanuman (*see also* Anoman and
 Hanoman) 11, 25, 27, 33, 34,
 36, 46, 47, 52–63, 91, 92, 107,
 110, 132–136, 153, 154, 159,
 196–198, 211, 212, 217, 219,
 220
heaven 32, 35, 56, 83, 84, 92, 93,
 97, 109
heritage 3, 21, 107, 123, 125, 126,
 138, 179, 182, 183

ideology 5, 7, 9, 10, 15, 25, 176
incarnation 1, 7, 10, 11, 15, 20, 27,
 36, 92, 95, 96, 117, 217, 218
Indian diaspora 115, 116, 119,
 137, 138
Indrajid 110, 154
Indrajit 8, 55, 91, 135
intellectual 3, 5, 19, 26, 73, 165,
 168, 169, 173, 176, 181, 183
interpretation 4, 7, 10, 25, 26, 72,
 73, 81, 83–88, 125, 128, 131,
 135
 diverse 3
 fluctuating 5
 original 26, 27
 subjective 99
Intrachit 55
Intrachitt 91, 106, 107, 110

Janaka 32, 94, 95, 152, 153
Jatayu 8, 33, 41, 126, 153, 190, 194
Javanese mysticism 12, 158, 160
Javanese shadow puppetry 37–41,
 147, 148, 191
Joe Louis Theatre 46
justice 10, 26, 55, 57, 66, 95, 96,
 166

Kaikesey 96
Kakawin Ramayana 7, 8, 72–75,
 77, 133
Kalakshetra 128, 130, 132, 135
Kalaya School of Dance 130

Kamasan paintings 122
Kamba Ramayanam 133
katanyu 64, 66
Kathakali 117, 129, 130
kecak 2, 22, 75, 223
Khmer Reamker 92–96, 104, 109,
 110
Khmer Rouge 97, 98, 202
Khmer shadow play 100, 106
khon 3, 5, 12, 26, 28, 46, 58, 60, 62,
 63, 66–68, 165, 166, 168–184
kingdom 9–11, 31, 33–36, 50, 147,
 151, 152, 154, 167, 182, 189,
 195, 196
King Rama I 11, 93, 170, 172, 174
King Rama II 170, 178
King Rama IV 169, 170, 172
King Rama V 170, 171, 173, 174,
 177
King Rama VI 171–176, 178–180
Kishkindhya kingdom 31, 33, 36
Krishna 11, 95
Kumbhakarna 8, 10, 26, 47, 54, 61,
 63, 64, 66, 71, 72, 74–88, 91,
 144, 151
Kumphakan 47, 54, 61–64, 66
Kumphakar 106

Laksamana 71, 74, 79, 80, 83–86
Lakshmana 8, 32–35, 71, 91, 92,
 108, 110, 144, 152, 154, 200,
 201
Lakṣmaṇa 54
Langka 152
Langkah 34–36
Langkah kingdom 33, 34
Lanka 8, 62, 92, 93, 105, 155, 157,
 198
Leksmana 38, 153, 154
Lesmana 38, 144
lkhon khol 166, 182
Lokapala kingdom 147

magic circle 153, 154

Mahabharata 10, 11, 19, 75, 76, 87,
 92, 124, 126, 145, 148, 149,
 159, 187, 191, 195
Maharikshikala 94
Maitreya Buddha 59
Malay shadow play 6
Mantili kingdom 152
Marica 33, 152, 153
mask 2, 6, 12, 104, 171, 178, 187,
 191, 194–196, 198–200, 203
 exhibition of 188, 196
 green 58
 papier-mache 122
 red 58
Maya Dance Theatre 125
meat 62, 63
Melting Pot 98
mermaid 27, 36, 198, 209, 210
Mermaid Savan Macha 27
modernization 14, 15
modern sense 168, 183
monarchy 105, 175, 183
moneytheism 120
monkey army 7, 34, 67, 74, 78–80,
 85, 154, 219
monkey soldier 2, 8, 9, 11, 15, 19,
 25, 31, 36, 209, 220
monster 57, 59, 213
monster crayfish 27, 210
monster shrimp crab 211
moral values 5, 7, 10, 16, 21, 25,
 149, 158, 160, 161
motif 12, 123, 190
movie 48, 52, 54, 55, 57, 60, 61, 63
museum 107, 122, 123, 135, 183,
 187, 188, 191, 193, 194, 202,
 205, 221
museum exhibition 5, 27, 115
music 2, 4, 6, 11, 99, 100, 102, 117,
 119, 129, 130, 133–135, 160,
 188, 189, 212, 213, 219, 225
 chamber 102
 church 225
 classical 127

digital 219
gamelan 191
marching 102
popular 102, 103
musician 28, 100, 102, 132, 136, 155
mysticism 12, 146, 158, 160, 161
myth 58, 104

Nang Sida 68
nang talung 46, 195
nang yai 46, 51, 67, 195
Nano Edon Lighting 222
Natya Lakshita 215
Nippon Ramayana Films 118

ocean 33, 34, 36, 212
Odyssey 92
oral tradition 50, 93, 98, 100, 109, 145, 175, 181

pakem 211, 217
Palee 46, 58
pati obong 223
patriotism 82, 86
Peach Boy 181
Peali 96, 97
perception 3, 5, 26, 168, 182
performance 2, 3, 5, 6, 8–12, 16–19, 21–23, 46, 62, 63, 66–68, 72, 73, 75, 76, 79–88, 136–138, 144–146, 148–152, 154–158, 160, 161, 191, 194, 195, 203–205, 210
 adopted 117
 artistic 6
 colorful 212
 complementary 76
 creative 76
 dance 24, 150, 211
 derivative 76
 dramatic 3, 11, 156, 166
 easy-to-understand 75
 episodic 157
 experimental 17
 female dance 215
 gamelan instrumental 123
 live 22, 125, 205
 onetime 146, 152, 153, 155, 156
 plot-dominant 158
 popular 152
 public 188
 puppet 11, 19–21
 puppet theater 9
 Ramayana fusion 125
 secondary 76
 staged 124
 traditional 117, 219
 unique 13
performance style 2, 22, 72, 144, 145, 148, 149
performer 63, 72, 76, 124, 126, 127, 149, 155, 157, 203, 204
 male voice 2
 multiracial 125
performing arts 72, 73, 98, 104, 115–138, 177, 187, 188, 191, 193, 194, 198, 200, 202–205
perspective 3, 134, 166, 179, 183, 194
philosophy 11, 92, 188, 190
Phiphek 46, 62, 63
Phra Rak 54, 62, 67, 68
Phra Ram 46, 49, 62–64, 66, 169
politics 26, 93, 121, 138
Prabu Rahwana 152
Preah Leak 91, 96, 107, 110
Preah Ream 91, 92, 95–97, 105, 106, 109, 110
protagonist 8, 9, 12, 15, 31, 146, 148, 151, 152, 159
puppet 2, 6, 8, 20, 21, 37, 46, 72, 76, 187, 188, 194–197, 199
puppeteer 19, 26, 159, 191, 209, 211, 217, 221
puppetry 106, 137
puppet theater 9, 10, 19, 20, 194, 195, 203

Puranas 134

Rahwana 37, 143, 152–154, 211
rakshasa 33, 35, 54, 195, 196, 200,
 201
Rama 7–11, 31–36, 49, 50, 58, 71,
 74, 75, 79, 80, 84, 85, 88, 91–
 93, 95–97, 108–110, 116–119,
 133, 134, 147, 148, 152–155,
 175, 176, 200, 201, 217–220,
 222, 223
Rama's army 9, 10, 34, 36, 78, 80,
 83, 87
Rama's incarnation 148, 159
Rama VI 50, 51, 173, 176
Ramlila 116, 117
Ravana 8, 10, 32–34, 91, 92, 94,
 95, 108, 110, 116, 126, 134,
 135, 152, 154, 155, 158, 159,
 198–200, 217, 218
Ravana's army 34, 36
Ravana's birth 35, 147, 158
Rawana 71, 74, 75, 77–82
Reap 91, 92, 96, 105, 109, 110
Red Khmer 97
Red Monkey 97
reign 109, 170, 171, 173, 174, 176,
 177, 179, 183
reincarnation 32, 147, 152, 154
Rekatha Rumpung 27, 210–214
religion 13, 14, 27, 92, 133, 190
Renaissance City 121
repertoire 3, 4, 12, 100, 128,
 146–149, 158, 203, 211
rituals 2, 5, 27, 60, 92, 146, 147,
 166
 purification 195
 royal 174, 177
Romeo and Juliet 92
royal Khon 178

Salad Bowl 98
sbaek thomm 106, 195, 198,
 202–204

scene 52, 54, 55, 57, 58, 62, 63, 66,
 67, 79–82, 85, 86, 108, 117,
 152, 155–157, 219, 222
 acting 146
 brutal 86
 clown's 157
 contemporary art 4
 contrasting 62
 discrete 156
 diverse cultural 135
 face-to-face 80
 ferocious 83
 global art 16
 meeting 146, 157
 memorable 54
 romantic 83
scene composition 79, 85
script 56, 72, 73, 81, 85, 87, 170
sendratari 22, 144–150, 152,
 155–161, 211
 creation of 149, 160
 performance of 145, 161
shadow play 8, 12, 22, 99, 104,
 106, 107, 116, 194, 201, 218,
 219, 221
shadow puppet 2, 8, 10, 46, 122,
 125, 145–147, 156, 158, 159,
 195, 198, 203, 219, 220
shadow puppetry 10, 22, 25, 147,
 148, 151, 211, 219
Shinta 152–154
Sinta 38, 194, 222, 223
Sinta Obong 27, 210, 221, 223
Sinto 38, 151
Sita 7, 8, 32–36, 38, 91, 94–97, 104,
 105, 108–110, 129, 132, 135,
 147, 151, 152, 154, 155, 217,
 224
slokas 7, 31, 35, 36
society 8, 9, 96, 122, 128, 176, 204,
 205
 global 101
 modern 68
 multicultural 127
 vibrant 121

Song of Love Dance 213
spectacle 2, 11, 145, 157, 158, 160
 acrobatic 63
 fiery 155
stanza 77–79, 83, 84, 104, 145
storyteller 109, 123
storytelling 104, 109, 123, 134,
 194
story world 4, 12, 27, 147, 149,
 159, 160, 217
Subali 153
Suek Kumphakan 47, 61–63, 65–67
Sugriva 33, 34, 36, 46, 58, 72, 83,
 91, 97, 110, 144, 153, 154
Sugriwa 39, 72, 144, 153
Sukrip 91, 96, 97, 110
Sukureep 46, 58, 62, 63
Surpanaka 74
Surpanakha 33
Swayamvaram 129

television series 118
theater
 dance 4, 24, 130
 folk 46
 masked 194
 outdoor 170
 street 125
 traditional 18, 156–159
theatrical form 2, 5–8, 18, 19, 21,
 36, 105, 143, 144, 161, 219
theme 4, 5, 8, 9, 17, 24, 25, 62, 77,
 79, 97, 101, 108, 123
 artistic 11
 binding 24
 didactic 12
 literary 156
 theatrical 138
 traditional 10
 universal 8, 132
Thotsakan 46, 49, 54, 55, 62
throne 32, 33, 35, 74, 171, 174,
 180
tourism 2, 5, 15, 26, 103, 148–150,
 159, 160

tourist 2, 3, 11, 12, 22, 23, 26, 46,
 75, 103, 137, 143–146, 148,
 149, 152, 156–161
tradition 23, 28, 46, 51, 94, 97, 99,
 100, 106, 127–130, 134, 167,
 168, 170, 204, 205
 artistic 23
 classical 129
 dance 109, 130
 female 104
 regional art 2
 religious 14
 theatrical 117
 village 106
Tulsidas 116, 123
Tulsidas's Ramayana 129, 133

Ultra Brothers 55–57, 60
Ultra Hanuman 55–57
Ultraman 47, 52–63, 67
Urang Rayung 27, 211–214
Uttarakanda 7, 35, 73

Valmiki 7, 31–40, 73, 92–94, 116,
 129, 133, 135, 197
Valmikian Ramayana 8, 12, 31, 50,
 73, 145, 146, 148, 149, 151,
 152, 155, 160, 196
Vibhishana 8, 10, 34, 35, 46, 62, 72
Vishnu Purana 51, 173
Voice of Bali 221–224

wayang 9, 10, 12, 19, 72, 73,
 75–77, 79–82, 87, 191,
 193–196, 198, 199, 201, 211,
 219–221
 komik 19
 original 221
wayang kulit 37–41, 125, 145, 148,
 191, 194, 195, 199, 201
Wayang Square 194
Wibisana 40, 72, 75, 78, 80, 83, 84,
 154